Memories before the State

CENTER FOR THE STUDY OF
**GENOCIDE
& HUMAN RIGHTS**

Genocide, Political Violence, Human Rights Series

EDITED BY ALEXANDER LABAN HINTON AND NELA NAVARRO

Memories before the State

Postwar Peru and the Place of Memory, Tolerance, and Social Inclusion

Joseph P. Feldman

Rutgers University Press
New Brunswick, Camden, and Newark, New Jersey, and London

Library of Congress Cataloging-in-Publication Data

Names: Feldman, Joseph P., author.
Title: Memories before the state : postwar Peru and the Place of Memory,
Tolerance, and Social Inclusion / Joseph P. Feldman.
Description: New Brunswick : Rutgers University Press, [2021] |
Series: Genocide, Political Violence, Human Rights |
Includes bibliographical references and index.
Identifiers: LCCN 2020045032 | ISBN 9781978809543 (hardcover) |
ISBN 9781978809512 (paperback) | ISBN 9781978809550 (epub) |
ISBN 9781978809567 (mobi) | ISBN 9781978809574 (pdf)
Subjects: LCSH: Lugar de la Memoria, la Tolerancia y la Inclusión
Social (Peru)—History. | Historical museums—Peru. | National
museums—Peru. | Collective memory—Peru.
Classification: LCC F3403.5 .F45 2021 | DDC 985—dc23
LC record available at https://lccn.loc.gov/2020045032

A British Cataloging-in-Publication record for this book is available
from the British Library.

www.rutgersuniversitypress.org

Manufactured in the United States of America

CONTENTS

Preface

On December 17, 2015, the Place of Memory, Tolerance, and Social Inclusion (Lugar de la Memoria, la Tolerancia y la Inclusión Social) opened its doors in Miraflores. After years of debate and deliberation, Peru finally had a national museum that memorialized the country's late twentieth-century internal armed conflict. The inauguration ceremony itself reflected some of the complexities and contradictions that had characterized the institution's history. Taking place in a temporary enclosure installed on the museum's esplanade, the event was attended by diverse sectors: ministers and high-level government officials, current and former Place of Memory staff, and well-known figures in the country's human rights community, along with artists, intellectuals, members of the armed forces, and representatives from victims' organizations and rural communities affected by war. Fashion-conscious hipsters intermingled with functionaries in black suits; several attendees from the Andean region of Ayacucho wore traditional dress. The purple-hued lighting, white couches, and "reserved" signs on some tables produced a nightclub-like ambience that some of my colleagues considered odd, if not inappropriate, for the type of institution being inaugurated.

President Ollanta Humala's appearance at the event was an important gesture of official recognition for the human rights–oriented museum. At the same time, friends and colleagues of mine noted that the head of state, a former military official, sounded like an unsophisticated *cachaco* in his speech (which referenced the "political and ideological myopia" of believing that all soldiers committed atrocities or, alternatively, that all peasants living in emergency zones were "terrorists").[1] After a ribbon-cutting ceremony, the crowd on the esplanade thinned, with groups of visitors passing through the Place of Memory's exhibition halls for the first time. A couple of individuals who had been involved in the curatorial process told me that some minor errors had already been spotted (dates, the spelling of last names, etc.) and would need to be corrected in the coming days. The rush to finish the exhibit during the preceding weeks was symptomatic of the limited financial and institutional support the Place of Memory project had received since its inception.

Larger questions about audience, impact, and relevance (also recurring issues throughout the project's history) persisted. Although the museum's opening received significant coverage in Peru's major newspapers the day of the inauguration—and the president's speech that evening was broadcast on national television—I was told by friends that unless someone had been following the Place of Memory on social media or was otherwise "in the know," it would have been easy to be unaware of the milestone. What's more, it was likely that for certain critical observers who had been tracking the museum's development, the #HoyNosEscuchamos (#TodayWeListenToEachOther) hashtag used to promote the institution (and projected on a black screen at the inauguration) only reinforced concerns about a lack of dialogue and transparency in the process of making the site.

Having flown in from neighboring Ecuador to attend the event, I, like others at the Place of Memory that evening, wondered what the coming weeks and months would bring for the memorial museum. It would not be an exaggeration to say, however, that the overwhelming sense for me and many attendees was one of mild astonishment. The subject of much drama and disagreement over a period of almost seven years, the Place of Memory was now a real, working institution.

This book examines debates and practices that led to this moment. The Place of Memory, Tolerance, and Social Inclusion—now popularly known as the LUM (pronounced "loom")—is an institution charged with representing the history of political violence that took place in Peru during the 1980s and 1990s. The main actors in this internal armed conflict were the Peruvian state, the Maoist guerrilla organization Shining Path (Communist Party of Peru–Shining Path [Partido Comunista del Perú–Sendero Luminoso]), and another, smaller insurgent group, the MRTA (Túpac Amaru Revolutionary Movement). The war began in 1980, when Shining Path initiated an armed struggle with the goal of overthrowing the Peruvian government. The leftist group's brutal tactics were met with an equally violent response from the Peruvian military, which engaged in "dirty war" practices not unlike those found in other Latin American countries that experienced armed conflict and authoritarian rule during the 1970s and 1980s. Levels of violence declined in most parts of Peru following the 1992 capture of Shining Path's leader, Abimael Guzmán. However, the 1990s were marked by human rights abuses perpetrated by the authoritarian government of Alberto Fujimori (1990–2000) in the name of combating terrorism. According to the analysis of the Peruvian Truth and Reconciliation Commission (2001–2003), an estimated 69,280 Peruvians died as a result of the conflict (CVR 2003). Much of the violence was concentrated in Peru's Andean and Amazonian regions, with rural and indigenous populations disproportionately affected.

My ethnography is based primarily on fieldwork conducted between January and December of 2013 in Lima, the nation's coastal capital and home to the LUM. I spent much of my time that year conducting formal interviews (a total of seventy-two) with individuals involved in the museum project as well as representatives from sectors participating in the process: human rights NGOs, victims' organizations, the armed forces, academic and research institutions, and international donors. I also attended relevant meetings and public events, followed developments in the news media, and regularly conversed with friends, colleagues, and interlocutors about issues related to my research. This work built on shorter research trips to Peru in 2009, 2010, and 2011 and was complemented by subsequent visits in 2014, 2015, 2017, 2018, and 2019 (for a total of approximately eighteen months in the country).

In designing and carrying out the main period of fieldwork, I sought to track the networks of people and institutions involved in discussions that influenced the LUM's creation. Following the work of other ethnographers of museums (Bunzl 2014; Handler and Gable 1997; Isaac 2007; Macdonald 2002; Price 2007; Shannon 2014; White 2016), I considered it important to document how visions of (and for) the LUM became bound up in the specific individuals, events, and encounters that came to constitute the project. It was evident that the initiative I was studying was far from a canvas on which "contested visions of history" or some such thing would be projected. The LUM initiative had acquired its own historical and institutional trajectory and that reality needed to be taken into account. Although I worked mostly in Lima, the relations and processes I examined extended beyond the nation's capital, and I incorporate some material from research conducted in the highland region of Ayacucho in chapters 4 and 5. This region—the birthplace of Shining Path—was home to a wave of memorialization initiatives that, at one point, the LUM was keen on channeling into a national network of memory sites.

Further, my approach as a researcher enabled me to appreciate the way that distinctions between "commentator on" and "participant in" the museum project could be blurry and sometimes shift over time. For example, the charismatic activist I depict in the introduction (Karen Bernedo) would eventually find herself participating in the state initiative (see chapter 5). And particularly in the later stages of the LUM's creation, several of the institution's employees were intellectuals I had previously known as colleagues, prompting reflection about how academic researchers are drawn into institutional design and the making of historical narratives.

As the reader will see, when delving into the history and social life of the project, my research experience was shaped to a significant degree by my position as a young foreign anthropologist as well as my (perceived)

relation to the LUM. It is through this experience and from this position that I gathered material for the chapters that follow.

A note on names and terminology: For reasons of simplicity, I typically refer to the "LUM" as opposed to the "Place of Memory," despite the anachronism of doing so (this acronym became widely used in 2015 as the result of a promotional campaign). In addition, I often use pseudonyms when describing individuals interviewed for the book. There are several exceptions to this, especially in cases where participants are well-known public figures or indicated their willingness to be identified. Such decisions are always difficult, and I have made them in accordance with research protocols at universities with which I have been affiliated, the American Anthropological Association (AAA) Statement on Ethics, as well as my own sense of what is fair and appropriate. All translations, unless otherwise noted, are my own. I try to explain relevant translation and terminology decisions as they appear in the text.

Memories before the State

Introduction

DANGEROUS OBJECTS

A transnational culture of memorialization has gained traction in Peru. Like any culture, it is characterized by a particular set of norms, values, and prohibitions. If "transnational culture" is to have analytical value, it must be conceptualized with reference to social worlds and power relations that emerge as people engage with mobile ideas and practices (Ong 1999).

On Avenida España, in downtown Lima, there is a most interesting museum. You cannot just walk in though. Prior permission or a well-connected friend is essential, but even then, you must pass through at least two levels of security before reaching the exhibit.

Once inside the small, two-room site—more a "gallery" than a full-fledged museum, its custodians admit—one finds a diverse assortment of visually striking artwork. Paintings, ornamental rugs, flags, embossed handbags, woven baskets, Andean *retablos* (altarpieces), all of them bearing Maoist iconography or otherwise referencing Shining Path's armed revolutionary struggle. The museum is housed in DINCOTE (National Counter-Terrorism Directorate), the antiterrorism unit of the Peruvian National Police, which has its origins in the 1980s.[1] Most of the artifacts were seized in early 1990s raids of Shining Path safe houses in Lima that anticipated the capture of the group's leader, Abimael Guzmán, in "Operation Victory" on September 12, 1992. Technically still in police custody, the pieces were produced mostly in area prisons, including sites notorious for riots and extrajudicial executions during the armed conflict. In addition to the gallery's artwork, there are printed photos providing an inkling of historical context as well as a life-size mannequin of Guzmán standing in a cage and wearing a striped prison jumpsuit, a display evoking the way the guerrilla leader was publicly exhibited by the Fujimori government following his capture. In the second room, near the mannequin, is a small collection of the philosophy professor–turned–guerrilla leader's personal effects, including pill bottles for the medication Guzmán took to treat his psoriasis (an important clue in the police's search for the Shining Path

head). Stacked on the floor of that room are the hundreds of books that comprised Guzmán's personal library. According to several news articles written on the museum over the years, the gallery showcases some 1,200 objects.[2] And from a curatorial standpoint, it displays them with a professional appearance matching that of most museums of its size in Peru.

My short, twenty-minute visit to the DINCOTE museum in January 2013 was made possible by an invitation from Major Pedro Sánchez, a retired officer who was a member of the antiterrorism body's Special Intelligence Group (GEIN), the eighty-person unit that orchestrated the operation that took down Guzmán. I met Major Sánchez at a meeting he had with representatives from the Place of Memory, Tolerance, and Social Inclusion (LUM), where I expressed interest in speaking with him further about the DINCOTE site and its potential relation to the national museum project.

We spoke several times and, although the facts surrounding the DINCOTE museum's creation always remained murky to me, I became drawn to Sánchez's musings on the captured objects' significance. The exhibit appears to have its origins in a small gallery established shortly after the police raids of the 1990s.[3] Sánchez told me that in the beginning there were just two large glass cases standing back to back to one another in a room that was smaller than the one I had visited. The objects were selected for display based on their aesthetic value, he said, with the most "striking" and "eye-catching" (*vistosos*) pieces being singled out. The small gallery stayed this way until the early 2000s. At that time it was decided (by whom, I do not know) that the gallery needed to have a proper circuit for visitors and be organized chronologically. Sánchez told me about DINCOTE's cabinet of curiosity-to-museum transition, in which the principle of showing the "nicest" pieces was maintained but dates and periods were added to give the exhibit a "more professional character."

There were, however, a few errors in the process, according to Sánchez. He drew my attention to one in particular. "Some errors were committed. Because . . . well, the designer, an engineer, with very good intentions, inflated the act [*sobredimensionó el acto*] and put some very nice glass cases and, the Shining Path flags, he put them in gold-leaf frames. In the end, they criticized us for that. Because it was practically apologism." When I asked who criticized them, he said it was Peru's National Institute of Culture (INC).[4] DINCOTE had, as Sánchez tells it, requested recognition from the agency. An INC delegation came, and they were "horrified" at what they saw. Sánchez recounted how the institute's officials lectured him about their mandate to safeguard the cultural heritage of the nation and expressed their view that DINCOTE's collection of "objects of death and destruction" did not qualify as "part of the culture of our people." What's more, Sánchez recalled a warning he received from one of the cultural institute's representatives. "Be very careful

about the people who visit this site because they can take away a very different idea," the representative told him. Students and young people might be drawn to the artifacts' sophistication and leave the exhibition thinking that Shining Path "could have led us to a better way of life."

It was for these reasons that the INC did not recommend the DINCOTE museum for inscription, according to Sánchez's telling. He sensed that the outcome might have been different had he and his colleagues displayed the objects in a more austere fashion, perhaps without shiny new glass cases or gold-leaf frames that accentuated the works' artistry and visual force.[5] The museum was never opened to the public, but people did come to see the Shining Path objects—foreign delegations, academics, truth commissioners, police cadets, military officials, the odd journalist—and Sánchez served as an occasional guide over the years.

Despite some objects' deterioration due to moth damage and the effects of halogen lights, the collection retained its symbolic potency for the retired police officer. Proclamations that the "spirit" of Shining Path was captured in the DINCOTE collection appeared in each of my four interviews with Sánchez. "We [at DINCOTE] think that while these objects in the museum are in our hands, and if it is the case that Abimael Guzmán is shut away in a maximum-security prison . . . the spirit of the organization, we have it in the museum. The spirit . . . the ideological essence. . . . And while we have it in our hands, [Shining Path] will not be the same again." So were the objects themselves dangerous? "Of course," Sánchez replied. "If this ideological essence is returned to them, the fanaticism will grow," he explained.

Knowing that my primary interest was in the LUM initiative—the museum that would potentially represent DINCOTE's story alongside those of other key actors in Peru's armed conflict—Sánchez insisted that this state-sponsored initiative needed to be careful. He told me he had already warned a representative from the LUM in a manner similar to how the INC official cautioned him and his colleagues years before: "I told [the LUM representative] that . . . one had to be very careful. Because this 'Place of Memory' could be taken as a pilgrimage center, a place where terrorists visit frequently, those who are free now, their relatives . . . the front organizations. Like a pilgrimage center, like a sanctuary for terrorists. It was very dangerous." He expressed concern that the site could become like the Ojo que Llora (Eye that Cries), a well-known Lima memorial that Sánchez (wrongly) believed was a hub for Shining Path commemorative activities. "This worries us." Security would be a key issue for the LUM if they were to display Senderista objects. Shining Path militants or sympathizers could rob the museum "at any moment." "What would happen with an organization that recovers its spirit? It's very dangerous [*peligrosísimo*], right?" For this reason, and perhaps out of a desire to maintain DINCOTE's collection intact, Sánchez opposed donating

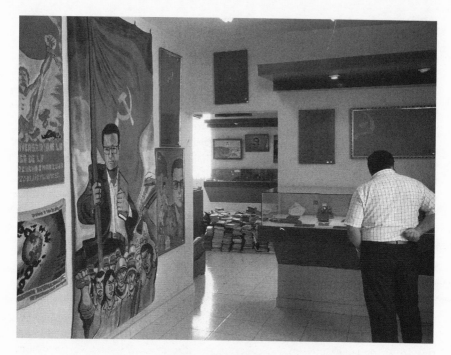

DINCOTE museum.

or selling a significant number of objects to the LUM.[6] Making replicas—
presumably free of the Shining Path spirit—would be the better option.
And besides, why should the LUM, with all of its money and resources, get
to mine DINCOTE's collection?

The Senderista objects were hazardous, but Sánchez also stressed their
value, his discourse evincing a reverence for Shining Path that appears to be
shared by many of his associates in the Peruvian National Police. Historian
Cynthia Milton (2015:365–366), documenting her 2012 visit to the DIN-
COTE museum, describes her guide (who seems to have been someone other
than Sánchez) as, "[appearing] concerned that the images and objects on view
might have the power to make people sympathetic to Shining Path." Without
proper training, one might easily be duped by their impressive appearance.

That did not mean that they should be destroyed, however. Here, the nar-
rative about the confiscated objects elaborated on a distinction that DINCOTE
officials are keen to make: their tactics and worldview were fundamentally
different from those of the Peruvian armed forces.[7]

"The *militares*, for their part, were not happy that the police had this
museum," Sánchez insisted. According to the retired police officer, a member
of the military would say that the collection "should be burned immediately."
Sánchez also told me stories of visiting military officials who supposedly

attempted to steal objects from the museum. The police, on the other hand, "didn't agree with killing or destroying," as "when one has a live terrorist, one can study him, question him . . . even convince him." The treatment of objects served as an allegory for treatment of the terrorist enemy.

"We don't combat ideas," Sánchez told me, expressing an institutional position that DINCOTE tells itself and anyone who might be listening. There was nothing inherently wrong with reading Marx, Lenin, or Mao; it was the "violent interpretation" of these ideas that was the problem. DINCOTE's approach was premised on learning such interpretations, trying to get a sense for how Senderistas thought, what they read, what their associations were, what they ate, how they slept, and so on.[8] The military, Sánchez declared, had little interest in such matters and routinely engaged in the indiscriminate tactics that DINCOTE eschewed.[9]

Where DINCOTE saw civilization in their museum—or at least a testament to their rejection of the military's barbarism—others saw a site that was out of step with contemporary norms. There had been an official LUM visit to the DINCOTE museum in late 2012 and representatives had gone to the collection individually before that. The national museum project was facing its own object dilemmas and the police museum represented a potential source of inspiration, if not actual materials. LUM workers with whom I spoke referred to the gallery as DINCOTE's "war trophies." Officials expressed their pessimism about the likelihood of DINCOTE donating or otherwise letting items pass to the national museum. They would never give them up, several representatives assured me. DINCOTE's reluctance, couched in terms ("war trophy") that contrasted the police's triumphalism with human rights–oriented logics of memorialization, reinforced a general view that the antiterrorism police would be a highly interesting partner to deal with, but also a potentially problematic one. Adding to this uncertainty was perhaps a sense that giving too much attention to police narratives ran the risk of displacing the armed forces, a powerful sector in debates about the national museum.

A member of the LUM's exhibition design team, who described his visit to the DINCOTE museum as "really intense" (*bien fuerte*), elaborated on the curatorial challenges that Senderista objects posed. The DINCOTE museum, in short, was a model of what *not* to do:

> One thing is showing the paraphernalia or the Senderista objects as a kind of altar, like how they have them at DINCOTE . . . and another thing is presenting them in a plainer way, a more quotidian, more mundane way, right? It all depends on how you present them.
>
> But I would not do what DINCOTE has done, in their museum. At DINCOTE, it's like a war trophy, a type of chapel or something. And it

seems good to me . . . [*laughter*] that they don't have it open to the public.

Even if the objects could be domesticated through curation in a national museum, there was still the risk of making an exhibit that would resemble a "temple of worship," a scenario the LUM worker described as dangerous. With overtures to DINCOTE (and the Public Ministry, also believed to have Senderista objects in custody) producing nothing tangible, the consensus view during my main period of fieldwork was that if the curatorial team wanted to display Shining Path–inspired art or artifacts, they would have to make replicas, using the "real thing" only as creative inspiration.

THE MEMORIAL MUSEUM IDEA AND PERU

The scenario sketched above demonstrates a basic truth about memorial museums in Peru and in other parts of the world that have recently been affected by conflict: experiences of war and authoritarian rule produce a plurality of meanings, affective ties, and commemorative practices that may or may not fit neatly within a contemporary wave of human rights–oriented memorialization. As anthropologists María Eugenia Ulfe and Vera Lucía Ríos (2016:27) state plainly in their study of the DINCOTE museum, the gallery "cannot be understood as a 'museum of conscience' or a 'site of memory.'" Despite some clear ways in which the DINCOTE site mobilizes artifacts and representations of past violence to transmit its own particular vision of "never again," few would disagree with these authors' assessment.

In a comparative sense, scholars and practitioners have begun to examine the "memorial museum" as a global cultural form (Sodaro 2018; Williams 2007), one that has been taken up by diverse actors to serve a variety of agendas but is nevertheless characterized by certain unifying characteristics. Paul Williams's (2007) survey of this museum genre acknowledges its antecedents in sites memorializing the World Wars and the Holocaust while emphasizing the international proliferation of memorial museums in the post–Cold War era. Amy Sodaro (2018:3), in her comparative study of five memorial museums, underscores the "global, transcultural nature of this new commemorative form," attending to transnational flows that influence the making of these sites. Attempts to make sense of the form's emergence and circulation on a global scale often cite factors such as the growing relevance of memory and human rights discourses since the latter part of the twentieth-century, locating these museums within a "memory boom" evident in art, academia, and other domains of social life (Huyssen 2003). Cultural theorist Silke Arnold-de Simine (2013) goes a step further, arguing that logics and curatorial practices associated with memorializing difficult pasts are now evident in other genres of museums. The author observes that

a hallmark of such sites is a "postmodern shift from 'history' as the authoritative master discourse on the past to the paradigm of memory" (Arnold-de Simine 2013:10).[10]

It is possible to set out some common features of memorial museums without an exhaustive review of the scholarly literature. To begin with, these sites tend to be centered on victims and the effects of violence as opposed to the defeat of foreign or internal enemies. They are intended to promote ideals of human rights and democracy rather than the martial nationalism that an earlier generation of monuments, memorials, and museums (ostensibly) sought to instill. They typically emphasize the inclusion of diverse voices and critical interrogation of dominant narratives, defining themselves in opposition to "official history." They almost always combine pedagogical goals with commemorative ones, albeit to varying degrees. Increasingly, they make use of audiovisual technology to promote identification with those who were directly affected by violence.

Even when it comes to matters as specific as the kinds of objects an institution should display and how it should display them, there are identifiable norms and conventions—Williams (2007:25–50) devotes a chapter of his volume to the topic. The DINCOTE collection, though providing material evidence of past violence, falls outside of the usual categories of objects found in memorial museums, such as the personal effects of victims or artifacts of state terror (Williams 2007:28; see also Arnold-de Simine 2013:78). As illustrated above, the display of Shining Path objects as war trophies, cautionary relics, or artifacts that contained the insurgent group's "essence" did not sit well with those tasked with creating a museum of this type in Peru. And it was difficult to imagine how the perspective of a figure like Sánchez could be incorporated into a human rights–focused display. The custodians of the DINCOTE museum did not establish their site within the conventions of globalized memorial museums whereas the LUM initiative did so in a clear and self-conscious way.

The immediate origins of a push toward memorialization in Peru could be traced to the Peruvian Truth and Reconciliation Commission (TRC) and the subsequent creation of local and regional memory projects during the first decade of the twenty-first century. The truth commission produced a photo exhibit based on its work, Yuyanapaq, which was inaugurated in August 2003 and quickly became one of the most influential displays in recent Peruvian history (see chapter 3). The Ojo que Llora memorial (referenced above) was constructed in the aftermath of the TRC as a private initiative and remains Lima's most prominent monument to the war dead and disappeared. In the region of Ayacucho, the iconic relatives-of-victims organization ANFASEP (National Association of Relatives of the Kidnapped, Detained, and Disappeared of Peru) inaugurated the Museo de la Memoria de ANFASEP in

2005, a development that helped spur the creation of other memorial sites and museums there and in neighboring regions in the years that followed (Portugal Teillier 2015; Reátegui, Barrantes, and Peña 2010; Weissert 2016). Many of these small-scale initiatives were collaborations that involved national human rights NGOs and international donors (the ANFASEP museum, for example, received funding and technical support from a German development agency). In regions like Ayacucho, Huancavelica, and Junín, as well as in the nation's capital, the construction of monuments and museums was complemented by forms of memorialization in spheres such as art, music, film, and theatre (Milton 2014a). The creation of these spaces responded to the Peruvian TRC's call for symbolic reparations for victims and the establishment of memory sites, with protagonists often considering public commemoration as part of a broader process of transitional justice.[11]

At first glance, the emergence of memorialization projects and an "impetus to remember" in Peru might be interpreted as disrupting a narrative of progress that suffused representations of the Andean nation during the first two decades of the twenty-first century. At the time of my research the country had experienced over a decade of consistent economic growth—driven largely by mining and fuel exports—even if the benefits of this so-called Peruvian miracle remained unevenly distributed. No less salient were cultural projects such as Marca Perú (Peru Brand) (Cánepa Koch and Lossio Chavez 2019), a national branding outfit, and the so-called culinary boom led by celebrity chefs like Gastón Acurio (e.g., García 2013) that enacted desires, long shared by nationalist intellectuals the world over (Handler 1988; Tenorio-Trillo 1996), to present Peru as a nation that was both modern and culturally distinct. Taken together, these developments inspired a new national confidence in a country notorious for lamenting its past failures.[12]

The exhibition of past violence, whether at official sites or as part of grassroots initiatives, had—and still has—the potential to unsettle celebratory accounts of Peru's present and imagined future. Public acts of commemoration can "unravel the political temporality that . . . Peruvian elites attempt to fabricate" by reminding them of atrocities that many would rather forget (Rojas-Perez 2017:5).[13] An analysis of memorialization that focuses exclusively on the disruptive and potentially transformative qualities of projects such as the LUM, however, risks overlooking how goals of "never again" and the national visions of political elites can coexist and become intertwined (Wilson 2001). Perhaps more critically, such an emphasis can obscure the social dynamics and power relations that arise as the memorial museum idea (along with accompanying notions of memory and human rights) becomes grounded in particular institutional and political realities. As I illustrate below, and indeed throughout the book, the LUM's enrollment

in global cultures of memorialization as a formal state initiative was conse-
quential, even as the Peruvian government's political and financial support
for the museum was far from consistent. This discursive and institutional
connection to the nation-state made it urgent to consider how memorializa-
tion in Peru could potentially promote critical reflection on the nation's
recent history while legitimizing the postwar status quo and, at least in
a broad sense, the postconflict state. As an ethnographer, this connection to
stateness prompted me to register differences of acting and commenting
"within" vs. "outside" the official museum project and attend to the signifi-
cance my interlocutors attributed to such positions.[14]

Two Displays in the Plaza

The LUM initiative's embrace of memory discourse was characterized
by tensions and contradictions. On the one hand, individuals charged with
making official representations were wary of triumphalist accounts and
often sympathetic to the human rights–focused narratives of activists. On
the other, their practices were shaped by—and to some extent, subject to—
certain demands of postconflict statecraft. Economic constraints, political
change, and institutional precarity molded the ever-changing context of the
LUM's creation.

In the absence of a working LUM, artists and activists in Peru were not
content to wait for a permanent, official space for promoting reflection on
the country's political violence. Moreover, the memorial museum project
struggled to generate the interest, dialogue, and sense of vitality that char-
acterized many civil society initiatives. This set of circumstances was espe-
cially evident to me at an event marking the tenth anniversary of the TRC
Final Report, the nine-volume document produced by the investigative
body active between 2001 and 2003. The specific scene involved a con-
trast between the LUM's presence at this event (a "Meeting for Memory"
sponsored by the Municipality of Lima) and that of an activist-produced
display.[15]

Reactions to Tiempos de Memoria (Times of Memory), an exhibit
organized by the Lima-based Itinerant Museum of Art for Memory (Museo
Itinerante Arte por la Memoria), had begun to pour in even before the
display was assembled. I arrived at the open-air exhibit in the city center
around midday on August 27, 2013, the day before the main event. A group
of Itinerant Museum activists and volunteers had gathered, with workers
coming and going throughout the afternoon, when there had been some
glimmers of sun that are uncommon during Lima's dreary winter. Certain
passersby did not need to see the full contents of the exhibit, which was
composed of white cloth prints fastened on metal frames, before offering
their remarks: that the Lucanamarca massacre (perpetrated by Shining Path

in 1983) was a "candy" the government sold to human rights activists; or, from the opposite end of the political spectrum, that one of the well-known human rights cases for which former president Alberto Fujimori was convicted was "a lie." Some Itinerant Museum activists delivered comebacks ("You can go suck on *your* candy!") or, in more typical interactions, calmly explained the exhibit and its purpose.

The setting of the exhibit was Lima's Plaza San Martín, located in the historic downtown district not far from the older, more gentrified Plaza de Armas. Although the surrounding white buildings and the plaza itself retain the architectural charm and *criollo* sensibility that have driven efforts to "clean up" the city center, the zone also preserves a dingier, less refined heritage, one perhaps not envisioned by strongman president Augusto Leguía when he inaugurated the plaza in 1921. The informal vendors, street performers (Vich 2001), and petty criminals who became targeted in the 1990s by campaigns to "redefine Limeños' relationship to their city and its history through ideas of cleanliness, order, and beauty" (Gandolfo 2009:33) continue as part of the Plaza San Martín's landscape, even if there is less garbage on the streets and fewer teenagers smoking joints on the plaza's stone benches. Unlike the Plaza de Armas—the city's main square, where the Palacio de Gobierno and the Lima Cathedral are located—the Plaza San Martín serves more as a civic meeting ground (and a working-class one, at that) than as a place for national rituals or tourist sightseeing. The plaza was also a known hangout for militants of MOVADEF (Movement for Amnesty and Fundamental Rights), an organization sympathetic to Shining Path.

The next day, Wednesday, August 28, the Tiempos de Memoria exhibit was filled with visitors throughout the afternoon and into the evening. There were various stands in the plaza that were sponsored by human rights organizations and artistic groups, but the constant crowd swelling out around the Hotel Bolívar side of the plaza marked Tiempos de Memoria as a sight to be seen. Itinerant Museum activists were especially heartened when participants from a rally that had started at Lima's Ojo que Llora memorial visited Tiempos de Memoria later that evening. Included in this group were members of ANFASEP, the victims' organization from Ayacucho that the exhibit depicted in an altar at the maze-like display's conclusion.[16] A pair of Itinerant Museum activists had gone back and forth over which commemorative message they should spell out in flower petals at the foot of the altar—"never again" (too Argentinian), "so that it's not repeated" (too NGO-sounding)—before settling on the words "truth" and "justice."

Meanwhile, the national museum project I had been tracking, a multimillion-dollar undertaking, was represented in the Plaza San Martín that day, but more or less blended in with the other kiosks. The LUM's display had

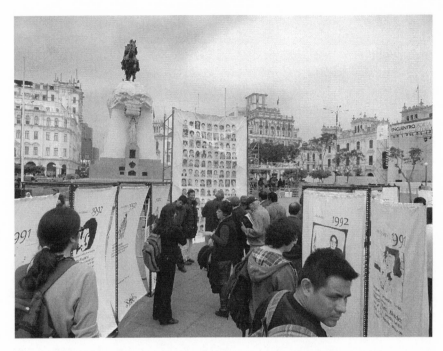

Itinerant Museum of Art for Memory's Tiempos de Memoria exhibit.

some illustrated panels outlining the museum's objectives as well as a guestbook where passersby could write their hopes and suggestions for the site. The project had also shown a short promotional video on a stage in the plaza that would later be graced by nationally recognized artists, musicians, and politicians. Whatever presence the LUM had, however, was easily outdone by the Tiempos de Memoria exhibit. And unlike the big museum project, which had hired a professional design team to make its panels, the Itinerant Museum collective had only a paltry budget provided by the Municipality of Lima that paid for installation materials, some sandwiches and fried rice, and a few security guards who patrolled around the display's perimeter.

The "Meeting for Memory" festivities in the Plaza San Martín were part of a range of activities taking place in the country to commemorate, and evaluate the legacy of, the Peruvian TRC. Academics in seminars offered their assessments of the truth commission, as did pundits in the news media. Former TRC commissioners and others in the human rights community commented on the undeniable "before and after" of the truth-seeking initiative as well as the unfinished work of implementing the *Final Report*'s recommendations (e.g., Macher 2014). Other observers noted that no account of violence, including that of the TRC, had gained consensus.

Right-wing commentators who had spent much of the previous decade trying to discredit the truth commission and its report condemned the TRC's "half-truths" and "exaggerations." A conservative congressperson, for example, called the TRC a "trick created by the *caviares* [left elites] to distort [Peruvian] history" (Llamo 2013). In the weeks leading up to the event in the Plaza San Martín, some of these same critics had seized upon the appearance of "internal armed conflict" in a Twitter post by Municipality of Lima, citing the use of this term (popularized by the TRC) as proof of the human rights community's alleged unwillingness to call the violence what it was: "terrorism."

As with many of the Itinerant Museum's exhibits and interventions, Tiempos de Memoria was firmly grounded in the findings of the Peruvian TRC. Panels for the exhibit were based on a timeline found in *Hatun Willakuy* (CVR 2004), the abbreviated version of the TRC *Final Report*, and Itinerant Museum activists were conscientious about striking a balance between depictions of abuses committed by insurgent groups and those perpetrated by the armed forces. The collective's members were also pragmatic, even savvy, about the way in which appealing to the *Final Report*'s authority could serve as "credibility armor" (Handler and Gable 1997) in interactions with visitors or help ease the concerns of municipal planners. Much of the discourse between Tiempos de Memoria visitors and the Itinerant Museum guides had recourse to aspects of the exhibit itself, but these conversations often took on a life of their own. The back-and-forth, the contested histories being negotiated among images, text, spectators, and guides, along with the interplay of pedagogy and politics, offered a vivid example of the kind of dynamics that interested me as an anthropologist.

I had met members of the Itinerant Museum six months earlier, at a meeting organized by the LUM that involved a delegation of European museum specialists whose visit was sponsored by a German philanthropic organization. The main objective of the foreign experts' visit was to advise the LUM's staff and curatorial team, though there were also meetings with civil society groups doing relevant work. A few weeks after that encounter, during which members of the nine-person activist collective expressed concern over issues like the LUM's lack of consultation with victims' organizations and the project's seeming reluctance to embrace the findings of the Peruvian TRC, I had occasion to speak with two members of the Itinerant Museum, Karen Bernedo and Orestes Bermúdez. The activists contrasted their efforts to recover and democratize the museum concept "from below" with the LUM, which belonged to the realm of elites and state mandates.[17] It was the type of museum more likely to promote distance and silent reverence, they suggested, than the spontaneous dialogue that the Itinerant

Museum activists were accustomed to provoking. Karen, who was in her thirties and had a background in communications, noted that the LUM would be the place where schoolchildren would go to learn about Peru's political violence. She recalled her own childhood visits to museums of anthropology and natural history, where she was supposedly learning the official, "unquestionable" truth. Surely, many Peruvians shared this experience of attending official museums as a rite of citizenship (Duncan 1991).

Karen's and Orestes's interactions with the LUM initiative had been few and far between. The events they did attend seemed ineffectual, even if the activists did not think that those involved in the project had bad intentions. When I asked what they thought would happen with the LUM, Karen replied, "Well, it will be done," as if to point out the most obvious bit first; "It will be done, as many things are done, and I don't know if it will be too important, for now at least." She paused. "Nobody cares. The reality of things is that no one cares here. If someone cared, I think the people from the human rights movement would be there, striving to know, asking what is happening in that 'Place of Memory.'" Orestes, a young artist with red-rimmed glasses, agreed with Karen's assessment, pointing out that the government seemed uninterested in the LUM. He asserted that even if the museum eventually gave visibility to issues related to the war's legacy, the initiative would be a "ball of hot air" if it were not matched with tangible changes in public policy.

"They're going to inaugurate it," said Karen. She joked that the LUM staff would do so "from the French Embassy," her speech slowing down and becoming more melodious for dramatic effect, "with French wine. Will they invite us? Surely not." Concluding the interview on a more earnest note, Karen stated, "We are going to keep on working. Each one is working in their field of action. Ours is different." In short, Karen and Orestes knew that their work shared certain goals with the LUM initiative, but they were not foolish enough to think that the national museum would accept their activist perspectives without reservation. The Itinerant Museum was but one of many groups being consulted.

The LUM initiative, represented at the August 2013 Plaza San Martín event with its panels and a few staff members, had once elicited the passions of military and right-wing critics of the Peruvian TRC. And everyone suspected it would again at some point in the future. The project had been largely invisible in the preceding years, however. According to various earlier predictions ("by the end of 2012" and then "by the second half of 2013" or, well before those, "by the end of Alan García's term [July 2011]"), the LUM was supposed to be inaugurated, or at least have its doors open for events by this time. Further, outside of the occasional progress report or

mention of the museum project in an op-ed piece, news coverage of the LUM had been virtually nil during the eight months since my arrival to Peru in January.[18]

Those who were in the know might have heard of leadership changes that had taken place two months before the TRC commemorations or wondered about the new exhibition script that was in the works. Most of the people in the plaza who walked by or stopped to read the lines on the placards, however, would have had only a vague awareness of the project and its history: that in 2009, President Alan García rejected a $2 million donation from the German government to build it (only to reverse his decision); that Peru's Nobel Prize–winning author, Mario Vargas Llosa, had once headed the project: or that the museum would be housed in the exposed concrete building that had slowly been emerging on Lima's Costa Verde, just off the Circuito de Playas highway that runs along the shoreline (see chapter 1).

For the right, the assumption was that the museum would be another cultural project of the "champagne socialists" (*caviares*). On the left, the principal concern was that the LUM initiative was in close communication with the military and would present a triumphalist narrative. The institution still counted on the backing of Germany, along with the United Nations Development Programme and the European Union, but support from the government—headed by a former military official (Ollanta Humala) who was elected on the left but had governed from the right—was lukewarm. The LUM's requests for additional funds were pending. Observers and those involved in the project repeatedly told me about the lack of political will to move forward with the museum initiative. As Karen and others had put it, nobody seemed to care anymore, not even the LUM's enemies.

But without an officially sanctioned memorial museum, Peruvians at the Tiempos de Memoria exhibit were being educated about their recent past, and engaged with history in a spontaneous, interactive fashion that arguably would have been hard to replicate in a major national museum. What's more, the activist collective's display was firmly grounded in the findings of the TRC *Final Report*—the country's de jure history of the conflict—while most who followed the LUM closely suspected the project would try to distance itself from this account and its baggage. Vocal supporters of the TRC were, indeed, a sector the national museum had identified as an interest group, as bearers of a particular "memory" the institution had to consider. But there were others.

MEMORY, MEMORIES, AND POLITICS IN PERU

The objective and problem-space for activities like those of the Itinerant Museum is "memory." And it is no exaggeration to describe memory as the central concept through which Peruvian struggles over the country's

recent past have taken shape. Gabriel Salazar Borja (2015), focusing on the trajectory of the term in scholarly discourse, emphasizes developments such as the Social Science Research Council's (SSRC) "Collective Memory of Repression in the Southern Cone" project (which trained numerous Peruvian graduate students during the late 1990s and early 2000s) and the Peruvian TRC, as well as critical responses to the Fujimori regime's attempts to promulgate a "salvation memory" of the political violence during the 1990s (Degregori 2011; Stern 1998b).[19] At a regional level, historian Steve Stern (2016) traces how idioms of memory emerged as a reaction to the official "forgetting" of authoritarian governments in Latin America during the 1970s and 1980s. Discussing the experience of Chile, the author observes that memory came to stand for ideas of human rights, truth, and justice during the country's democratic transition, "linking [these ideas] to struggles against oblivion" (2016:121; see also Jelin 2002).

Stern (2016) and others who have studied the concept's circulation point to memory's contingency as a "cultural code word" in postconflict societies like Peru. Paulo Drinot (2009:18), locating Peruvian assimilations of memory rhetoric within regional and global currents, raises a series of critical questions: "Where does this interest in memory come from? Why is memory favoured over other concepts related to the past (such as history)? What consequences does the focus on memory (some would say the obsession with memory) have?" As the reader can imagine, memory is one of a number of possible framings for the work of addressing a difficult past, even if one limits oneself to a Western lexicon (alternatives such as justice, rights, truth, and healing immediately come to mind). Anthropologist Marc Augé (2004:87) has observed that the often-invoked "duty of memory" is as much a call for *vigilance* as it is a call for remembrance. Assessing the memory paradigm in contemporary Germany, Alice von Bieberstein (2016:909) points to how cultures of commemoration typically center on "how we feel about [the violent past] and how it informs our present-day behaviors" and conduct in the public sphere, as opposed to cohering around detailed knowledge of the past as such. Cultural theorist Susana Draper (2012:95) asks why "museum of memory" has become the predominant label for institutions in Latin America as opposed to something along the lines of "museum of the last dictatorship." Alexandra Hibbett (2013), whose study of contemporary Peruvian novels likely represents the most thorough interrogation of the memory concept in the country to date, spotlights the depoliticizing effects of invocations to remember, along with the notion's "denial of social antagonism." Narratives found in works such as Iván Thays's (2008) *Un lugar llamado Oreja de Perro*, according to Hibbett, present memory as a cure for melancholic suffering, reproducing a modernist, time-as-progress account of postwar reconstruction.[20]

Although I encountered "memory" in various senses as I researched the LUM—sometimes referring to a "never again" ethos and the challenge of intergenerational transmission, other times invoking scholarship on social memory or psychoanalytic notions of trauma—this study places particular emphasis on the term's association with plurality.[21] Put succinctly, the museum project's work became conceptualized and narrated as the management of diverse memories of violence as opposed to the creation of an authoritative historical account of Peru's internal war. The exclusion of certain memories (namely those of former insurgents) remained important, however what ultimately captured my attention were the dynamics that emerged as the LUM sought to respond to and consult with different sectors, including activists, victim-survivors, and the armed forces. The scenarios above offer glimpses of these points of contact between the museum initiative and the perspectives of different groups, with the former seeking to somehow channel or transfigure the latter. Thus, the "before" in *Memories before the State* is meant to refer to the spatial sense of this word—as in a person or group standing before a judge, king, or review board—as well as to an institutional prioritization of "memories" over official history.[22]

An argument I sustain throughout the book is that relations between the LUM and various sectors were marked by practices of disciplining and regulating diverse memories of violence, with acceptance of groups' legitimacy as participants in the national museum project often being accompanied by skepticism toward, or even outright rejection of, the perspectives and visions they expressed. Many of the discussions I tracked when studying the LUM initiative were not simply about who should be consulted in the making of a national representation; they were about how, and to what extent, one should listen. Major Sánchez's musings about dangerous Senderista objects or the confrontational, activist spirit of the Itinerant Museum's urban interventions were perhaps relevant to the process of making the museum, but they could not *be* the national museum. Moreover, the LUM's construction as an institution that could authoritatively manage and encompass these various perspectives (Ferguson and Gupta 2002) often took place through appeals to global norms as well as references to the political and institutional constraints that framed efforts to translate the memorial museum idea in Peru.

My thinking about this set of problems is influenced by scholarship that has critically examined the politics of inclusion in "late liberal" societies. Anthropologist Elizabeth Povinelli (2011:ix) defines late liberalism as "the governance of social difference in the wake of anticolonial movements and the emergence of new social movements." The author analyzes how rhetorics of multicultural inclusion in countries like Australia and the United States frequently become entangled with repudiations of the lifeways and

worldviews that are ostensibly being "recognized." Indigenous peoples are told they have a right to be different and receive compensation for past harm, for example, but the possibility of accessing such rights is often bound up in a need to simultaneously demonstrate connection to traditional beliefs and practices while acknowledging their "repugnance" or incompatibility with modern, liberal values (Povinelli 2002). In Latin America, scholars have observed how an increase in official efforts to recognize cultural diversity during the 1990s coincided with the entrenchment of neoliberalism in the region, with a number of states declaring their tolerance for certain forms of difference (e.g., language, dress) while defining the terms under which collectivities could assert their rights. The figure of the *indio permitido* (authorized Indian) (Silvia Rivera Cusicanqui cited in Hale 2004; see also Hale 2005), an Other that "complies with the rules" of cultural recognition (Povinelli 2011:26), emerged as a proper subject of governance throughout much of the region. Meanwhile, the mobilization of indigenous cosmologies in the public sphere—especially in the context of natural resource disputes—has continued to be met with a fierce (liberal) backlash, including expressions of cynicism and rejection by political actors who advocate for multicultural (or in some cases, "plurinational") visions of the nation (de la Cadena 2010; Postero 2017).[23]

A similar dynamic of inclusion and dismissal could be observed at the LUM (albeit more often involving categories of victim, hero, or activist than directly addressing indigeneity and cultural difference), even as one must take care when speaking of any particular institution as "the state." From a methodological standpoint, it has become common for anthropologists and historians to study the state as a heterogeneous ensemble of discourses, actions, and subject positions (Sharma and Gupta 2006; Trouillot 2001) and to underscore the fluidity of categories of state and civil society (e.g., Alvarez, Dagnino, and Escobar 1998). An emphasis on contingency and diversity—whether applied in investigations of museums, courtrooms, military bases, or health care clinics—can be complemented by recognition of the extent to which globalized scripts and models continue to inform performances of stateness in different parts of the world. Efforts to enact the state and ideas about how official institutions should function often remain closely associated with Western notions of modernity and rationality (Feldman 2008; Hansen and Stepputat 2001). In Peru, as elsewhere, the state derives much of its power from representations and commonsense assumptions that render it as the expression of universal ideals, as an entity that is "above the fray" (Mitchell 1991) and able to encompass the local particularity of specific communities, institutions, or groups (Ferguson and Gupta 2002). Major Sánchez, for example, told me of how DINCOTE ceded to the bureaucratic expertise of the INC official who declared that the Shining

Path–produced pieces were not Peruvian heritage or culture. The retired officer and his colleagues acknowledged that their site was more a gallery than a museum. Karen's childhood recollections of learning the "official truth" at public museums evoked the state's capacity to access, decontextualize, and reassemble artifacts and specimens from particular places in an authoritative fashion (Andermann 2007; Bueno 2010).

In the case of memorial museums specifically, state actors often embrace human rights-oriented forms of public commemoration as a means of political legitimation. An "unstated goal" (Sodaro 2018:180) of official sites is typically to demonstrate that a nation-state or a particular regime "[has] come to terms with the past, made amends to the victims, and promised a better future." The Peruvian government's decision to accept a donation to construct the institution that would become the LUM enrolled the country in a transnational culture of memory and aligned Peru with a regional constellation of initiatives aimed at refashioning (Babb 2011) and sometimes even marketing (Bilbija and Payne 2011) recent histories of violence, upheaval, and authoritarian rule. Political scientists have commented on a "new kind of credibility" being sought by (some) Latin American administrations when it comes to the management of difficult pasts (Hite 2013:341), with the construction of memorial sites and museums typically being viewed as less politically contentious in settings like Argentina, Brazil, and Chile than measures such as criminal prosecutions (Collins 2011:251; see also Andermann 2012b:71–73).

The political implications of official memorialization extend beyond such perceived benefits though, and share features with those of other, more established modes of statecraft that have taken history and culture as their focus. In Latin America and elsewhere, global tropes of memorialization coexist, often uneasily, with patterns of representing the nation that are premised on the modernist notion of "having a past" that is distinct from the present.[24] As Hansen and Stepputat (2001:25) assert in their survey of contemporary "languages of stateness," official representations generally incorporate subjects and communities "in a hierarchically organized yet homogenous nation-state through strategies that relate certain identities to certain spaces [and] time sequences." Museums have long been influential sites in efforts to cultivate notions of citizenship and situate national subjects vis-à-vis "tradition" and "heritage" (Bennett 1995; Kirshenblatt-Gimblett 1998). Research on Latin America has illustrated how World's Fair exhibits, natural history museums, and emerging heritage industries (Alonso 2004; Anderman 2007; Earle 2007; Tenorio-Trillo 1996) gave substance to dominant visions of the nation, often through valorizing the achievements of pre-Columbian cultures while distancing contemporary populations (including indigenous peoples) from this past glory. The attempts of intellectuals in

nineteenth-century Mexico to make "national heritage" out of archaeological remains tied to local and regional identities became associated with condemnations of the "savagery" and intransigence of communities that resisted the state's patrimonial agenda (Bueno 2010). Modern-day residents of Pelourinho (Bahia), Brazil, have become cognizant of their "patrimonial" status and mobilize this identity to pursue benefits and make demands on the state (Collins 2015). On the whole, it is fair to say that in Latin America, the secular and encompassing logic of universal museums—which permits the display of forms of otherness whose expression would be discouraged, and even repressed, in mainstream society (Price 2007:38)—has most often been directed inward, with the nation's diversity being the focus of reformist heritage regimes.

The contemporary turn toward memorialization animates and elaborates on ideas about who belongs to the past of the nation and who belongs to its future. This relationship between public commemoration and modernizing agendas can at times be quite explicit.[25] At the laying of the first stone for the LUM, President Alan García asserted that the new museum would be a "temple for thought" and strongly implied that the memorial site should serve as a reminder of the violence and chaos that would ensue if Peru deviated from the neoliberal course his government pursued (Poole and Rojas-Pérez 2010). At a ceremony to publicly relaunch a collective reparations program in Lucanamarca (the site of a 1983 Shining Path–perpetrated massacre), García's successor, Ollanta Humala, declared to villagers that "there is no forgetting, only development," adding that "we cannot stagnate in history; we have to go on because the times go on" (Weissert 2016:305). Initiatives sponsored by the Peruvian armed forces regularly employ "never again" to refer to the banishing of Shining Path and "criminal terrorists" from the nation (Milton 2018).[26]

In many cases of official memorialization, however, sincere commitments to inclusion, human rights, and honoring victim-survivors come to intersect with exigencies of statecraft—above all, a need to make past violence *past*—in more subtle and complex ways. And even when instrumental goals are in the foreground, the production and circulation of representations of the postconflict nation can be subject to forms of transgression and resistance (Mookherjee 2011a).

The chapters that follow offer a critical engagement with memory as a framework for addressing Peru's recent history of political violence in the context of the LUM initiative. Consistent with the issues set forth above, my ethnography examines the politics that emerged as the national museum became positioned as an institution that would manage diverse memories of violence, focusing particular attention on how these memories and their bearers became constructed as "stuck in the past" or otherwise out of step

with the national present. Through entwined analyses of the image of the melancholic victim, military officials enamored with their own heroism, and human rights activists who associated themselves too closely with the Peruvian TRC, I suggest that such acts of definition and regulation are fundamental to understanding the relationship between politics and public culture at a time when memory has become a predominant concept for managing difficult pasts.

The book seeks to contribute to scholarly discussions about violence, state making, and reconciliation processes in Latin America as well as to wider debates about the implications of memorial museums on a global scale. Historical and ethnographic studies of postwar Peru, reflecting trends in literatures on other Latin American nations, have examined topics such as the experience of violence and repression in specific places and historical moments (Burt 2007; Degregori 2011; Del Pino 2017; Heilman 2010; Kernaghan 2009; La Serna 2012; Stern 1998b), the micropolitics of postwar reconstruction in communities affected by war (González 2011; Theidon 2013; Yezer 2007), ongoing struggles for justice, recognition, and reparation (Bueno-Hansen 2015; Rojas-Perez 2017; Ulfe 2013b; Weissert 2016), and the role of artistic interventions in shaping understandings of the violence (Greene 2016; Lambright 2016; Milton 2014a, 2018; Saona 2014). Some notable exceptions notwithstanding (Bilbija and Payne 2011; DeLugan 2012; Jelin and Langland 2003; Stern 2010; Tate 2007; Weld 2014), anthropologists and historians researching Latin America have devoted comparatively little attention to the institutional management of difficult pasts and to the role of experts, elites, and state officials during and after periods of transition.[27] This ethnographic focus can elucidate how different actors respond to the complexities of representing and addressing contentious national histories, often conducting such work from geographic, institutional, and social positions that differ from those of communities and individuals they seek to include. It can also complicate a distinction between official (i.e., state) versus alternative (i.e., civil society) forms of memory work that continues to inform much research, if often implicitly. Further, as the memorial museum is a cultural form that Latin American states and political elites are increasingly drawing upon to "engineer (or simply proclaim) a desired social outcome" (Lehrer and Milton 2011:6), close attention to the experience of institutions like the LUM offers insights into how this concept—and accompanying discourses of memory and "never again"—travels, mutates, and attains politicocultural significance in particular contexts.[28] My study thus complements and deepens the analyses of scholars who have explored memorialization practices and their politics through global-comparative surveys (Sodaro 2018; Williams 2007).

Perhaps in a more general way, *Memories before the State* sheds light on shifting relationships between museums and communities (Clifford 1997; Karp, Kreamer, and Lavine 1992), along with the aftermath and trajectories of national reconciliation efforts. The rhetorics of inclusion and collaboration encountered at the LUM and in memorialization initiatives around the globe are characteristic of how the design and operation of museums has become more polyvocal and collaborative in the wake of indigenous and postcolonial critiques, interventions associated with the new museology, and the rise of memory discourses.[29] Studying the limits of these principles' deployment at a national institution as well as forms of expertise and authority that emerge through contact with the experiential accounts of different groups (read memories) aligns this work with the goals of other critical ethnographies of museums (Shannon 2014; White 2016).[30] In a different, though not entirely dissimilar way, the book also presents findings relevant for understanding how truth commissions and the "redemptive," inclusionary narratives they produce (Shaw 2007) come to be viewed with the passage of time (Collins 2010; Stern 2010). In Peru, as in much of the Global South, memorialization efforts have taken place alongside, and in the aftermath of, state initiatives oriented toward the promotion of truth, justice, and reparation.[31] This reality meant that discussions about the LUM frequently became enmeshed in assessments of the country's experience of transitional justice (Hayner 2011; Hinton 2010; Shaw, Waldorf, and Hazan 2010) and most centrally, the impact and legacy of the Peruvian TRC.

Though I am inspired by and engage with scholarly literatures on these phenomena, it is my hope that the organization of the book and the style in which it is written makes *Memories before the State* a worthwhile text for a diverse range of readers, including students and practitioners with interests in museums, human rights, and contemporary Peru and Latin America.

OVERVIEW

Chapter 1 presents historical background on the LUM initiative, focusing on the museum project's development prior to the time of my main period of fieldwork. The chapter also provides relevant information on Peru's experience of war and postconflict transition for nonspecialists. In discussing the LUM's early stages, I demonstrate how the project's embrace of memory discourse positioned it as an institution that was, ostensibly, opposed to univocal history and relegating violence to a "thing of the past." Chapter 2, the book's first ethnographic chapter, analyzes the LUM as a transnational cultural production. I do this primarily by detailing the experience of the museum project's longtime director, an elite Limeño who lived in Europe during much of the political violence. A recurring tension I explore is one between

an awareness of global norms concerning the memorialization of difficult pasts and the existence of cultural, historical, and political factors viewed as complicating Peru's participation in this new paradigm of commemoration.

Chapters 3, 4, and 5 examine relations between the LUM initiative and various publics. Chapter 3 analyzes a dispute centering on the potential incorporation of Yuyanapaq, the photo exhibit of the Peruvian TRC, into the new museum's permanent display. There, I focus on how members of the country's human rights community responded to the LUM initiative's attempts to "go beyond" the authoritative, victim-centered account of the truth commission, along with how commentators within and outside the project symbolically disciplined attachments to the TRC. The chapter also shows how the disagreements that resulted in the museum not including the Yuyanapaq exhibit solidified the LUM's identity as a post-TRC project.

Chapter 4 examines interactions between the museum project and two key sectors: victim-survivors and the armed forces. Victims of the political violence were initially considered the LUM's raison d'être, whereas the participation of the armed forces came to represent a core feature of the institution's post-TRC identity. Drawing on interviews with representatives from both groups as well as observations from meetings and public events, I underline ways that victim-survivors and members of the armed forces became valorized for their experiential authenticity while illustrating how exchanges between the museum project and these communities were characterized by considerable anxiety and distrust. Chapter 5 analyzes a formal consultation process the LUM initiative carried out as well as initial debates about the museum's exhibition script. In addition to documenting how members of the LUM curatorial team considered questions of audience and responded to imagined and imposed limits on their work, I focus on the performative dimensions of efforts to share the script with different groups in Lima, Ayacucho, and the Amazonian town of Satipo (Junín). Specifically, I demonstrate how practices of circulating this document served to distribute authorship of and accountability for the LUM's contents while positioning the museum project as an institution that could manage different perspectives in a modern, transparent, and thereby authoritative fashion.

Chapter 6 is a concluding chapter that surveys topics such as the museum's inauguration and initial reception, the LUM's permanent exhibition, and controversies in recent years that have raised questions about the institution's independence and role in Peruvian society. Synthesizing the book's principal findings and insights, I address continuities and departures from the time of my main period of fieldwork and reflect on the LUM initiative's significance within contemporary currents of memorialization in Latin America and beyond.

CHAPTER 1

Place, Memory, and the Postwar

PERU HAS BECOME an exporter of transitional justice experts. An influential text in the field (Hayner 2011) lists the country's Truth and Reconciliation Commission (TRC), which was designed and carried out with assistance from international specialists, among the "five strongest truth commissions" to date. An outcome of such recognition has been that a number of Peruvians have drawn on the experience and expertise they developed through their work on the TRC to serve as international consultants. These individuals can be found assisting with official truth-telling projects and reconciliation initiatives in other Latin American countries such as Colombia and Ecuador, but also in far-flung locales like Yemen, Côte d'Ivoire, and the Solomon Islands. I had occasion to speak with one such expert, a middle-aged man, who shared his impressions of the Place of Memory, Tolerance, and Social Inclusion (LUM) and helped me better understand a specific period of the museum project's history. At the conclusion of our interview I asked a question I often posed to interviewees, recognizing it was the type of query that reinforced my social position as an outsider to issues of war and memory in Peru: Why was it so difficult to make a museum about the political violence?

After some qualifying remarks acknowledging how processes of memorialization always tend to generate tension in postconflict societies—there was much universality to be found in Peruvian debates and the country did not represent a particularly grave or dramatic case—the specialist reflected on the continued salience of Shining Path in national culture: "In Peruvian society, Shining Path is a taboo. I recognize this as one of those who cultivates that taboo. That is to say, it's not like with the FARC or some other organization . . . M-19 in Colombia. Shining Path is the absolute devil. So, as an absolute devil, it's something that is very easy to use to close off any critical discussion about the violence."

Though I am sensitive to the risk of reifying certain discursive associations and presenting features of Peru's postwar landscape in essentialist terms, the demonization of the "terrorist" as a toxic category is a reasonable point of entry for addressing social and historical phenomena relevant for

understanding the LUM's significance. Beginning with a brief elaboration of the terrorist concept in Peru, this chapter surveys aspects of the internal armed conflict and the country's experience of transitional justice before focusing on the history of the LUM initiative prior to the time of my main period of fieldwork (2013).[1] My discussion centers on how the museum became presented as an institution that would respond to, and potentially incorporate, different perspectives on the violence, with conventional notions of "history" and "museum" being displaced in favor of more open-ended concepts of "memory" and "place." A number of tensions and contradictions that would recur throughout the process of creating the LUM began to surface even in these initial stages of the project: a divide between the museum's relatively privileged Lima-based producers and the regions and social sectors most affected by the political violence, an institutional rhetoric of inclusion that could mask crucial differences among various stakeholders (along with certain foundational omissions), as well as a disconnect between pronouncements touting the LUM's urgency and the project's continual lack of funding and institutional support.

Mapping Peru's Postwar Condition

Carlos Aguirre (2011) presents a historical analysis of the term *terruco*, a Quechua-ized version of the Spanish word *terrorista*. The term appears to have emerged in the 1980s during the early years of the conflict, but it is unclear whether the initial diffusion of "terruco" into mainstream Peruvian Spanish was primarily the result of Quechua-speakers' indigenization of "terrorista" or more related to the military's appropriation of the word in the context of counterinsurgency efforts in the region of Ayacucho.[2] Independent of its origins, the hybrid term's widespread use in Peruvian society (e.g., referring to NGOs as *pro terruca* [proterrorist]), is indicative of how the stigmatizing qualities of being a "terrorist" are closely tied to those of indigeneity in the country. "'Terruco,'" Aguirre (2011:134) asserts, "brings together all of the elements that explicitly or implicitly were associated with members of the subversive groups, but that also have historically been attributed to Indians and highlanders [*serranos*]: violent, irrational, fanatical, unpatriotic" (see also García 2005:42–47).

Literary critic Rocío Silva Santisteban (2009) makes a similar observation in her analysis of disgust (*asco*) as an affective force in Peruvian society. Arguing that the national image of the Senderista reflects processes of symbolic pollution wherein the Other is dehumanized, Silva Santisteban (2009:82) notes that the dominant cultural construct of the Shining Path militant was that of the "'resentful *cholo*': the peasant migrant who comes down to the cities looking for new ways of making a living and can't make a go of it and, therefore, distills his frustration against 'decent people.'"[3]

The stigma of "terrorist" and "Senderista" references, in an immediate way, the prolonged period of violence that Shining Path instigated when the guerrilla organization began its armed struggle against the Peruvian state in 1980. The insurgent group represented a distinctive phenomenon in Latin America not only for being the region's only significant Maoist movement, but also for the brutality with which the organization pursued its revolutionary aims (Degregori 2011:23). It is estimated, for example, that Shining Path was responsible for 54 percent of deaths resulting from Peru's armed conflict (CVR 2003), a figure that far exceeds those of other leftist guerrillas in the region. Yet the associations described by Aguirre and Silva Santisteban also reference the social and historical conditions out of which Shining Path grew to become, by the late 1980s and early 1990s, a significant threat to the Peruvian state.

Shining Path emerged both "within" and "against" the course of Peruvian history (Stern 1998a:13).[4] The guerrilla movement developed in the 1970s in the Andean region of Ayacucho as one of several factions created out of Maoist-Soviet schisms that had taken place within the Communist Party of Peru (Degregori 1990). It was one of a number of groups on the regional political scene that were Marxist in orientation, headed by provincial intellectuals, and convinced of the necessity of armed struggle to overthrow the state (Degregori 1990; Poole and Rénique 1992; Stern 1998b). The group's calls for revolution appeared at a time when Peru was returning to democratic rule, leftist groups were poised to make electoral gains through the United Left (IU) coalition, and progressive political actors in Latin America and elsewhere were growing skeptical of the "confident teleologies" posited by orthodox Marxism (Stern 1998a:6).[5] Further, Shining Path's inveighing against "semi-feudal" conditions and its efforts to incite rebellion among the rural masses took place in the wake of a massive agrarian reform initiated in 1969 by the government of Juan Velasco Alvarado that, however imperfect, did transform the social landscape of rural Peru in meaningful ways (Mayer 2009).[6]

While some early commentators mistakenly interpreted Shining Path as an indigenous or millenarian movement, the distinctly modernist features of the group's rhetoric and ideology can be emphasized (e.g., Starn 1995). Reason and scientific certainty were guiding concepts for the organization and Shining Path leaders often viewed Andean cultural traditions with disdain, considering them products of "feudal" or otherwise "backward" conditions in the Peruvian highlands. Despite the movement taking its name from a phrase used by noted Peruvian Marxist José Carlos Mariátegui (1894–1930), the organization typically made little use of variants of Marxist thought in the country that sought to account for features of Peruvian history and society.[7] "The Party" originated not in rural highland communities, but at a regional

university in the city of Ayacucho (the region's capital, also known as Hua-manga). Scholars such as Carlos Iván Degregori (1990) have emphasized the group's control over the San Cristóbal University of Huamanga, along with the place of education and notions of progress in Ayacucho—an impover-ished region that had long struggled for access to government services—as decisive factors in the organization's growth. Degregori's analysis highlights how the hyperrationalist ideology of Shining Path resonated with the aspi-rations of many students from rural backgrounds who gained access to higher education during the 1960s and 1970s. A simplified, accessible ver-sion of Marxist-Leninist thought formed the basis for the guerrilla organ-ization's "scientific" message of revolution, and students and professionals were often conduits for disseminating these ideas to rural and popular sec-tors. The lion's share of these early Sendero militants were, in the words of Henri Favre (1984), "depeasantized peasants" who, despite having distanced themselves from rural lifeways and beliefs in the pursuit of education and social mobility, encountered limited opportunities for advancement in Peru-vian society.[8]

Another distinguishing characteristic of Shining Path was the emphasis the group placed on its leader, Abimael Guzmán (also referred to by his nom de guerre, President Gonzalo). Hailed as the "fourth sword of Commu-nism" (following Marx, Lenin, and Mao) and given titles such as the "greatest living Marxist-Leninist" (Degregori 1990:163), Guzmán was a philosophy professor at the San Cristóbal University of Huamanga during the 1960s and 1970s before going into hiding in the years preceding the group's armed struggle. For militants and Peruvian society as a whole, Guzmán's lack of visibility during the war contributed to the aura of mystery that surrounded him. Further, as Shining Path militants never made up a significant percent-age of the Peruvian population, the movement tended to place far greater trust in the brilliance of Guzmán and the group's leaders (many of whom were provincial intellectuals or members of the rural middle class) than it did in "the masses" as such. Gonzalo Portocarrero (2012), for example, emphasizes how militants elevated Guzmán to a prophetic status—akin to the leader of a religious movement—with the bespectacled intellectual becoming a tute-lary, *patrón*-like figure whose supreme intelligence and overall exceptional-ism went unquestioned by followers.

Although Shining Path's distinctiveness as a guerrilla movement is one of the factors observers often accentuate when situating Peru's experience within patterns of violence and state repression in twentieth-century Latin America, the Maoist organization was not the only insurgent group active in Peru during the 1980s and 1990s. The MRTA (Túpac Amaru Revolu-tionary Movement) (La Serna 2020), which initiated its armed struggle in 1984, was influenced by and similar to guerrilla movements found in countries

such as Guatemala, El Salvador, and Nicaragua. This largely urban guerrilla group wore uniforms, organized itself in armed columns, and typically made efforts to limit civilian casualties. (Shining Path, on the other hand, routinely targeted civilians as part of an effort to instill fear in the population and provoke excessive reactions from the state that would generate support for revolution.) The Peruvian TRC found the MRTA responsible for 1.5 percent of the conflict's total deaths and disappearances and emphasized the group's systematic use of kidnapping as a strategy of war.

A feature of Peru's experience of political violence that unites it with histories of dictatorship and authoritarian rule in nations like Argentina, Chile, and Uruguay relates to the "dirty war" tactics the state employed as part of its efforts stamp out the insurgent groups. Beginning in 1982, the government ceded control of large portions of the south-central Andes to the armed forces in order to combat Shining Path, which many officials in Lima had initially underestimated. Levels of violence and cruelty reached by the armed forces could match and exceed those of the guerrilla organization. The Peruvian armed forces and police—working in both urban and rural areas— perpetrated rights abuses on a massive scale during the 1980s and 1990s, including extrajudicial killings and disappearances, sexual violence, and the widespread use of torture. It is estimated that these institutions were responsible for the death or disappearance of more than one third of the war's victims (CVR 2003). Further, according to the TRC *Final Report*, in "certain places and moments of the conflict" the conduct of the armed forces was characterized by "generalized and/or systematic practices" that violated human rights (CVR 2003, Tome VIII, Conclusiones Generales). To this day, however, much of Peruvian society remains sympathetic to the notion that such abuses were necessary "excesses" in the fight against terrorism.

A point of emphasis among scholars of the internal conflict has been addressing the war's implications for conceptualizing notions of victimhood and agency. Literary critic Víctor Vich (2002:47) provides an early, thoughtful example:

> This question about "victims" of the political violence is very problematic in Peru for several reasons. . . . [I]n the case of the Peruvian Andes, and given [Shining Path's] conscious invisibility developed as a tactic of war, we found ourselves in the face of a "no man's land" where the main part of the peasant population was positioned as suspicious for the two opposing sides. As is known, the situation reached such extremes that, in some moments, the only objective was to survive, and to achieve this people had to start to negotiate in the middle of the crossfire.

That Andean peasants were made to manage allegiances between two violent forces in the region (Shining Path and the state)—forces that often

imposed their will on entire communities—is not to imply that peasants were always simply *entre dos fuegos* (caught between two fires). An uncomfortable truth documented by historians and anthropologists who have worked in the region (e.g., del Pino and Yezer 2013; González 2011; Theidon 2013; Yezer 2007) is that Shining Path's message often resonated, at least initially, in rural communities. Shining Path–organized popular trials and moralization campaigns, frequently targeting thieves, adulterers, cattle rustlers, and local bosses, helped contribute to the group's appeal in places like Sarhua (González 2011) and Chuschi (La Serna 2012:149–154).[9] Recent scholarship has sought to historicize forms of "initial support" (Heilman 2010:193) and examine the guerrilla organization's emergence as a phenomenon that elaborated upon existing social tensions and regional political cultures. Still, in numerous cases peasants rejected, or came to reject, Shining Path's brutal tactics and authoritarian tendencies, sometimes positioning themselves as defenders of the Peruvian state (del Pino 2017). The most visible expression of opposition to Shining Path in the highlands was the *rondas campesinas*, peasant civil defense patrols that played a critical role in defeating Shining Path in the Andean region. An important consequence of dynamics involving Senderista and military or rondas campesinas-aligned sectors was that the war was fought largely within rural communities, among "intimate enemies" (Theidon 2013), rather as a series of battles between Shining Path rebels and state forces.

The geographic reach of the violence came to extend beyond the Andean highlands and include coastal cities such as Lima. Beginning in the mid-1980s, Shining Path sought to establish new bases of support, directing particular attention to the nation's capital. The group attracted a significant following among students at Lima's public universities and in marginal areas of the city populated mostly by poor migrants from the country's interior.[10] Shining Path perpetrated a number of attacks in the city—assassinating state officials, political leaders, entrepreneurs, and members of the military— with the group using Lima as a "soundboard" that would amplify the impact of its violent actions (CVR 2004:84). Car bombs and blackouts (resulting from attacks on urban infrastructure) became regular features of the urban landscape during this period, with violence increasing markedly in the city during the late 1980s and early 1990s. The July 1992 Tarata Street bombing in the district of Miraflores, which claimed 25 lives, was Shining Path's most visible attack in Lima and came at the peak of insurgent-perpetrated violence in the coastal metropolis (2004:94). Limeños also experienced forms of state repression similar to those inflicted upon their compatriots in Peru's Andean and Amazonian regions, with students and activists often being targeted for alleged links to insurgent groups.[11]

In Lima and much of Peru, levels of violence would decline significantly following the September 1992 capture of Abimael Guzmán in the nation's capital. Although the arrest took place as a result of investigations carried out by a special unit of the Peruvian National Police, the right-wing government of Alberto Fujimori (1990–2000) capitalized politically on this operation and others to present itself as the savior of the Peruvian nation.[12] The Fujimori administration, which had dissolved congress temporarily in 1992 in a "self-coup," regularly used the terrorist threat to justify its authoritarianism, detaining and disappearing suspected dissidents and instrumentalizing fear as part of an effort to silence critics (Burt 2006). It was ultimately a corruption scandal, rather than condemnation of the regime's repressive tactics, that brought the Fujimori government down. September 2000 witnessed the appearance of the first *Vladi-videos*, videotapes that showed Vladimir Montesinos, the head of Peru's intelligence service and one of the president's closest advisers, bribing politicians and other public figures in order to secure support for Fujimori. Fujimori fled the country amid the scandal and famously faxed in his resignation from Japan in November 2000.

The transition government of Valentín Paniagua (2000–2001) established a truth commission to investigate Peru's recent history of political violence, a measure that responded to long-standing calls among human rights activists to establish such a body (González Cueva 2006). The Peruvian TRC was a two-year project during which researchers investigated the country's internal conflict using interviews (including approximately 17,000 testimonies), archival research, regional histories, as well as systematic methods to measure the war's human cost. The commission was oriented toward criminal prosecutions and had a broad mandate to investigate rights abuses— deaths, disappearances, but also torture and acts of sexual violence—that were committed during the three democratically elected administrations that governed the country between 1980 and 2000.

Several of the most striking findings of the TRC *Final Report* had to do with the war's scope and magnitude. The TRC found that the internal armed conflict was the costliest war in Peru's history in terms of lives lost— the TRC estimate of 69,280 deaths and disappearances more than doubled existing figures of around 25,000 (Degregori 2011:285). The report also underscored the extent to which the war's effects were distributed unevenly with regard to differences of region, class, and ethnicity. According to the TRC's findings, 75 percent of the dead and disappeared spoke Quechua or another indigenous language; Ayacucho, the epicenter of the conflict and one of the poorest regions in Peru, accounted for 40 percent of the total war dead (CVR 2003). In a manner that reflected time-honored tropes of Peru

as a failed nation, the historical narrative of the TRC emphasized coastal indifference to highland suffering as a key factor in the origins and escalation of the violence. The report describes how the indiscriminate use of force to quell the insurgent threat resonated especially with "the moderately educated urban sector that benefited from state services and resided far from the epicenter of the conflict." This sector, the TRC asserts, "in the main, watched with indifference or demanded a quick solution, and stood prepared to face the social cost being paid by citizens of the poorer, rural regions" (CVR 2003: Tome VIII, Conclusiones Generales).

Although the TRC *Final Report* is nominally an official state account of the political violence, the national project it calls for has not been taken up in a serious way by subsequent governments. Progress in areas such as reparations, criminal prosecutions, and institutional reform has been slow and uneven (Macher 2014), resulting in a "deepening sense of pessimism and resignation" in discussions about the realization of transitional justice (Bueno-Hansen 2015:2). Moreover, as illustrated in the introduction, the TRC report's findings and analysis remains a politically contentious issue, with a frequently voiced critique being that the commission placed too much emphasis on atrocities committed by the armed forces. As Cynthia Milton (2014c:10) observes, "it is not quite accurate to refer to the CVR's [TRC's] *Final Report* as 'la historia oficial'; it is an 'official' history with which most officials are ill at ease." Discordant reactions to the TRC and its narrative have been particularly evident in debates surrounding the public memorialization of the violence.

MEMORIALIZATION, NATIONAL NARRATIVE, AND CONTESTATION

Among the recommendations of the *Final Report* of the Peruvian TRC was a call for a reparations program that would help reverse a "climate of indifference" in the country (CVR 2003: Tome VIII, Conclusiones Generales). The TRC Comprehensive Plan for Reparations cited a need for both "symbolic and material forms of compensation," with the former referring to "the recovery of memory and the return of dignity to the victims" (2003: Tome VIII, Conclusiones Generales). Proposed components of a symbolic reparations program included "public gestures, acts of recognition, reminders [*recordatorios*] or places of memory, [and] acts that lead to reconciliation" (CVR 2004:419). The objective of such activities would be to promote solidarity with victims, further national reconciliation, and rebuild the state's relationship with affected populations (2004:419). Many involved in the TRC conceptualized the commission itself as, among other functions, offering a "symbolic reparation" to victims of the war. Initiatives such as the TRC's public hearings, which broadcast firsthand accounts of suffering to a

wider public, as well as the commission's highly successful photo exhibit, Yuyanapaq: Para Recordar (Yuyanapaq: To Remember), arguably supported this goal, at least to a certain degree.

The impetus to memorialize and publicly commemorate came from civil society as well. Vich (2002:82), writing at the time of the TRC, spoke of an "urgent need to construct a 'Museum of Memory' that could give an account of the struggles for egalitarian and democratic citizenship" in Peru. Further, as noted in the previous chapter, the years following the TRC witnessed an upsurge of memory projects in Lima and the Andes, including the establishment of Peru's first memorial museum, the Museo de la Memoria de ANFASEP (Portugal Teillier 2015; Reátegui, Barrantes, and Peña 2010; Weissert 2016; see also chapter 4).

Yet, perhaps unsurprisingly, the public memorialization of the internal conflict also proved to be a complex task. The Ojo que Llora (Eye that Cries) memorial, located in Lima's Campo de Marte, is an illustrative case. Established in 2005 through the efforts of Dutch visual artist Lika Mutal and members of Peru's human rights community, the site has been the subject of numerous acts of vandalism over the years. A well-known incident occurred in November 2007 when a group—presumably made up of Fujimori supporters—attacked the memorial with sledgehammers and doused the stones comprising the site in orange paint, the color associated with Fujimori's political party (Drinot 2009; Hite 2007; Milton 2011). These actions came after an Inter-American Court of Human Rights ruling on the Castro Castro Penitentiary massacre of 1992, which stipulated that the names of those who died in the attack—many of them imprisoned Shining Path militants—be added to the monument. Uproar over the decision in the national press was amplified following the discovery that the names of many of the deceased prisoners were, in fact, already inscribed on the monument's stones.[13]

Analyzing the Ojo que Llora dispute, Drinot (2009) presents two basic narratives that have emerged in Peru for describing and making sense of the armed conflict as a national experience. The first posits that the violence was "a product of the actions of a criminal gang of terrorists" and the second presents the violence as "a consequence of the unresolved rifts that divide Peruvian society" (2009:25). Drinot suggests that this second perspective—where blame and causality are more diffuse—is more compatible with memorialization efforts that appeal to Peruvian society as a whole. The "criminal gang of terrorists" narrative, on the other hand, favors an emphasis on "heroic" efforts to defeat the terrorist threat. Where the main protagonists of that narrative used to be figures such as Fujimori and Montesinos, this representation now places greater emphasis on the armed forces as a historical actor (Degregori 2009:7).

Milton's (2014c:9–10) analysis, expanding on the work of authors like Degregori (2011), Drinot (2009), and Stern (1998b), presents an opposition between a "salvation memory" and a "human rights memory" of the conflict. The former underlines the defeat of Shining Path and the MRTA by the Fujimori government and armed state actors while downplaying rights abuses committed by the military and police. The latter, hewing to the narrative and analysis presented by the Peruvian TRC, emphasizes how conditions of racism and inequality in Peru contributed to the rise of Shining Path and shaped the brutal counterinsurgency efforts that, in many instances, resulted in the conflict's escalation. Proponents of the human rights memory, like virtually all Peruvians, condemn Shining Path's extreme violence and identify the group as the main instigator of the conflict, but reject the notion that war-era atrocities perpetrated by state forces can be reduced to excesses committed by a small number of individuals. Although not all perspectives on the violence fit neatly within these two narrative structures (e.g., those of former members of insurgent groups), the binary remains useful for approximating Peruvian memory battles. Further, as will become clearer in subsequent chapters, the salvation memory–human rights memory opposition exists as a kind of social fact that structures debates about initiatives like the LUM, including conversations taking place mostly within one memory camp or the other.[14]

A DONATION REJECTED

Differing views on the war came to a head in February 2009, when the newspaper *El Comercio* reported that the Peruvian government had rejected a $2 million donation from the German government to construct a museum that would memorialize the history of Peru's conflict.[15] The official rationale was that the funds would be better spent on reparations for victim-survivors and affected communities. Many in Peru suspected, however, that President Alan García's decision had more to do with the administration's desire to divert attention from rights abuses committed during García's first term in office (1985–1990). The controversy received much attention in the Peruvian press, and stories discussing the government's rejection of the German donation also appeared in international news outlets such as *Newsweek*, *The Economist*, and *Le Monde*.

Commentators within and outside the administration defended the government's position. Some claimed it was too soon to be constructing a museum of this nature. Others repeated the same kinds of arguments that had long been put forth by the TRC's opponents. The archbishop of Lima, Juan Luis Cipriani, of the conservative Opus Dei sector of the Catholic Church and a regular critic of the country's human rights community, referred to the proposed museum as "un-Christian," claiming that the German offer amounted

to foreign meddling in Peru's internal affairs and that such a museum would not further the process of national reconciliation. García and members of his administration, facing backlash over the decision, argued that their position had been misinterpreted. They were not refusing the German funds outright and were not opposed to the idea of a museum as such; the problem had to do with the *type* of museum that would be created.

A key ingredient in the controversy was that the proposed museum would house Yuyanapaq, the photo exhibit of the TRC. The donation's immediate origins could be traced to the German minister of development, Heidemarie Wieczorek-Zeul, visiting Yuyanapaq in March 2008. Moved by the exhibit, Wieczorek-Zeul recommended that participants in the upcoming European Union–Latin American and Caribbean Summit (EU-LAC/ALCUE) visit Yuyanapaq (Castillo 2008). Chancellor Angela Merkel, along with high-ranking officials from Germany and other European countries, came to Peru in May 2008 for the EU-LAC/ALCUE Summit, which held many of its events at the national museum that was temporarily housing the TRC exhibit. The visits to Peru by Wieczorek-Zeul and Merkel were accompanied by talks involving German officials and members of Peru's human rights community. According to most accounts, an offer to donate funds for a museum project that would house Yuyanapaq had been formalized by September 2008. Early backers of a national museum project had envisioned an "Avenue of Memory" (Alameda de la Memoria) that would provide a permanent home for the TRC exhibit and incorporate the Ojo que Llora monument at its current location in the Campo de Marte. At the time of the controversy, the assumption was that this initiative—which had emerged through the work of private citizens—would be the model for the new museum (see also Sastre Díaz 2015:101–104).[16]

These circumstances made it possible for the government to shift its discourse from one focused on the country's needs and priorities to one that critiqued the caviar left that would supposedly control, or be empowered by, a national memorial museum (Portugal Teillier 2015:154–158; Rodrigo Gonzales 2010:41).[17] "Memory is not the patrimony of a single group, no matter how intelligent they are or whether or not they're at the best university; memory is *national*," declared President García (El Comercio 2009a, emphasis added; see also Poole and Rojas-Pérez 2010; Rodrigo Gonzales 2010:41). Some in the armed forces floated the idea of building a second, rival memorial museum that would tell the "other side" of the story, as opposed to one based on Yuyanapaq and the TRC *Final Report*.

Following a campaign led by intellectuals, activists, and artists, the government reversed its position in March 2009, agreeing to accept the funds and construct the proposed museum. National and international human rights organizations welcomed the move, as did the government's Human

Rights Ombuds Office (Defensoría del Pueblo). A pivotal moment in the debate came when Peruvian novelist Mario Vargas Llosa, a former presidential candidate and an influential commentator on national and regional politics, criticized the government's position in a widely circulated op-ed piece entitled "Peru Doesn't Need Museums." In it, Vargas Llosa (2009) severely critiqued the "needs" line of reasoning put forth by the García administration and officials such as minister of defense Ántero Flores Aráoz, claiming that museums were as necessary as hospitals and schools for a nation's well-being. Moreover, he praised Yuyanapaq as one of the most moving exhibits in the country's history. On March 25, following the essay's publication, Vargas Llosa had a meeting with García, during which the author reportedly convinced him to accept the donation. Anthropologist and former member of the LUM's High-Level Commission, Juan Ossio, recounted the interaction in an October 2013 interview I conducted:

> Given the circumstances that the government of Germany offered a sum of money . . . as seed money so this project could be constructed, one could not waste that opportunity. That is to say that not accepting it was to leave Peru in bad standing. Germany is a very powerful country in Europe and if we were wanting to improve our international image, we also couldn't fight with a country that had this initiative that supported human rights. This was part of what weighed on [Alan García] . . . that pragmatic side of things. So, I had a dinner at my house and I invited Mario Vargas Llosa [and others].
>
> [García] had been very worried about the controversy that was taking place between Vargas Llosa and his minister of defense, right? So, he was looking for a way out. We ate at my house and the president says to Vargas Llosa, "Would you be willing to preside over the commission for the construction of the Place of Memory? Because if you are willing to do that, I will support the Place of Memory being made."

The administration's decision, which appeared to respond to pressure exerted by human rights activists as well as the government's concerns about its international image, brought the state's position in line with public opinion. According to a poll conducted at the time, nearly 75 percent of Peruvians expressed agreement with the idea of having a place dedicated to victims of the political violence, with few approving of García's initial rejection of the funds (Jiménez 2009; see also Portugal Teillier 2015:160–163). García's decision to appoint Vargas Llosa as head of a seven-member High-Level Commission that would oversee the institution's creation seemed to acknowledge public support for the famed author's interventions (as well as those of other commentators.) The museum project—referred to then as the Museum of Memory—became housed in the Ministry of Foreign Relations, with the

United Nations Development Programme (UNDP) managing the administration of the project's funds. A representative from Peru's Human Rights Ombuds Office would serve on the commission in an observational capacity.

MUSEUM TO "PLACE" AND THE PROBLEM OF INCLUSION

> We were mute witnesses [*convidados de piedra*]. We really were mute witnesses. [Alan] García arrived, all fat and all, and he passed by on the other side with his size 50 shoes. Didn't bend down to see us or anything, as we are short [*bajitas*]. . . . He mentioned nothing . . . nothing of the victims [in his speech]. So, there we felt completely ignored.
>
> We looked at one another and said, "At what point does he mention us? At what point does he say that this Place of Memory represents all of the victims in Peru?" That miserable man with his hands stained with the blood of our loved ones . . .
>
> He laid the first stone and, without anything more to say, he left. And he left us there. As president of the republic, the least he can do is apologize. We weren't just sad to have the Place of Memory there in that hidden little corner of the city . . . but listening to García and that he didn't direct himself to the victims. . . . We left feeling angry [*indignadas*]. . . . Instead of feeling welcomed, reconciled, we left feeling angry.
>
> —Doris Caqui, former president of CONAVIP
> (interview with the author, July 3, 2013)

Early debates surrounding the museum positioned the institution as a mediator of diverse perspectives about the violence, with officials rarely offering specific plans or visions for what the site would display. Following the donation controversy, Vargas Llosa and other LUM representatives made efforts to present the project as a politically neutral "museum of victims." Sensitive to the perception that the project was antimilitary in orientation, officials regularly spoke of the need to adopt positions that would be inclusive toward "all victims" of the violence. In December 2009, for instance, Vargas Llosa stated, "I want to reassure soldiers that they will see, in this museum, the sacrifice and heroism of the Armed Forces will be present in its rooms, in the same way as the suffering of the victims, since this place will be the house of all of the victims" (El Comercio 2009b; see also Ulfe and Milton 2010).

Vargas Llosa and other members of the project's commission also held meetings with military officials that were reported on in the news media. Perhaps owing to such conversations, or to the project's discourse on victims

and heroism, military calls to establish a separate, parallel museum started to die down. By February 2010, for instance, it was possible for Otto Guibovich, Peru's commanding army general, to declare that he was "totally in agreement with the Place of Memory." This came following a meeting with Vargas Llosa during which the renowned writer assured military officials of the museum's "impartiality" (La República 2010b). A representative from the project confidently declared several months later that statements and explanations given by Vargas Llosa had "dissipated some of the prejudices . . . that some sectors had [about the LUM]" (Agencia Andina 2010).

The sporadic meetings and events the museum project carried out with representatives from different sectors (human rights NGOs, victims' organizations, groups of intellectuals and artists) did not assuage fears that the museum's fate remained in the hands of a small group of individuals. Victims' organizations and members of the armed forces alike expressed concern over the absence of representatives from these sectors on the museum's High-Level Commission. Commentators within and outside of Peru noted the way that victim-survivors in particular seemed to be left on the sidelines in discussions about the Lima-based institution (Rodrigo Gonzales 2010; Ulfe and Milton 2010).

In April 2010, a statement from the national congress of CONAVIP (National Coordinator of Organizations of Those Affected [*Afectados*] by the Political Violence), a consortium of victims' organizations, expressed approval of the government's decision to accept the German funds, but urged "the members of the Commission of this important work to gather the voices of every blood [*todas las sangres*, a common phrase for referencing Peru's ethnic diversity] in order for the place of memory to help [Peruvians] toward the process of reconciliation" (CONAVIP 2010a). Later that year, CONAVIP issued a longer pronouncement following the LUM's laying of the first stone ceremony. The statement critiqued, among other things, Alan García's lack of mention of state-perpetrated atrocities in his speech at the event (CONAVIP 2010b). CONAVIP also underlined the LUM's tendency to locate victims as "inactive observers" as opposed to "actors" in the creation of the museum. Announcing that they had been "absent" in the project and did not feel represented by the members of the commission, the group demanded greater involvement in a process that was, according to much of the rhetoric, about honoring victims. The declaration echoed the sentiment expressed by CONAVIP leader Doris Caqui in her above-cited recollection of the 2010 ceremony, which emphasizes the way she and other victim-survivors felt like "mute witnesses" at the event. Representatives from national human rights organizations would second the call for the direct participation of victim-survivors on the museum's High-Level Commission.

For all the museum initiative's rhetoric of inclusion, the composition of the LUM commission (all male, and made up largely of artists and intellectuals from coastal backgrounds) did little to counter the notion that the project was an elite, Lima-centric endeavor. Vargas Llosa himself, though recognized as a national icon and a longtime critic of authoritarianism, was a polarizing figure in this regard, not only for his right-wing politics, but also due to the novelist's tendency to align himself with high culture and Western values. Further, Vargas Llosa's involvement in the investigation of the 1983 Uchuraccay massacre—controversial for its depiction of Andean peasants as out of step with the modern world (del Pino 2017; Mayer 1991)—was another factor that caused some to feel uneasy about his heading the LUM initiative.[18]

Adding to the institution's elitist image was the commission's decision to construct the memorial museum in Miraflores, a wealthy, upscale district in Lima. This came following bids from other, less affluent districts such as San Miguel and Villa El Salvador, as well as formal requests from politicians in Ayacucho to build the national museum in that region's capital. The original plan to locate the museum in the Campo de Marte and integrate the LUM with the Ojo que Llora memorial began to fall by the wayside during the second half of 2009. This was largely owing to conflicts with the municipal government of Jesús María, though some officials were also wary of associating the project with a monument that had become politically controversial. The outcome of an international architectural competition the LUM organized during the first part of 2010 all but secured that the Ojo que Llora would have no place in the new museum and that the initial, "Avenue of Memory" vision of the project would be scrapped (see chapter 3). An anonymous member of Lima's human rights community shared her reading of these developments with me: "There was always the opposition from the government to accepting the donation and finally, when they got it, [the goal] was to take it away from the human rights sphere and to give it to a so-called neutral group. And that has its reasons, of course. Because I don't think any president is 'clean' in the history of this conflict." Although some within the LUM spoke of the need to develop a national "public policy of memory" and establish connections with small-scale memorialization initiatives being developed elsewhere in the country, the commission never seriously considered locating the museum outside the nation's capital.

In what could be read as an attempt to "open up" the project, in January 2010, Vargas Llosa announced that the Museum of Memory would from then on, be referred to as the "Place of Memory." The name change, Vargas Llosa suggested, was meant to demonstrate that the violence in Peru was not

merely a "thing of the past": "The word museum is associated with an insti-
tution that preserves the past. We don't want the Place of Memory to be a
reconstruction of the violence in Peru, giving a perfect, most just, most
exact vision of the historical occurrence" (La República 2010a). Even before
the official change, Vargas Llosa had stated that, "the Museum of Memory will
not be an archaeological institution dedicated to preserving the past, but rather
something living and current, a place of exhibition, study, dialogue, and reflec-
tion" (El Comercio 2009b). The "museum-to-place" shift also could be viewed
as a way to unmoor the institution from urban, elite ideals.[19] As scholars who
closely followed the LUM during this period (Ulfe and Milton 2010) report, by
the end of 2009 there were internal discussions about the appropriateness of the
"museum" idea "due to its being reminiscent of spaces of 'lettered' knowledge,"
with some LUM planners suggesting terms like "space" or "place" as more
inclusive, encompassing alternatives.

Paloma Rodrigo Gonzales (2010), analyzing the name change and other
discursive strategies employed in discussions surrounding the museum,
argues that objectivity (embodied by figures such as Vargas Llosa) and inclu-
sion (considered as a willingness to incorporate diverse perspectives) became
two dominant concepts through which LUM representatives legitimized
their efforts. Framing the museum as an expansion of Yuyanapaq, for instance,
enabled the project to at once draw on the authority of the TRC while avoid-
ing some of the division and critique it evoked (Rodrigo Gonzales 2010:89).
Somewhat paradoxically, cultivating an institutional image of evenhanded-
ness and inclusivity often entailed praising the character and credentials of
those involved in the LUM initiative. For instance, in an interview with
Peru's state media outlet shortly after the High-Level Commission was formed,
commissioner Juan Ossio "highlighted the trajectory and professionalism
of each one of the commission's members, who . . . are sensible people and
aware of the responsibility they have" (Agencia Andina 2009). Vargas Llosa
and others expressed their confidence that skeptics would ultimately be pleased
with the LUM's "neutrality" and rigor: it would not be a "political tool";
it would not placate the extreme left by attacking the armed forces; rather, it
would strengthen democracy in Peru and teach new generations of citizens
about their country's violent past. As Rodrigo Gonzales (2010:85) incisively
observes, a lasting consequence of early discussions about the project—and the
name change in particular—was that the LUM became firmly established as a
"memory" project. "History" and "museum" became concepts that were at
best, essential starting points for the proposed project and, at worst, antithetical
to its objectives.

This apparent openness had a way of obscuring the reality that the
actual workings of the project remained, for the most part, an elite affair.

"All of the victims" might be consulted, but the management of their per-
spectives, it seemed, was best left to experts.

Delays and Discontinuity

Vargas Llosa's involvement in the project came to an abrupt end in
September 2010, when the author resigned in protest of Decree 1097, a de
facto amnesty policy for armed state actors that the García administration
proposed. There was an "essential incompatibility," Vargas Llosa claimed,
between the construction of a site like the LUM and, "using a legal trick to
open a false door in the prisons" for human rights violators (La República
2010c). Vargas Llosa was replaced by acclaimed visual artist Fernando de
Szyszlo, a friend of Vargas Llosa who had been serving on the High-Level
Commission since its establishment. De Szyszlo's tenure lasted through
October 2011.

The initial goal of completing the museum by the end of Alan García's
term in office (July 2011) proved unreachable. This owed mainly to the
project's numerous construction delays, many of which had to do with the
difficult topography of the Miraflores site. Formerly a municipal landfill—
the symbolism of creating a memorial museum there not lost on observers
(Ulfe and Milton 2010)—building on the site required extensive use of pil-
ing to ensure that the LUM would be structurally sound on the shaky earth
below. Planners were aware of such issues when they selected the ocean-
front plot but underestimated the difficulties the site would pose. The con-
struction problems also caused funding to run short. The LUM received no
significant financial support from the Peruvian state during the García gov-
ernment and the German donation, never considered sufficient for complet-
ing the project, was quickly exhausted. In October 2011, the European
Union (EU) and the UNDP would offer donations to augment the German
funds and, a year later, Germany provided additional money (a reported
1.5 million euros), largely to assist with construction costs.[20]

The LUM initiative did advance on the conceptual front, developing an
exhibition script during 2010 and 2011 that sought to reflect the principles
the High-Level Commission had set forth. Bernardo Roca Rey, a journalist
known for his spirited promotion of Peruvian cuisine (as president of the
Peruvian Gastronomy Association and an early advocate of the *novoandino*
[new Andean] food movement [e.g., García 2013]) rather than any prior
association with human rights causes, was appointed to produce the script.
Using different "memes" to convey its central narrative (such as "We, the
citizens, were attacked by an extremist group"; "Citizens and the state,
organized together, we defeated the terrorism"; and "Democracy has given
us positive results"), the script called for extensive use of new technologies

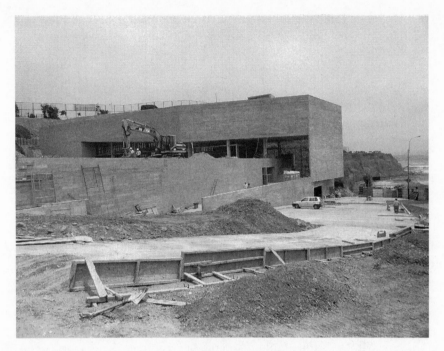

LUM construction site in January 2013.

as part of an effort to "go beyond the traditional limits of a museum."[21] The first floor of the LUM was to provide an overview of the history of the political violence—including attention to "biographical cases" selected to reflect a diversity of experiences—and the second floor would present Yuyanapaq (presumably in a much-reduced format) as well as information on developments such as Peru's reparations program and the prosecution of criminal cases. The third and final floor was to feature images and displays from museums and memorials located elsewhere in the country, along with contemporary and folk (*popular*) art inspired by the violence.

Raúl Castro, an anthropologist and journalist who was a member of Roca Rey's team, described the proposal as fitting with Vargas Llosa's "idea to remove the 'museum' designation to put into place a more dynamic logic," one that was more interactive (interview with the author, September 2013). Castro discussed some of the difficulties of finding a curatorial voice for the initiative:

> I think it's important to specify that the script is from [the perspective of] civil society. It is not an official version of the events. . . . It is also not a version [coming] from only the victims. . . . The victims are there and we had to see that all of this was dedicated to the victims. But [the

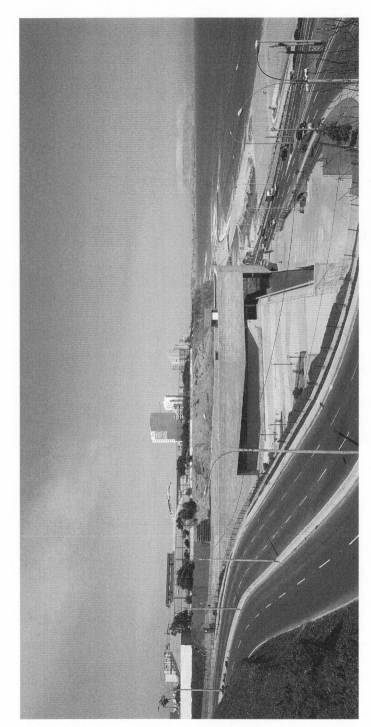

The LUM and Lima's Miraflores district in the background (credit: © Cristóbal Palma).

script] needed to have many more voices. . . . From this perspective, it was important to take up or highlight the recomposition of the social fabric in the face of the terrorism. . . .

You have to construct an account of triumph [in a museum like this]. You're not going to live in permanent psychotherapy. You have to assume [responsibility], you have to accept, you have to repair, you have to include. . . . But there's a very important issue: here, all of us had a role in defeating Sendero. . . . This is the story of *democracy*. I should recognize that it was Vargas Llosa who supported me most [on this point]. . . . He would say that this is the history of democracy, not just the history of the conflict.

Working on a tight deadline, and with few opportunities to consult with relevant actors (a point Castro stressed in our interview), Roca Rey and his team presented drafts of the script to the High-Level Commission various times in 2010; the commission approved the document in January 2011. The proposal was never implemented, however, due to changes at the LUM following the 2011 presidential elections.[22]

The LUM had, to a limited extent, become an issue in the 2011 presidential race that eventually featured Ollanta Humala and Keiko Fujimori as candidates in a runoff vote. Fujimori, the daughter of Alberto Fujimori who campaigned largely on her (imprisoned) father's legacy, at one point called for a "museum of victory" rather than a "museum of memory" to commemorate the history of Peru's internal war. Although she and her supporters later backed off from those comments—in April 2011, party officials announced they would support the LUM—it was clear that a Keiko Fujimori presidency would alter the course of the project significantly, if not jeopardize its existence. At the same time, Humala, a former military officer who participated in counterinsurgency campaigns in Peru's Upper Huallaga region during the early 1990s, had expressed support for the project in a general way, but his military-populist image did not inspire confidence among many of those who had advocated for the memorial museum. Thus, even before Humala won the election in June 2011 and entered office the following month, members of the High-Level Commission, a number of whom differed politically from both candidates in the runoff election, had begun to sense their lame duck status.

Despite assurances from the Humala government (2011–2016) that there would be continuity with the LUM initiative and that the national museum would materialize soon, the change of administration altered the course of the project in significant ways. In December 2011, Humala appointed a new High-Level Commission, selecting Diego García-Sayán to head the body. Many in Peru's human rights community, including some who had

grown skeptical of the project, were encouraged by the selection. García-Sayán had served as justice minister during the transition government (2000–2001), where he played a significant role in establishing the Peruvian TRC. At the same of his appointment to the *ad honorem* position at the LUM, he was also in the middle of his term as president of the Inter-American Court of Human Rights (2010–2012). Along with the new commission came a second name change for the project: "Place of Memory" was extended to "Place of Memory, Tolerance, and Social Inclusion," a title that, for García-Sayán, reoriented the project toward addressing the "time bomb" that "intolerance" represented for Peruvian society. Still, observers could note that, with the important exception of former congressional representative Hilaria Supa (a Quechua woman from Cusco), the general profile of the High-Level Commission was similar to that of the first one: "Limeño or longtime resident of Lima, male, Spanish-speaking, with higher education, and from the upper or upper-middle class" (Ledgard, Hibbett, and de la Jara 2018:19).[23]

The Humala government would provide state funds to assist with the LUM's construction (unlike the García government) and publicly expressed support for the project, albeit neither frequently nor forcefully. Midway through 2012, for example, Humala declared, "We are committed to constructing a culture of peace, ending terrorism, and consolidating democracy, and with the help of the European Union, Sweden, Germany, and the United Nations Development Programme and resources from the Peruvian state, we hope that at the end of 2012 the construction of the Place of Memory museum will conclude" (Agencia Andina 2012). The delays continued, however, and it became increasingly clear that the government would not put forth the resources necessary to complete the LUM in a timely fashion. Thus, at a regional level, tepid political support for the LUM's development could be contrasted with the creation of the Museum of Memory and Human Rights in Chile (Hite and Collins 2009) or the institutionalization of the ESMA Site Museum in Argentina (Kaiser 2020), projects that were backed consistently by the governments of Michelle Bachelet (2006–2010) and Cristina Fernández de Kirchner (2007–2015). Appeals to the international community during this period were mostly unsuccessful.

In addition to the recurring issues with construction and funding, there was little certainty as to what kind of narrative the museum would present. The Humala-appointed commission did not proceed with the previous, Roca Rey–authored script and a new curatorial team was not in place until December 2012. The commission drafted a short document containing guidelines for a new script earlier that year, but much of the work of creatively implementing these ideals and presenting a vision for the LUM's contents would not take place until 2013.

Progress on the museum project remained stalled in 2012 despite renewed calls to educate new generations of Peruvians about the country's violent past. Toward the beginning of García-Sayán's tenure it became increasingly common to hear the LUM discussed in association with MOVADEF, the pro–Shining Path organization that had failed in its bids to become recognized as a political party but nonetheless caused alarm due to the apparent ease with which its messages gained traction among youth from disenfranchised sectors. Headlines appeared such as "Place of Memory will look to curb pro–Shining Path groups" (La República 2012). García-Sayán, employing a "memory as vaccine" metaphor commonly used by human rights activists in Peru, asserted in August 2012 that "the way to vaccinate us against this [the rise of MOVADEF and similar groups] is citizenship" (La República 2012). Similar calls came from beyond the project as well, with members of Peru's human rights community asserting that the LUM was a necessary step in combatting the ascent of the pro–Shining Path group. An editorial published in La República in January 2013 (La República 2013), shortly after my main period of fieldwork began, proclaimed, "If some still doubted the need for having a Place of Money, what has occurred with MOVADEF closes the debate." The image of the demonized terrorist resurgent compelled action.

The LUM as an "anti-MOVADEF machine" was, as I have tried to demonstrate in the pages above, one of several narratives that existed about the museum project at the time I conducted my research. The "accidental" nature of the German donation, the alleged elitism and Lima-centrism of LUM decision-makers, and the way the project seemed to draw upon (and potentially distinguish itself from) the TRC represented other aspects of the institution's image that a Peruvian observer might emphasize to an inquiring outsider. Perhaps above all, however, there was the sense of delay and uncertainty that I presented in the introduction and have, to some extent, chronicled here.

Yet for all the LUM seemed to lack in terms of media visibility and tangible progress, the institution was anything but lifeless or devoid of internal visions.

Enacting Postconflict Nationhood

FERNANDO CARVALLO LIKES to walk. When asked about what he misses from his many years in France, "being a pedestrian" numbers among his responses. "Here in Lima, being a pedestrian is an audacious and irresponsible act . . . almost suicidal." More than that, he adds, it "locates one at a lower social level." Fernando's preference for walking places him at odds with his fellow Limeños, or so he claims when explaining the situation to foreigners like me. "There are two important status symbols for Limeños: owning a car and having a home near the sea." He sees the material expression of this ideology in what he perceives as a lack of sidewalks in San Isidro, the affluent Lima district where he spent part of his childhood.

The LUM's national director was critical of the assumption that the museum needed an underground parking lot. There were skyscrapers in London that had smaller lots, he pointed out, and it was not as if cars required protection from the elements in Lima's humid but generally rain-free climate. The real priority, in his view, should be ensuring easy foot access from Avenida del Ejército, where visitors who take public transport would arrive and descend part of the way down Lima's Costa Verde cliff to the site. Ramps and escalators would be best. What kind of message would it send if a disabled person without a car could not easily visit the Place of Memory, Tolerance, and *Social Inclusion*?

I recalled that Fernando, who was in his late fifties, did not own a car when I first met him in 2011. We walked and talked in a neighborhood in Miraflores during one of our meetings that visit—chatting about my planned research, his job at the LUM, our family backgrounds, and so on—until Fernando had to catch a cab for a meeting downtown. He refused to play the back-and-forth negotiation game with *taxistas*, he told me. By this, he was referring to the customary haggling that takes place in the absence of fixed prices or a regulated system of metered taxis. If the first figure offered by a taxi driver seemed unfair, he simply moved on to the next one. Massive deregulation of public transport in the 1990s helped make Lima a buyer's market when it came to the price and availability of informal taxis.

But Fernando made sure that I, a foreigner without much experience in the city, knew not to enter a taxi without first negotiating a price.

When I began my main period of research, Fernando had acquired a relatively plain black sedan—he already had that other status symbol in the form of a Miraflores condo that overlooked the ocean—but he avoided driving the car when he did not have to. In conversations, Fernando made no effort to hide his contempt for navigating Lima's crowded streets. More than once, after experiencing some slight on the road or while struggling to change lanes, I heard him criticize the macho attitude of Lima drivers. Fernando welcomed the news that car travel was on the decline in parts of Europe but knew there was little hope for Peru. Members of a growing middle class wanted their cars, and transportation reform in Lima had been a slow and politically contentious process. Fernando's attitudes toward walking and driving marked him as both cosmopolitan and potentially out of step with the typical Peruvian.[1] As I seek to illustrate in this chapter, this tension was recurring in his work as a representative for the LUM.

A crowd gathers in the auditorium of the National Library in San Borja. Fernando takes the stage late, but acceptably late for a 9:00 A.M. engagement in Lima. Traffic is the common excuse, though I know Fernando made part of the trip from his Miraflores home on foot. Approximately fifteen minutes into his presentation, a guest lecture for an adult education course on Peruvian art history, the national director begins to speak in a way that befits the introduction he received from the course's instructor: philosopher, graduate study in Berlin, many years spent teaching at a prestigious French university. The lights are dimmed enough for one to see the spotlight shining on Fernando as he talks at a small, light-brown podium that matches the color of the wooden stage. "Again, a general tendency is appearing in transitional justice to create places of memory. In Peru, this is coming with more of a delay than in other cases. . . . Why memory? Because [these sites] insert themselves in our collective discourse and become centers of collective memory. Now some think that this is a neologism, a concept invented by fashionable intellectuals. But collective memory as such has been studied and theorized since the 1930s, starting with the French sociologist Maurice Halbwachs."[2]

"The image that we have of wars changes with time." After briefly alluding to ongoing deliberations at The Hague that, according to Fernando, might shape how Peruvians view the legacy of the nineteenth-century War of the Pacific, he returns to the more general point. "All of these wars fill the collective memory of a society not only, and not even primarily, through school education." Instead, this occurs through "another phenomenon, one that Halbwachs, and a scholar who followed him, Pierre Nora, highlights, which is that of all of society, certain names are chosen to

Presentation on LUM initiative at National Library of Peru.

define space and to define the official calendar." Saint Rose of Lima, (film-maker) Armando Robles Godoy, and Nobel Prize–winning author Mario Vargas Llosa are examples Fernando lists for Peru. A number of living icons, including Vargas Llosa, could be found in photo images in the National Library's lobby wearing black "Missing [*Se buscan*]" T-shirts to support the library's campaign to recover thousands of books that had been lost or stolen over the years.

"But of the 7,000 streets [there are] in Lima, 50 percent of them have military names. How many women are represented there? Two percent? How many scientists are there?" Again referring to Halbwachs, he wonders aloud about the implications of children growing up in a city with streets that are named in this fashion. "This frames us collectively so that we see our history in terms of certain criteria. . . . The names of the streets in Lima, of the plazas in Lima. What are they? Grau, Bolognesi, San Martín, Bolívar. Tell me a plaza that is named for a civilian!" Fernando clarifies: He is not against military-named streets and plazas as such. (Indeed, it was important for someone in his position at the LUM to avoid the impression of being antimilitary.)

As the LUM's national director—and undeniably the public face of the project for years at that point—Carvallo had taken up the task of translating

and broadcasting a transnational culture of memory in Peru.[3] The discussion of memory and street names was bracketed by Fernando's pontificating about the post–Cold War context of this new sense of "self-criticism" before history (referencing Francis Fukuyama, debates surrounding the five hundredth anniversary of Columbus's arrival in the Americas, and the possible role of colonialism in Rwanda's genocide) and Peru's place in this international movement. Here, he drew particular attention to critiques of Fujimori-era narratives of the violence (Degregori 2011; Milton 2014c; Stern 1998b) and recognized the Peruvian Truth and Reconciliation Commission (TRC) as the country's most systematic truth-telling effort to date. Why had Shining Path gained such a following in the first place? What role could art play in helping Peru process and move on from its difficult past?

Sitting in one of the library auditorium's plush red seats, I tried to remain attentive to the rhetorical strategies through which Fernando communicated his message. The charismatic director—light-skinned, frequently unshaven, and with graying hair—was a skilled public speaker. Fernando's face would retract into an anguished, almost wincing expression when he sought to convey the seriousness of the point at hand (e.g., that reparations for victim-survivors were an urgent necessity, or that Peru remained a discriminatory, "even racist" society). He had a trebly voice and sometimes rolled his "r's" to accentuate a particular word ("*rrreconciliación*"). And although there was a sheet of paper on the podium where he had draped his jacket a few minutes into the talk, Fernando spoke without notes for approximately an hour and a half.

Before the presentation, he had convinced a recently arrived German intern to join him on stage to manage his PowerPoint slides, which were mostly photo images of the LUM construction site. The initially reluctant German, encouraged by his new boss telling him that "life is theatre" (or something to that effect) was amused by the way that Fernando mentioned the German museum with which the intern was affiliated, but omitted any reference to the foreigner's lowly position at that institution. Fernando never disabused audience members of the notion that the tall, fresh-faced visitor from abroad might be some kind of high-level consultant.

Further, the director's ability to flout certain sartorial norms of Peruvian society seemed to add to his air of intelligence and cosmopolitanism. While Fernando possessed the collection of suits necessary for an official of his stature, he often opted for a less formal appearance: khaki pants and a partially unbuttoned dress shirt. In place of the well-polished dress shoes that are expected of Limeños of all social classes, Fernando sometimes softened the formal look of his necktie and blue blazer by sporting black, Crocs-style sandals.

Toward the end of his talk, Fernando gave out his personal email address to the audience. He did not sleep a lot, he explained, and often found himself responding to emails in the middle of the night. All in attendance were invited to visit the LUM construction site the following week, where there would be no admission fee, but visitors would "pay intellectually" with their ideas for the museum. The goal, he reminded everyone, was to build an "anti-narcissistic museum," one that could serve to critically reflect on the Peruvian condition.

Managing Memory as Transnational Work

This chapter profiles Fernando Carvallo in his role as national director of the LUM, focusing especially on the transnational dimensions of his work. Where chapter 1 chronicled how memory became the dominant framework for conceptualizing the task of representing Peru's violence in a national museum, this chapter attends to the lived experience of enacting this institutional position and conveying its relevance to a broader public. In the context of the book's overall argument, the material here illustrates what might be considered a foundational negation at work in the making of the LUM. Global models of postconflict nationhood—not unlike the image of orderly, walkable streets referenced above—did not fit neatly with Peruvian realities, and this perceived lack congruence was a source of tension and creativity. In the discourse of figures like Fernando, ideas about what postconflict Peru was (or might be) emerged in relation to what it was not (or could not be). Sensitive to a need to modify the memorial museum concept in Peru, he and others within the project would contrast the Peruvian situation with other postwar conditions while positioning the LUM as an initiative that could be an agent in the creation of a more modern, democratic state.

My examination of these themes is informed by scholarship that has explored the transnational dimensions of memorializing violence, a literature that addresses topics such as the role of foreign actors and international publics in the making of memorials and museums (Bunzl 2003; Schwenkel 2009; White 1995) as well as the cross-referencing of world cases and use of universal tropes (peace, "never again," etc.) at such sites (Mookherjee 2011b; Yoneyama 1999).[4] As Amy Sodaro (2018:3) observes, there is an "increasingly transnational flow of memorial museum aesthetics and design," and in certain cases, such as the Kigali Genocide Memorial Centre in Rwanda (2018:92–93), international consultants play a leading role in the creative work of establishing memory initiatives. Assessing these developments, some commentators even warn of the "standardization of memory" (David 2017) on a global scale.[5]

Throughout Latin America, there are countless examples of national memory debates being molded by international actors and transnational processes. In Chile, the 1998 detention of former dictator Augusto Pinochet in London after being indicted by a Spanish judge provoked a renewed debate about the country's period of authoritarian rule (Stern 2010). The Truth Commission for El Salvador (1992–1993) was organized and carried by the United Nations following UN-brokered peace agreements in that country (DeLugan 2012). A police archive uncovered in Guatemala City in 2005, which provides documentation of war-era detentions and disappearances, became operative largely through international aid and the alliances local advocates forged with institutions and experts from abroad (Weld 2014). Alternatively, in Spain, "memory activists" draw inspiration from Latin American movements such as Argentina's Mothers of the Plaza de Mayo as they strive to account for atrocities committed during the dictatorship of Francisco Franco (Rubin 2018).[6]

This chapter's principal concern is with transnational connections that are arguably of a less literal variety. I consider how the everyday work of conceptualizing and talking about memory and transitional justice at the LUM came to involve "dynamic and 'eventful' reconfigurations" (Goswami 2002:271) of the postconflict nation as a modular form (Anderson 2006).[7] Peru was not Germany or South Africa, nor was it Chile or Guatemala. If there was a "culture" of thinking through how to create the memorial museum, it was one of travel, mobility, and interconnection—more akin to the goings-on of a "hotel lobby, urban café, ship, or bus" than a closed-off laboratory or dwelling in a village (Clifford 1997:25; see also Erll 2011). Still, as Andreas Huyssen (2003:16) is careful to note, "although memory discourses appear to be global in one register, at their core they remain tied to the histories of particular nations and states." Fernando's relentless cosmopolitanism only accentuated processes of comparison and negation that have become an integral part of managing war memory in many places around the world.

LIFE EXPERIENCES AND THE LUM

As the most visible representative of the project and something of a point person for the LUM—facilitating communication between the office and the High-Level Commission, overseeing progress on the museum's construction and its contents, and maintaining relations with international donors—Fernando was a natural source of information for a visiting researcher. "From a legal standpoint, I represent the state before the state's interlocutors," he responded, after I asked him about his job responsibilities in our first formal interview. The main "interlocutor," he explained, was the UNDP, which administered the project's funds, but there were others, such as the

High-Level Commission (considered above the ministry level) and entities representing countries that were "friends" of the project. "From an action standpoint, [my responsibility is] to secure relations between the project and the state, with victims' associations, with NGOs concerned with human rights and memory, and with intellectual and artistic communities that work on the topic." In practice, Fernando added, he was the head of a small administrative team that included an accountant, a project engineer, and a functionary he described as a legal economist (*economista jurídica*); "in reality, this project is done only with four people." Members of the High-Level Commission discussed and debated, but they did not sign off on many of the LUM's activities, he clarified.

The office where the team worked was housed in Peru's Diplomatic Academy, a compound with a high wall and row of trees surrounding it that blocked off the two-story building from street view. The large wooden-door entrance to the complex was located at a bus stop, across the street from an assortment of unassuming businesses: drug stores, hair salons, two veterinary clinics. The office was technically in Magdalena del Mar but was on the border with Jesús María, another largely residential district of Lima. Upon entering the compound, one was met by a security guard dressed in a black suit who, after verifying the appointment, would signal the visitor to LUM project's second-floor office.

Lately there had been too much emphasis on the construction issues for Fernando's liking. He was able to wax philosophical about the imbalance, however. "The engineering issues end up being almost a *relax* (in English), from issues that are more conceptual . . . and more distressing." He contrasted the technical matters with the "philosophical or anthropological ones" that were far more difficult to resolve. "Because we're talking about something that has to do with death . . . that has to do with compassion . . . that has to do with the humblest people in society." Fernando told me he always marveled at how Aristotle combined writings on political philosophy, epistemology, and ethics with studies of topics like the reproduction of birds and fish: "So, I think that maybe it was this, no? The way in which, as complex as a technical issue might be, it doesn't have as its backdrop this angst that 'meaning' produces. Because the best efforts of architecture, of engineering, of museography, can fail . . . in the sense of not reaching their public." Although reluctant to opine about a museum he had not visited, Fernando noted that a prominent example of "the best efforts failing" was the National Museum of the American Indian (NMAI) in the United States. The takeaway from this case, a visiting specialist told him, was that a museum needed to distinguish between its "constituency" (using the English term) and its audience. The likeness was evident for Fernando in context of the LUM initiative: victim-survivors, like Native Americans at the NMAI,

represented a constituency, but the majority of future visitors—many of them young people—would not identify as victims of the war as such.[8]

Fernando was used to playing an informant-like role, and I was one of a number of students (foreign and Peruvian) he welcomed to the project. There were also the journalists and more seasoned researchers, but Fernando seemed to relate to students—and visiting students especially—in a particularly direct way. He was eager to discuss Peru with interested listeners, and his enthusiasm was grounded in a sincere belief that foreigners were well positioned to shed light on the country's reality.

When I first met Fernando in 2011 he expressed interest in my work, even agreeing to write a short, supportive letter for one of my grant applications. The LUM initiative experienced leadership changes later that year, so I was somewhat surprised to learn that he was still with the project when I wrote him toward the end of 2012. He responded quickly to the message, referencing the LUM's "difficult context" and decrying the way that politicians had been using clashes linked to the drug trade as a pretext for celebrating Fujimori's legacy and attacking the human rights community.

A speaker of Spanish, German, French, and English, Fernando would often alternate between Spanish and English in informal conversations with me, viewing this as an opportunity to practice his language skills (he advises Peruvians heading abroad to avoid hanging out too much with other Latin Americans). Fernando sometimes inserted an English phrase or expression when speaking during interviews ("don't quote me") or giving a presentation, with the latter sometimes serving to demonstrate his knowledge of global affairs (uttering Franklin Delano Roosevelt's supposed quote about a Latin American dictator: "He may be a son of a bitch, but he's our son of a bitch").[9] A radio journalist for part of his time in France, Fernando regularly consulted English and French language news sources in addition to the two major Peruvian newspapers.

Some of his coworkers—who described Fernando with words like "contemplative," "entertaining," "intelligent," and "cool," even if the philosopher-turned-official could be a bit "scattered"—believed that one of the main reasons Fernando was hired had to do with the facility with he communicated with international collaborators. One of his regular activities, for instance, was giving short tours of the construction site to foreign and Peruvian visitors. Often scheduled at 12:00 P.M. to coincide with the workers' lunch hour (a time of relative quiet), the tours provided the national director an opportunity to expound on the LUM's vision. "We don't refer to this as a 'museum,' but as a 'place.' . . . The architectural concept is to have visitors ascend from below to above. . . . We want the esplanade to be a *truly* public space, something that is hard to find here in Lima." Fernando

had a red hard hat for the tours that he kept in his car; visitors wore white ones that were made available on-site.

In addition to maintaining relationships with donors such as the German Society for International Cooperation (GIZ), the UNDP, and the EU, there was a perpetual search for international funding. Typical activities for Fernando and others at the project would include preparing an English-language PowerPoint presentation for a meeting at an embassy, or trying to get the LUM on the agenda of a visiting official from a wealthy Middle Eastern country that was said to be a major funder of museums. International support had its immediate, practical function for the chronically underfinanced project, but foreign partners also helped legitimize the LUM politically, Fernando stressed. "[International support] has been very important, I believe, because initially a critique of the museum was that it was part of a national political agenda. 'This is a maneuver against Fujimori,' or it's a maneuver of the people on the left, a maneuver of the NGOs, a maneuver of the Truth Commission, but slowly I think it has become clear that . . . it's [more about] an evolution in the contemporary sensibility that can be seen in many other countries . . . in all of the countries of Latin America."[10] In an informal conversation, Fernando highlighted the significance of having support from the U.S. embassy, which came in the form of a small delegation of museum specialists and embassy-sponsored events corresponding with the visit. Who could accuse the LUM of being sympathetic to "terrorists" if they were doing events with the Americans?[11]

Fernando's attention to the international dimensions of managing Peru's violent past arguably predated his involvement in the LUM initiative. Describing how he came to the project, Fernando mentioned living in Paris and learning about the work of the Peruvian TRC. "The *Final Report* of the Truth and Reconciliation Commission fascinated me. It seemed to me that there was . . . an entire conceptual-philosophical apparatus there that was implicit . . . and it was the work of a generation." Observing these developments from France, he told me, Fernando was as interested in how ideas about history appeared to be changing in Europe as he was in processes of transitional justice in Peru and other parts of Latin America. Fernando listed several cases that struck him as exemplifying this new "attitude of self-criticism" before history, mentioning dialogues between French and German historians about World War II, the evolution of the Catholic Church's position on the conquest of the Americas, and the museum to the slave trade established at Gorée Island in Senegal (House of Slaves). "So, all of this impressed me a great deal and I wanted to come to Peru to work on these issues."[12]

Perhaps owing to his social background and masculinity, it was somewhat easy to situate Fernando's return to Peru and subsequent work at the

LUM within a long tradition of elite efforts to modernize the Andean nation, politically and economically. Not unlike how intellectuals during the first part of the twentieth century spoke of industrialization and the cultivation of "proper" urban laborers in aspirational terms (Drinot 2011), Fernando viewed citizen awareness of the violent past—and, equally important, awareness of why the state was creating the LUM—as a way of helping make Peru a modern, democratic nation.

In 2010, for example, Fernando published an op-ed piece in the Peruvian edition of *Le Monde* entitled "Ten False Ideas about the Place of Memory" (Carvallo 2010). In it, he went point by point, often drawing on examples from other world cases, in an effort to dispel notions such as "the concept of collective memory is a neologism," "memorial museums threaten the credibility of the armed forces," and "terrorism is a mistaken concept that hides the structural problems of a society." He critiqued the argument that it was inappropriate to construct the LUM while there were still remnants of the violence by suggesting that such thinking would have made it impossible to "build memorials to victims of Nazism, racism, violence against women, and homophobia." The "terrorism" point was accompanied by a discussion of the post-9/11 manipulation of the term by George W. Bush and its global consequences. In the 1980s, Fernando recalled, members of Peru's United Left marched under the banner "United against Terrorism," and today, no serious person could characterize Che Guevara as a terrorist, he claimed. I imagined that, at some level, Fernando viewed his interventions in forums like *Le Monde* or at the National Library as something of a citizen-by-citizen effort oriented toward a larger, patriotic goal. The objective in the background was, in Fernando's words, "preserving an inclusive democracy" in Peru.

The nationalist appeals and their space of enunciation were probably familiar to most Peruvians. Fernando's life trajectory mirrored the experience of many upper-class Limeños of his generation. Born to a family that resided in downtown Lima, Fernando's parents moved to San Isidro during the period of "white flight" the district experienced during the 1950s and 1960s, as Andean migrants began to displace the historic population of what remains the city's center of political power. He was educated at a private secondary school (he still complains about the conservative *franquista* priests) and Lima's Catholic University before pursuing graduate studies in Europe.

Fernando is proficient in the codes of an elite Limeño microculture that is marked by notions of race, education level, and family ancestry, even if he has an irreverent attitude when it comes to many of such "rules of the game." It is a culture that, historically, has policed boundaries between those considered "decent" and those in need of reform (Gandolfo 2009; Whipple 2013), the literate vanguard that speaks for modernity and the uneducated masses (Drinot

2011), or the white-collar worker (*empleado*) and the manual laborer (*obrero*) (Parker 1998).[13] At the time of my research, Fernando was less well known among Limeños than his deceased brother (Constantino Carvallo), with whom the surname "Carvallo" was most closely associated. (This changed in the years that followed, as Fernando eventually became the co-host of a popular radio news show in Peru; he is now a well-known public figure.)

Aptly described by a coworker as the "most comparative" person at the LUM, it was clear that Fernando's knowledge, life experience, and responsibilities at the museum project consistently pushed him to think beyond Peru. He could adequately convey the distinctiveness of Shining Path as a Maoist movement in Latin America to a foreign visitor, citing relevant world cases such as Cambodia and Nepal, or speak of the irony of militants in Peru launching its rebellion at a time when China was beginning to "transform into what it is today." South Africa's model of public testimony and forgiveness was a source of inspiration, he would point out, but forgiveness of Shining Path was not "politically possible" in Peru and there were legal barriers to amnesty, including at the level of the Inter-American Court. Speaking to me about the possibility of exhibiting videos showing Fujimori-era corruption, Fernando said the focus on corruption not only ran the risk of diverting attention from the violence, it could put the museum "out of equilibrium." Because there were not equivalent images of Shining Path or the MRTA (Túpac Amaru Revolutionary Movement), "[showing the videos] would be like a U.S. museum about the fight against terrorism having Guantánamo be more important than September 11th." I once asked which case he thought was most useful for comparative purposes and Fernando quickly answered, "Colombia," citing the lack of full-fledged military dictatorships in the countries' recent histories, the plurality of perpetrators, and the shared backdrop of the drug trade. He had traveled there and was reasonably knowledgeable of memorialization initiatives in the country. (As Sodaro [2018:38] notes in her survey of national memorial museums like the LUM, visits abroad are an almost universal feature of making of such sites.)

Fernando was certainly not the only person at the LUM initiative who was inspired and challenged by developments in other parts of the world. For instance, in one of my interviews with Patricia Rodríguez, a member of the administrative team whose practical knowledge of "how the state worked" complemented Fernando's penchant for conceptual matters, the functionary spoke of her process of learning about the objectives and functions of memorial museums. Patricia—a tall, middle-aged woman who had experience working in a number of Peruvian government agencies—drew particular attention to a trip she took to Chile with her husband to visit the Museum of Memory and Human Rights in Santiago. "Above all, it gave me a vision of what memorial museums are, which I wasn't familiar with

before . . . it was the first time I had been to a museum of this type." Although her work dealt primarily with "logistics" as opposed to developing the LUM's contents, she felt the visit to the Chilean museum fulfilled its objective in that it, "gave her an idea of what we should have here." (She made the trip on her own accord rather than as a sponsored representative of the LUM.) Flipping through an exhibition catalogue she kept by her office desk—and subsequently let me borrow for a few days—Patricia talked about features of the Museum of Memory that struck her as particularly moving, such as a wall of photos where visitors were able to use a computerized system to search for the names of the pictured victims. She was also impressed by the back wall of the museum's reception area, which had plaques with information about different truth commissions around the world. "I didn't know that there had been *that many*."

Before the visit, Patricia told me, she did not have the "slightest idea" of what a memorial museum was or the type of messages such sites presented. She added that many Peruvians would not be familiar with this kind of institution. Reminding me several times in our conversation that she was a "total non-expert" and lacked the comparative perspective that some at the LUM had—of going to museums like this in Mexico or Brazil—Patricia thought that Chile's Museum of Memory was a good model to follow in some ways. At the same time, it was not as if Peru could copy the Museum of Memory wholesale, "because Chile is a different reality." There, "they only had the problem of the military . . . here [in Peru], on the other hand, we have terrorists, problems with the armed forces, the *ronderos* [civil defense patrols], and so on . . . thousands of things that [the Chileans] did not have." It was for this reason that the LUM's exhibition script was a "very delicate" matter.

PERUVIAN LIMITATIONS

In Fernando's case, references to other parts of the world often had the effect of demonstrating Peru's lack of congruence with global norms, reinforcing the notion that existing models of commemoration were useful but insufficient. He criticized the right-wing actors in the country who were opposed to the LUM despite there being memorial sites and museums all over Europe that were similar in scope and function. Coastal indifference toward highland populations was another recurring theme in the director's reflections on factors that prevented Peru from dealing with its traumatic history in a modern, transparent fashion. Anecdotes from his experiences in Ayacucho, the war-affected region that few Limeños had visited or had much familiarity with, were a common feature of the director's talks and public appearances.

Three perceived "Peruvian limitations" Fernando emphasized in our conversations—albeit not in the distilled, sequential fashion in which I present them here—had to do with the political configuration of the human rights movement, cultural factors inhibiting dialogue among Peruvians, and attitudes about the Peruvian state.[14] In Fernando's view, participating in the global waves of memorialization he spoke so eloquently about meant confronting these features of Peruvian society. The LUM itself became positioned as an initiative that could create meaningful changes in societal norms, a theme echoed by other actors throughout the project's history.

In interviews, Fernando spoke candidly about how he viewed the LUM as a political project: the museum, for him, was an opportunity to promote dialogue and foster alliances between liberals and the democratic left (using "liberal" in the Latin American sense of the term).[15] He said he saw such a convergence in France with François Mitterrand and noticed a similar pattern in other parts of Latin America, such as Chile. "So, when I arrive in Peru I feel that there's this divorce, which continues to exist." He spoke of the "many liberals who truly have pro-human rights, pro-democracy convictions," but also have a distrust of the left. "I thought that [the LUM] was only viable if this convergence took place." One of the points Fernando emphasized in his early "Ten False Ideas" essay, for instance, was that "the defense of human rights and memory politics are not left values" (Carvallo 2010).[16] Although he identified as a former member of the "seventies left," Fernando's general sense was that the Peruvian human rights movement was situated too far on this end of the political spectrum, with most on the right having abandoned the issue entirely.

To illustrate this point, Fernando shared an example with me that involved "one of the most important left intellectuals who works on memory." At a conference, Fernando questioned the author's use of the term "demo-liberal allies." "I ask[ed] him, 'If the *demoliberales* are the allies, who are you?' 'We are the human rights movement,' was his answer." The implication, for Fernando, was telling. "There is a human rights movement then, but the way he put it, it means that the definition of the human rights movement is an ideological one . . . and even if he would not say it, it's of the left. And I consider that a very important mistake." Suspicious of most forms of essentialism, Fernando likened the demo-liberal ally category to the way that communists used to refer to "useful idiots."

The national director repeatedly stressed the importance of fostering liberal-left alliances but admitted that the task had proven more difficult than he anticipated. Part of the problem, Fernando felt, were conditions in Peruvian society that were averse to dialogue. "I speak with everyone," was as a kind of mantra for the national director. The phrase implicitly endorsed

the notion that contemporary museums should be created through dialogue and collaboration (Clifford 1997; Karp, Kreamer, and Lavine 1992; Shannon 2014), with the perspectives of victim-survivors, the armed forces, and the human rights community positioned as exterior to the LUM itself. One could see evidence of the overflow of contacts and connections Fernando was making in the way that he screened calls and closely monitored emails and texts on his BlackBerry phone.

The thirty years he spent in Europe gave him something of an advantage in this area, or so he claimed. Even after being back in Peru for some time, he told me, he did not know who many public figures were—the equivalent of an American not knowing anything about Oprah Winfrey or Lance Armstrong. Fernando felt that because he had lived abroad for so long, he lacked some of the prejudices of his peers, and this attribute helped him speak with members of various sectors in Peru (the military, Fujimoristas, victim-survivors in Ayacucho) with relative ease. He read books that his friends would not, such as a right-wing conservative's account of the 1996–1997 hostage crisis at the Japanese ambassador's residence. He spoke of having a sensitivity to issues of cultural diversity that many people of his background lacked (Alcalde 2018).[17] Further, his life situation as a recently returned Peruvian allowed him to "act a bit naïve" when speaking about topics that could be politically charged. When Fernando made this observation, I resisted an urge to point out how his job, in some ways, resembled my work as an ethnographer.

Fernando would speak frankly about what he viewed as Peruvians' tendency to trust foreigners (from Europe and North America) more than they trusted one another. "You, as a North American, are received with greater ease than a Peruvian, even by the military," he said after I had mentioned a recent meeting I had with a military official. "If you were a Peruvian anthropologist, they wouldn't receive you. . . . 'He's probably a communist' [would be their thinking]. You understand?" The director asserted that "thousands of prejudices appear among Peruvians" in these types of encounters and this reality inhibits dialogue. "Distrust in government starts with distrust among Peruvians," Fernando submitted, and he could cite the relevant Latinobarómetro polls to support the notion. The director contrasted this state of affairs with that of Europe, where he thought there was greater openness and transparency.

In one interview, Fernando claimed that visiting experts, in addition to their more immediate contributions, assisted in a second, "unexpected" sense that related to an alleged "communication deficit" that existed among Peruvians. "The presence of a foreigner . . . someone who says things without an ulterior motive and without taking into account internal affairs,"

could facilitate discussions that would not happen otherwise, as, in the director's view, Peruvians often failed to separate conceptual disagreements from personal ones. Fernando speculated about the roots of the communication problem he diagnosed:

> I would like some anthropologist to deepen our understanding of [this problem] and explain why [it exists]. I have a Peruvian-American friend who told me something once and I'll submit it to you here. He says that very few people are confident of having achieved something objectively grounded in merit . . . because [in Peru] people get things through relations, through family origins, through marriages, through complicities.
>
> This is why people inflate their titles so much here. People really like, "Professor Doctor, Philosophical Doctor, blah, blah, blah. . . ." Everyone with their titles. . . . It's a very small country and one where everyone doubts the real value of their knowledge, their academic merit, their general professional merit. Very few people have a real sense of security. This makes it so that people don't communicate with one another and everyone wants to protect their prestige or their earned space. I'm exaggerating a little bit here, and if people hear this they're going to get upset that I'm talking this way about Peru, but I think this is how it is.

I never asked Fernando, who would openly question the intelligence and credentials of noted Peruvians in casual conversation, if he himself ever felt this sense of insecurity.

In addition to being motivated by solidarity with victim-survivors of the conflict and a sense of service to his country after having lived abroad for many years, Fernando "discovered something else . . . something more complex and more difficult to justify" through his work at the LUM: respect for the state.[18] "It's something I did not anticipate," and that he did not have when he was younger. He emphasized Peruvians' lack of trust in their state, explaining that this attitude was symptomatic of, but also elaborated upon, generalized distrust among Peruvians. The distrust went both ways, Fernando added. The director recalled a series of small bureaucratic procedures he recently had to pass through when picking up a friend from the airport— among them, a worker carefully inspecting a ten-sol bill (the equivalent of three or four dollars) to make sure it was not false. Fernando spoke of the quality of many public officials in Peru as well, offering the examples of a philosopher colleague employed in the prison system, memories of his father's work as a physician in public hospitals, and a congressional representative's recent visit to Ayacucho to express solidarity with victim-survivors' demands. The latter was a symbolic act that, according to Fernando, was unlikely to be recognized by Lima NGOs because the congressperson was a public official.

"It's not like this in other societies where there is more respect for the demo-cratic authorities of the state. For some reason we have a bad image of our-selves," he reflected. "We don't trust a ten-sol bill!"

Fernando contrasted the Peruvian situation with that of the French state, where he observed that people considered it an honor to represent an official institution. "Why can't we appreciate the creation of our state?" Fernando asked. The feelings of solidarity with victim-survivors still pro-pelled him, but he was also motivated by the goal of promoting an overall sense that he and his colleagues at the LUM could work to cultivate: "the respectability of the Peruvian state" as an entity that protects the rights of all its citizens.

Criticism and Hope

Just as Fernando felt that Peru was not living up to certain ideals of postconflict nationhood, he was often reminded of ways in which he and the LUM initiative also might be falling short. For all the emphasis on dia-logue, a common critique among the museum project's observers was that Fernando would talk too much and maybe not do enough listening. "Fer-nando Carvallo is a smart man and he has a talent for talking that not many people have," said a human rights activist who attended his presentation at the National Library that morning. "He should know when he's speaking that he has to leave fifteen minutes at the end for questions. He never allows for any discussion." There was a perception that Fernando, and by extension the LUM as an institution, tended to organize events that effectively closed off meaningful debate, or limited discussion to topics that were less conten-tious than the museum's contents, such as the building's architectural design.

A further concern was that the project did not follow up on the sugges-tions and concerns that attendees expressed at events. The lack of concrete results from meetings held in Ayacucho or with delegations from Germany or the United States did little to ease concerns about the LUM initiative's transparency. As one human rights activist described, "They have meetings in which they invite the victims, they invite us, we all say this and that, and in the end, it's 'bye,' and we don't know anything." She suggested that the LUM might be better off taking the position she heard expressed by a visit-ing German specialist: be honest (*sincerarse*) and admit that consulting with victim-survivors and civil society would never really happen. Other critics suspected that Fernando strategically played down his influence on the proj-ect relative to the curatorial team or the High-Level Commission. "It's not as if he's an office boy [*portapliegos*]," was one commentator's sharp response to Fernando's unwillingness to explain aspects of the LUM's exhibition script at a meeting. Such critiques evidenced broader concerns, not only about transparency, but about accountability. Who, if not the national director,

would be held responsible for the museum's representation of the political violence?

In private conversations, Fernando acknowledged criticism of the process, and admitted that there had not been as much dialogue as he would have liked (perhaps it would have been uncouth to say otherwise). At the same time, he noted that critics tended to vastly overestimate the people and resources the LUM had at its disposal. And he and others were of the opinion that it would not be useful to publicly debate the museum's contents without first having a draft of the exhibition script prepared.

There were also critics who questioned Fernando's credentials as national director, even if few doubted his intellect or capabilities as such. In meetings and public events, Fernando had a tremendous capacity to marshal the right anecdote or piece of evidence that would illustrate the point he wished to make. He could eloquently summarize the recently published memoir of a former child soldier in conversation (Gavilán Sánchez 2012) or extemporaneously incorporate findings from a talk he attended the week before on the "psychosocial impact of the TRC" (Espinosa et al. 2017) into a presentation. It was a kind of sharpness, a performative intelligence that, as some suggested to me, did not always translate into written plans or specific policies.

While a number of critics emphasized that Fernando "lived in France during the violence" or "did not know the issue"—placing a negative value on traits that Fernando considered advantageous—I recall one member of Peru's human rights community expressing amusement at how some of his colleagues seemed miffed by Fernando's ascendance. "He's a philosopher. He studied up, and now he knows the topic fairly well." Fernando, for his part, admitted that there was something of a learning curve to the job, especially when it came to dealing with the bureaucratic culture of the Peruvian state and the UNDP regulations.

Regardless of how well he "knew the topic," Fernando was undeniably savvy when it came to the politics of managing social relations. Some even accused him of having obtained the position through personal connections rather than on merit. Many knew that this was, all too often, how Peru worked. Titles and foreign degrees, combined with the right connections, could take you a long way. Few sectors were immune to accusations of personal favoritism.

A friend of mine, gesturing to legacies of racism and colonial thinking in Peruvian statecraft (Drinot 2011; García 2005), described Fernando as a "show-off" (*figureti*), commenting that people in positions like his "always have foreign last names." From the vantage point of observers who were eager to view the LUM director as a typical Limeño—maybe a well-intentioned Limeño, but inescapably Limeño—Fernando likely did himself no favors when he attempted to justify the museum's Miraflores location or criticized

the "methodological populism" (Carvallo 2010) of those who called for more direct collaboration with victim-survivors.

In sum, whether it was building alliances, promoting dialogue, or improving the image of the Peruvian state, one did not have to look far to find areas where some of Fernando's hopes for the project were perhaps not coming to fruition. Still, there was a sense that someone had to speak for the museum-in-progress and that those involved in the project would ultimately have to assume responsibility for the decisions they made. "You're not going to please everyone," was a reality that Fernando accepted when it came to the LUM. Hearing this piece of advice from visiting U.S. experts—one of whom spoke at length about the 1990s *Enola Gay* controversy (e.g., White 1997) as an example of failed dialogue—only reinforced the notion. They needed to move forward, beyond the construction delays, and beyond the High-Level Commission's deliberations over a script outline that the curatorial team had submitted. There would always be critics, Fernando emphasized.

And perhaps the LUM would succeed in realizing some of the goals that figures like Fernando had assigned it. The institution might strike an acceptable balance among diverse memories of the Peruvian armed conflict ("only those that are consistent with human rights though," Fernando was quick to add). It might help make memory, transitional justice, and legacies of exclusion core concerns for the average citizen. It might promote dialogue and foster Peru's development as a modern, "respectable" postconflict nation. And the LUM might just succeed in areas where the TRC, its predecessor as a state initiative, had fallen short.

CHAPTER 3

Yuyanapaq Doesn't Fit

No one, not even Salomón Lerner, wanted *only* the Yu-
yanapaq photo exhibit in the new museum. Lerner, the former president of
the Peruvian Truth and Reconciliation Commission (TRC), told me as
much as we talked in his office at Lima's Catholic University in April 2013.
At the time of our interview, Yuyanapaq was being temporarily housed in
Peru's Museo de la Nación.

An emeritus rector at *la Católica*, and the longtime executive president
of the university's Human Rights and Democracy Institute (IDEHPUCP),
Lerner spoke in a calm, matter-of-fact way about the relationship between
Yuyanapaq and the LUM. The senior philosopher looked the part, wearing
a black suit with a gray tie, and his office befitted this role. In addition to the
walls of books—among them, all nine tomes of the TRC *Final Report*—
there were dozens of classical music CDs stored in the plastic holders that
were common in the 1990s, some family photos, and numerous white *retab-
los* (altarpieces) from Ayacucho displayed throughout. Unlike many people
I interviewed during my research, Lerner used the formal *usted* second-
person pronoun when addressing me, a form that conveys respect, but also
distance.

The TRC photo exhibit with a name that derives from the Quechua
phrase "to remember," was initially going to be the "core," the "vertical
column" of the LUM, he told me. Lerner also noted that there were official
documents signed by two Peruvian ministers that explicitly referenced the
exhibit's place in the new institution.

Made up of approximately 200 photographs, Yuyanapaq presents strik-
ing images from the war. The exhibit emerged out of the investigative work
of the truth commission, with curators Mayu Mohanna and Nancy Chappell
drawing on war-era photos obtained mainly from newspapers and human
rights organizations to offer a visual account that reflected the TRC's findings.
Still housed at the Museo de la Nación as I write (in 2020), the exhibit is orga-
nized into five chronological periods spanning the "Beginning of the Armed
Conflict" (1980–1982) through "Decline of Subversive Action, Authoritari-
anism, and Corruption" (1992–2000). Yuyanapaq includes images of events

that had long formed part of Peru's national imaginary of the violence (such as the 1983 Uchuraccay massacre and the 1992 capture of Shining Path leader Abimael Guzmán), but also focuses on aspects of the war that were less present in public debates prior to the time of the TRC. These include the scale and magnitude of violence experienced in the country's Andean and Amazonian regions (represented in photos of the war dead and from events such as mass funerals), the dirty war tactics employed by the Peruvian armed forces, and civil society responses to Shining Path violence and state-perpetrated rights abuses (depicted, for example, in a 1985 photo of relatives of disappeared Peruvians at a municipal council to give their testimonies to the European Commission of Human Rights).

As commentators on the exhibit have noted (Milton and Ulfe 2011; Murphy 2015; Poole and Rojas-Pérez 2010; Portugal Teillier 2015; Saona 2014), Yuyanapaq's presentation of stark and often disturbing images employs the evidentiary nature of photography to call on Peruvians to recognize the political violence as a shared tragedy as opposed to a triumphant victory over terrorism. The exhibit was originally displayed in the Casa Riva Agüero, an abandoned mansion in Lima's Chorrillos district, before eventually being transferred to the Museo de la Nación in 2005. Receiving over 200,000 visitors during its time at the Casa Riva Agüero between 2003 and 2005 (Murphy 2015:29), Yuyanapaq is often considered one of the most successful museum exhibits in the country's recent history.

Although the promise of a permanent home for Yuyanapaq had been central to securing the German funds to construct the LUM, Lerner explained that the original plan was to have much more than the TRC photo exhibit in the new museum. He spoke of other permanent and temporary exhibits, an information center, a theatre, and the creation of a national network of memorial museums in the country.

Prior to the interview, I knew that Lerner had been vice president of the LUM's first High-Level Commission. I also knew he had resigned from this position in May 2010 for "personal reasons." Based on my brief, initial interaction with Lerner—some weeks before at a Gershwin concert put on by the U.S. embassy—it was clear that he ardently supported the original vision for the LUM. He and I were both aware, however, that Yuyanapaq's place in the museum-in-progress was far from secure. There was also the matter of exhibition space. Everyone knew that the LUM would not have enough of it to display Yuyanapaq in its entirety.

This chapter examines the disagreements that eventually resulted in Yuyanapaq not being incorporated into the LUM, a move that solidified the museum's identity as a post-TRC project. Drawing on insights from research that underscores the ritual dimensions of transitional justice (Celermajer 2013; Cole 2010; Osiel 1997; Wilson 2001), I suggest that a focus on ritual

outcomes is useful for analyzing the trajectory of national reconciliation initiatives in "post-transition" settings (Collins 2010; Stern 2010; Vaisman 2017). Influential actors within and outside of the LUM came to consider the Yuyanapaq exhibit an inappropriate centerpiece for a national museum to be inaugurated in a political context that differed from that of the Peruvian TRC. These same individuals generally praised Yuyanapaq and recognized its contribution to Peruvian society, but insisted that the LUM should not be a "repetition" of the country's truth commission.

Taking discussions about Yuyanapaq and the LUM as a case study, I suggest that ethnographic attention to perceived failures and shortcomings in the symbolic work of transitional justice furthers understandings of post-conflict transitions in two main ways. First, beyond registering critiques of reconciliation initiatives or pointing to how the lofty, transformational aims of institutions like truth commissions are met with complex social outcomes, this approach can shed light on the emergence of different positions concerning the impact and present-day relevance of past transitional rituals, examining the logics through which such positions are expressed. Second, an emphasis on the afterlife of productions like Yuyanapaq and the Peruvian TRC reveals the performative nature of assessments of "failure" in the ongoing management of difficult pasts (Austin 1962; Butler 1990).[1] I underline this latter point when analyzing the Yuyanapaq debate's resolution, particularly the rise of a clearly defined post-TRC identity within the LUM project and the intuition's decision to depict the TRC and Yuyanapaq as "historical milestones."

As I illustrate here and in subsequent chapters, discussions about the truth commission and its exhibit's enduring relevance (or lack thereof) typically involved subtle but consequential disagreements. The varying assessments of this legacy responded to the LUM's institutional history—the Yuyanapaq exhibit, after all, was once the foundation for the memorial museum—but they came to shape this history as well.

YUYANAPAQ AND THE LUM

Although Yuyanapaq was not part of the TRC's original mandate, it became a critical vehicle for transmitting the truth commission's findings and narrative to a national audience. In a speech given at the exhibit's inauguration at the Casa Riva Agüero in Lima (in August 2003, shortly before the release of the *Final Report*), Salomón Lerner (2004:138–139) described Yuyanapaq as a "continuation of the [TRC's] public hearings," a display that encouraged Peruvians to see the faces that the country "did not want to look at." Lerner's words referenced cases like that of Angélica Mendoza de Ascarza, founder of the iconic relatives-of-victims organization ANFASEP (National Association of Relatives of the Kidnapped, Detained, and Disappeared of Peru), whom a visitor to

Yuyanapaq encounters in a 1984 photo that shows the Ayacucho-based activist staring plaintively and holding a note sent by her imprisoned son shortly before he was "disappeared." Other images similarly convey forms of suffering that were not commonly portrayed in the national media prior to the time of the TRC: high school students in a small highland town holding a wake for their deceased classmate, a man falsely convicted of terrorism charges embracing family members upon his release from prison, a group of indigenous Asháninka women tending to children shortly after being liberated from a Shining Path camp. Likely owing to the emotional force of such images, the exhibit far exceeded expectations in terms of visitor turnout and overall impact. Yuyanapaq's three-month exhibition period (2003) at its original home, the Casa Riva Agüero, was extended and today, at the Museo de la Nación, the exhibit continues to receive thousands of visitors each year.

Whereas some might describe Yuyanapaq as "the public face" of the Peruvian TRC, it would not be an exaggeration to say that Yuyanapaq *was* the truth commission for the many Peruvians who visited the exhibit and otherwise engaged with the TRC's work in only a peripheral way.[2] Indeed, many key elements of the TRC ritual are laid bare in Yuyanapaq, including the exposing of highland suffering, an insistence on recognizing the violent actions of both state and insurgent forces, and the call against racism and Lima-centric visions of the nation. Arguably, however, some of the TRC's contradictions are masked (e.g., the commission's own forms of Lima-centrism).[3] Yuyanapaq itself helped "materialize the abstract"—long recognized by anthropologists as a core function of rituals (e.g., Moore and Myerhoff 1977)—by distilling stories and findings from the TRC's vast work and presenting them in a clear and emotionally compelling fashion.

It is perhaps unsurprising then that Yuyanapaq also comes to symbolize the Peruvian TRC for those who oppose the commission's findings and recommendations. For instance, in 2009, word got out that the subject depicted in Yuyanapaq's iconic image—which shows the heavily bandaged face of a man who survived the 1983 Lucanamarca massacre—was misidentified due to the fact that the individual, Edmundo Camana, had given the original photographer a fake name. Critics such as congressional representative Edgar Núñez promptly used the example to cast aspersions on the TRC as a whole, rather than limit themselves to the Yuyanapaq exhibit in particular (Ulfe 2013a:88–89).[4] Military officials have been especially vocal in critiquing Yuyanapaq and have cited the exhibit as evidence of the TRC's alleged bias against the armed forces (Portugal Teillier 2015:220–221). As discussed in chapter 1, such attacks on the truth commission have been a common feature of Peru's postconflict landscape, with critics typically expressing a salvation memory of the war (Milton 2014c; see also Degregori 2011;

Yuyanapaq exhibit at Casa Riva Agüero (credit: Daniel Lobo [Creative Commons commercial use permission: https://ccsearch.creativecommons.org/photos/742b92f1 -d3de-43a9-b009-4c2424fcba75]).

Drinot 2009; Stern 1998b) that foregrounds the defeat of Shining Path and the MRTA (Túpac Amaru Revolutionary Movement) by the Fujimori government and armed state actors.

Lerner, who regularly responded to critiques of the TRC in the news media, began narrating his experience as a member of the LUM's High-Level Commission by saying a few words about Yuyanapaq. "It was a very, very careful display," he noted, referencing the difficulty of making a visual account that reflected the report's findings and was balanced in its depiction of atrocities committed by the state versus those of insurgent groups. He lamented that Yuyanapaq did not stay in the Casa Riva Agüero, as the house's state of decay and abandon provided the appropriate setting for an exhibit about the nation's moral deterioration and descent into chaos. Like several others I spoke with in the human rights community, Lerner sometimes pronounced the "*q*" in the exhibit's title as an affricate (a breathy "*kh*" as opposed to a hard "*k*" sound), a linguistic move that communicated a degree of proximity to the subject.

At one point during our interview, his administrative assistant helped him retrieve a set of black, spiraled notebooks with visitor responses from

Yuyanapaq. They were stored in a clear plastic, rectangular container and each were about an inch thick. Lerner lowered the glasses that were perched on his forehead for much of the conversation and softly read excerpts from some of the handwritten entries he flipped through. I did not hear him well but could make out phrases like "'no' to terrorism" and "today I know the truth about my country." "If someone writes this after seeing it," Lerner wondered aloud, "how can they say that this exhibit is 'pro-terrorist'?"

Lerner served as de facto president of the LUM's High-Level Commission during much of his tenure at the project (2009–2010), as renowned author Mario Vargas Llosa, the nominal president, was abroad for most of that period. After recalling some of the initial controversy that surrounded the museum, Lerner spoke about the work of the LUM's commission in these early stages. He and the other commissioners met on the Catholic University campus, where they would have working lunches to discuss topics such as funding, relations with donors, and identifying an appropriate site for the LUM (there were sixteen sessions in all, he told me.)

From a conceptual standpoint, their framework was clear, according to Lerner. "Obviously the guide for all of this had to be, to a good extent— without us staying there, but to a good extent—the report of the Truth Commission," he told me. Yuyanapaq needed to be there as well. "Other things too," Lerner immediately qualified, but the TRC exhibit represented the heart of the recently approved museum project. "A team [of specialists] was formed, and they had been working. But owing to a series of . . . well . . . internal incidents . . . all of what we made progress on during those sixteen sessions collapsed" by the first part of 2010.

SOME "INTERNAL INCIDENTS"

The incidents Lerner referred to relate to the architectural competition that resulted in a building too small to house the full Yuyanapaq exhibit. The events are worth briefly summarizing, as they provide a historical backdrop for the discussions I examined in 2013.[5] By late 2009, one could identify a division within the LUM between Lerner and his team of specialists (many of them had been involved in the TRC and viewed their participation as a continuation of that work) and those who were aligned more with Mario Vargas Llosa. Among several sources of disagreement (Ulfe and Milton 2010; Sastre Díaz 2015) was the priority to be given to Yuyanapaq. For Lerner's group, the safeguarding of Yuyanapaq and the project's correspondence with the TRC were fundamental concerns, whereas the Vargas Llosa allies tended to prioritize the LUM's physical construction (securing a location, selecting an architectural design, etc.) rather than debating the museum's content.[6] Although Vargas Llosa had praised the exhibit publicly, he and others were wary of the TRC display's political baggage. It was also evident

that the desire to produce a representation that could promote greater consensus among Peruvians (than the powerful but imperfect Yuyanapaq) was a motivating force.

There were several incidents that appear to have exacerbated these divides. One was the apparent "veto" of the Lerner camp's nominee to write the exhibition script (a social scientist with relevant training and research experience). This came after an ally of Vargas Llosa circulated an essay written by the scholar that included comments mildly critical of the novelist. Another was the decision to proceed with an international architectural competition rather than basing the plan on an existing project (recall chapter 1).[7]

The event that interlocutors drew my attention to was a minor but revealing last-minute change to guidelines for the LUM's architectural competition: the elimination of a reference to Yuyanapaq on the list of criteria that contestants were supposed to take into account. Joaquín, a member of the Lerner-affiliated team, recalled the incident:

> So, we started to design the bases of the public competition. And you know that there's a lot of tension with the military in relation to Yuyanapaq, right? So, knowing this, we put Yuyanapaq as but one point of reference among others. We included that the architects should take into account—I don't know—seven different things and, among them, Yuyanapaq. But nothing more. Just like how a visit to Yuyanapaq was recommended. . . .
>
> But then when the guidelines were going to be published [an ally of Vargas Llosa] told us that by the order of Vargas Llosa we ought to delete that reference to Yuyanapaq. And it was like a "made decision," because we had to publish it right then, like the next day . . . despite the fact that we had been discussing this in great detail [among the team of specialists and with the High-Level Commission], right? . . . So it was a last-minute measure. An imposition.

For Lerner and members of his team, the removal of this reference was symptomatic of a gradual reorientation of the project that moved away from considering the LUM primarily as a refuge for Yuyanapaq. Joaquín, who left the project shortly after the incident involving the competition guidelines, told me that the decision "reflected a fundamental disagreement with respect to the place that the [Yuyanapaq] account would occupy in the future Place of Memory." When I pointed out that the TRC's place in the LUM remained an issue of debate, even years after the internal controversy we were discussing, he offered to the following commentary: "Yeah, well, you know . . . I imagine this is your topic, right? How an elite constructs an account, an account that becomes the story of our memories . . . how we construct our memory. And Yuyanapaq wanted to be an account—it's an

extraordinary account of what happened to us—but it didn't become the account of Peru's elites."

Further, although there was no concrete evidence to suggest that members of the High-Level Commission or anyone else intentionally arranged the competition so that it would result in a winning design too small to contain Yuyanapaq, it was not unreasonable to suspect this was the case. When speaking about this issue, Lerner told me that "there, there was a type of . . . mirage." He could not prove that there was bad faith or hidden intentions, he clarified, returning to his original train of thought. "The mirage consisted in the following: as [Alan] García maybe was against the Place [of Memory], perhaps he says, 'It's not happening anymore; let's assure things.' And the way to assure things is already having the building . . . from the point of view of standing before the fait accompli." An individual close to the situation, who preferred to remain anonymous, discussed this possibility in the following way: "When the bases for the [architectural] competition were made, the Yuyanapaq photo exhibit had to be taken into account and it wasn't taken into account. And that was done by the commissioners. Okay? It is not random. It is not naiveté. Intentionality is needed to understand it. They didn't want the Yuyanapaq photo exhibit in the Place of Memory. . . . Ultimately, it's on them."

In addition to the architectural design and the way that the competition was handled, the commission began moving forward with an exhibition script that, in Lerner's view, was not consistent with the findings and conclusions of the TRC *Final Report* (see chapter 1). When it was clear that the LUM was set on a course that he could not tolerate, Lerner resigned in May 2010, submitting a cordial letter of resignation. The above anonymous source described the falling out: "You know what happens is that in those circles, the changes aren't sudden and abrupt. Nobody fights. They hate each other to death. They dispute things. But they don't fight. That was something that always caught my attention. . . . It's that it's a commission of *señores*, of *señores distinguidos* [distinguished gentlemen] . . . who can't fight among themselves like the people in the markets. Here, manners are very much what order things." Indeed, consistent with historically entrenched norms of Limeño sociality, both sides made efforts to avoid Lerner's resignation becoming a distraction or media event.

SCHISM AND THE DISCIPLINING OF "TRC ORTHODOXY"

I was not in Peru to track the initial controversy as it unfolded, but the Yuyanapaq issue remained pending as I conducted fieldwork in 2013 (housing the exhibit was still part of the LUM's official mandate even though it was clear that the museum would not center on Yuyanapaq). And the legacy

of Lerner's departure and continued tensions with sectors of the human rights community marked the LUM initiative in a profound way.

The event that made these relations of distrust most visible to me was the March 2013 presentation of a preliminary outline of the LUM's exhibition script to a small group of artists and members of the human rights community. The presentation, which took place as part of a visit by a foreign delegation, was a basic, PowerPoint-slide rundown of how the exhibition space would be distributed in the new museum. A member of the curatorial team went room by room (e.g., "Faces and Voices of the Victims," "University Community," "Looking for Hope"), outlining how the team was conceptualizing these spaces. The presentation was short, taking no longer than fifteen minutes, and complemented by talks given by other members of the curatorial team and the LUM's architects.

During the question-and-answer session that followed the presentations, audience members raised a variety of issues. Several implored the curatorial team to make greater use of the TRC *Final Report*; others expressed concern over the proposed "military" section of the exhibit, fearing that the LUM would emphasize the "heroism" of the armed forces rather than state-perpetrated abuses. A few attendees cited an apparent lack of attention to women's experiences during the war. The intervention most relevant to the themes of this chapter occurred when Mayu Mohanna, co-curator of Yuyanapaq, voiced concern over the space allotted for Yuyanapaq in the LUM: 200 square meters for what was, according to her, a 2,000-square-meter exhibit. Although Mohanna and co-curator, Nancy Chappell (also in attendance that day) were aware that some within the LUM viewed the reduction of the TRC's exhibit as a potential solution to the Yuyanapaq problem, seeing the plans was disconcerting. The agreement to house Yuyanapaq in the Museo de la Nación ran only to 2016 and paring down the display to one tenth of its original size in order to save it was not an attractive option. What's more, there was the sense that "reducing" Yuyanapaq could mean removing parts of the exhibit deemed sensitive to certain political interests.

Suffice it to say, no agreement was reached that day and the LUM seemed to be far from offering an institutional response that would quell concerns about Yuyanapaq's future. One LUM representative told me that the curators' interventions struck her as "quite harsh" (*bien duro*); several others emphasized the curators' intransigence when it came to the management of their acclaimed exhibit.

Some weeks before, I had heard the term "orthodoxy" in reference to certain advocates of the TRC during an improvised briefing delivered by Fernando, the LUM's sharp and loquacious national director (profiled in chapter 2). The talk—given to members of a different foreign delegation—rapidly outlined some of the challenges the project faced, including the political

context, funding shortages, and lingering construction issues. After survey-
ing topics such as MOVADEF (the pro–Shining Path group), the country's
reactionary Catholic Church, and the Peruvian president's military back-
ground, he mentioned a "certain orthodoxy" that surrounded the TRC,
referring to a tendency among some to adhere to the truth commission's
findings and messages in a way he viewed as rigid, even dogmatic. Fernando
put forth Salomón Lerner, who was similar in age and social background to
himself, as the figure who embodied this position. (Diego García-Sayán, the
LUM's president at that time, was presented as someone who also played a
vital role in the TRC but had a more moderate view when it came to the
truth commission's relevance in the present). Fernando also highlighted a
refusal among some in Peru's human rights community to acknowledge con-
cerns about the TRC that he saw as legitimate, such as those pertaining to
the calculation of the TRC's official estimates of deaths and disappearances.
How to remain loyal to the TRC was a delicate topic for the LUM, he
explained to the visitors. I would only learn later that Fernando had emerged
as national director during the time of the conflict between Lerner and
Vargas Llosa, in part due to his siding with the latter.

In the wake of Mohanna and others' interventions at the March 2013
meeting, I asked Fernando about the Yuyanapaq issue on several occasions.
The day after the event, when I commented that the LUM-Yuyanapaq
dynamic seemed like an interesting one, Fernando noted that he "appreci-
ated Mayu's comments." He added that conversations with international
experts had reinforced the notion that there had to be more than photos in
the museum.

When we sat down for a formal interview nearly a month after the
event, the director reflected more on the subject. "The greatest challenge is,
how do you maintain loyalty to what the Truth and Reconciliation report
meant, *without staying in the year 2003*" (emphasis added). Fernando stressed
that there was a "different sensibility" and "different pedagogical demands"
with the passage of time. Later in the interview I asked what he thought
about the Yuyanapaq supporters' comments at the event and, recalling some
of what I had been hearing from others within the project, if he thought the
LUM might be viewed as diminishing the achievements of those involved
in Yuyanapaq and the TRC. He replied by saying that "unfortunately," the
disagreements were not personal but "conceptual."

[A Yuyanapaq/TRC supporter in the meeting] said that she isn't inter-
ested in reconciliation. . . . *It's not my matter* (in English). "The work is
showing what happened."
And that is a profound difference. Because that means: "I do things
according to what I think and I don't care about the results." . . . If

what I do only serves to convince those who are already convinced, I don't care. . . . Could you make a museum that only victims' associations and NGOs would go to?

Here Fernando expressed the view that Yuyanapaq advocates were satisfied with little more than a repetition of the TRC's ritual work at the LUM, even if it meant that sectors opposed to or indifferent to the truth commission's findings and narrative would remain unswayed. As part of his discourse emphasizing the need for reconciliation, Fernando cited what he perceived to be a reluctance among many in the human rights community to engage in dialogue with the armed forces. Activists' hesitation in using words such as "terrorist" and "terrorism" was another example of the kind of academic posturing that only served to alienate a large number of Peruvians (see chapter 6 for later discussions about this term).

"Not preaching to the converted" and "widening the consensus" represented key concepts when it came to the type of image the LUM should project. Where Fernando saw "reconciliation," however, critics of the museum-in-progress often saw cowardice and a reluctance to take on powerful forces in Peruvian society that the TRC challenged. It would not be an exaggeration to say that he and others at the LUM initiative could be more frustrated by the mind-set of would-be allies in the human rights movement—those who accomplished brave and important work during the TRC, but who seemed unwilling to acknowledge that times had changed—than they were in dealings with entities such as the military or police, who could be more clearly identified as cultural and political others.

Although Fernando knew how to play to his audience well (interviewers being no exception), I did not doubt that these issues troubled him. Nor did I view his praise for Yuyanapaq and the TRC as insincere. In conversations and public events Fernando would often make comments like, "Yuyanapaq showed us the war we didn't want to see," and emphasize the crucial role that the TRC played in countering the savior narrative of the war that he found repugnant. "Ten years ago you had to hit directly against an obstinate, denialist [*negacionista*] sector of the society that exalted what was done by the successive governments," he told me in the April 2013 interview.

It was also apparent that Fernando's position, though perhaps not an official one, was consistent with the LUM's behavior as an institution. For example, the authorized guidelines for the project, drafted by members of the High-Level Commission shortly after they were appointed in December 2011, stated that "the *Final Report* of the Truth and Reconciliation Commission is the established document for Peruvian legislation dealing with the effects of the terrorism. . . . Our Commission assumes said report as a principal referent, *but it will not be the only one*" (emphasis added). This

bullet point is found between one referencing collaboration with relevant police and military institutions and another declaring that the museum "Will avoid equating the actions of the Armed Forces or the Police with those of the terrorist groups," a stance that appeared to respond to right-wing critiques of the TRC. Yuyanapaq was not mentioned once in the three-page, single-spaced document. Ledgard, Hibbett, and de la Jara (2018:23), offering a close reading of these guidelines in their retrospective account, note the "explicit displacement" of the TRC's conclusions in plans for the museum project.

While the LUM's official positions and the rhetoric of Fernando tended to invoke the image of a TRC loyalist who was stuck in the past, it was not the case that members of the human rights community came out exclusively in favor of a Lerner-like, pro-Yuyanapaq position. Perhaps the most prominent example of a differing viewpoint came in Sofía Macher, a former TRC commissioner who, like Lerner, remained influential in discussions about human rights and the war's aftermath. In a talk Macher gave at the "TRC+10" conference in August 2013, which marked the ten-year anniversary of the TRC *Final Report*, she asserted that she did not believe the LUM should be "a repetition of the Truth Commission." Delivering these words before a large number of activists and academics in attendance, the longtime president of Peru's Reparations Council (Consejo de Reparaciones) added that she did not even think that the TRC *Final Report* needed to be in the museum as such. Instead, Macher suggested, "we ought to make an effort that will be one more step in the construction of a collective memory." She elaborated on these points in a question-and-answer session that followed her prepared comments:

> The situation is that with the Truth Commission, when it presents its *Final Report*, we—by mandate—are on the side of the victims. Our mandate is to document what happened to the victims. So, for us, Shining Path, MRTA, and the armed forces, police . . . all are aggressors. So, I think what the Place of Memory wants to do . . . I think, I assume . . . is say "this needs to be changed, right?" One needs to turn this around a little and say that the Shining Path and MRTA militants are the bad guys and the military and police who won the war and are the good guys.

In interviews I conducted with her before and after this presentation, Macher exhibited a similar outlook on the LUM. She had had some interaction with the institution, mentioning, for instance, her "lobbying" (she used the English word) to have digitized recordings of the TRC public hearings available to the LUM's visitors. Fernando and others involved in the LUM counted Macher among the project's allies.

Speaking with me at her home in Miraflores, Macher described the LUM as "part of a process" that included but was not limited to the TRC. "If we're talking about the construction of a collective memory about the conflict in Peru, we're talking about political negotiation, we're talking about power." Referencing the museum initiative, she noted that, "It seems legitimate to me . . . maybe not legitimate . . . but *inevitable* that you have to make concessions." Macher emphasized that any "scandal" concerning Yuyanapaq and the LUM should have taken place at the time of the architectural competition, not then (in 2013). She criticized Lerner and others who seemed to oppose the LUM "simply because Yuyanapaq isn't there."

Macher was not an outlier in the human rights community, at least not when it came to her disappointment at the way TRC supporters had represented their concerns in the early days of the LUM initiative. For example, Rocío Silva Santisteban, the poet and literature professor who had served as executive secretary of the National Human Rights Coordinator (Coordinadora Nacional de Derechos Humanos [a consortium of human rights organizations]) since 2010, expressed little sympathy for those who seemingly underestimated the LUM's political nature: "What happened was that in that first moment, it was claimed, among certain sectors of the human rights movement . . . the most, let's say, traditional sectors . . . it was claimed that the Place of Memory was the victims' space, the human rights movement's space. I have always been clear on this. The museum of memory is a space of the Peruvian state." After noting the existence of powerful sectors in Peru that advocate for a salvation narrative focused on "excesses" rather than "systematic abuses," and suggesting that those interests would not necessarily be excluded in the making of the LUM, Silva Santisteban emphasized that although she felt that general consistency with the TRC was important, the notion that the human rights movement would be deciding the museum's contents was "completely false."

Another well-known member of Peru's human rights community, who preferred to remain anonymous, had even less tolerance for a perceived lack of pragmatism and political savvy on behalf of those committed to having Yuyanapaq be the core of the new museum. An attempted repetition of a TRC-like ritual at the LUM was, for him, symptomatic of a certain part of the human rights community "[closing] itself off by saying "the truth" is what we have obtained [in the TRC]." Mentioning that Peru's president (Ollanta Humala) was a former military official whom he was convinced "ordered disappearances of people," the activist criticized the politically-naïve logic (*lógica totalmente antipolítica*) of some of his peers in the human rights community when it came to the LUM.[8] Moreover, he expressed disapproval for what he viewed as Lerner's and others' tendency to consider the

TRC as a kind of infallible foundational ritual in such discussions. "So the [TRC] *Report* . . . the *Report*'s methodology . . . the *Report*'s figures . . . the truth is the *Report*," he noted sarcastically. "And Yuyanapaq, what's more, was this great cultural product."

The gist of such comments was something along the lines of, How could Lerner and others have been so seemingly unaware of the fact that the LUM was *always-already* about politics? The second, related question seemed to be, How did Yuyanapaq advocates not realize that they were no longer in the fortuitously exceptional moment of transition (e.g., Root 2009) that made the TRC politically possible? Those who raised such issues did not care to hear the stories about the architectural competition; in their view, Lerner and his colleagues should have known better.

The position expressed by these members of the human rights community was premised on a recognition of ways that Peru's political landscape had changed since the time of the TRC. Even if such individuals did not dwell on perceived errors or misexecutions in the TRC rite (e.g., controversy surrounding the *Final Report*'s figures), they considered it important to acknowledge the extent to which critiques of the truth commission had made their imprint on national discussions.[9] Whatever one once thought of the TRC's or Yuyanapaq's potential to transform Peruvian society, there were constant reminders that powerful sectors still rejected core elements of a human rights memory. There was also much to suggest that the ritual work that disseminated this narrative was limited to a particular social and historical context. Advocacy that appealed to the special or timeless qualities of Yuyanapaq, therefore, was at best politically naïve and—perhaps more troublingly—represented a missed opportunity for the human rights community to influence the LUM.

A RESOLUTION?

Something of a resolution to the Yuyanapaq issue was reached toward the end of 2013. It became clear that LUM officials would not try to shrink Yuyanapaq or transfer a portion of it to the new museum, and steps were taken to extend the TRC exhibit's lease at the Museo de la Nación to the year 2026, a decision announced in December 2013. Following these developments, some of Yuyanapaq's supporters would take solace in the fact that, in spite of all the drama surrounding the LUM, human rights advocates would now have "two spaces instead of one" in Peru's capital. Others, including Lerner, were less convinced.

In an interview I conducted shortly before the Museo de la Nación agreement was made official, Yuyanapaq co-curator Mayu Mohanna expressed qualified approval of the decision. She was pleased that Yuyanapaq would not

be closing and agreed, in a general way, with the "two spaces instead of one" sentiment. "Good luck, bad luck, who knows?" Mohanna said, quoting a Chinese proverb to describe the outcome of the LUM-Yuyanapaq travails. Still, Mohanna emphasized, her outlook on the situation would be very different if Keiko Fujimori or Alan García were to assume the presidency in 2016 and remove the exhibit from the Museo de la Nación (a plausible scenario at that time).

Even before the arrangements to safeguard Yuyanapaq were finalized, LUM president Diego García-Sayán could tell me in a September 2013 interview that Yuyanapaq's relation to the museum project, for him, "[wasn't] a controversial topic, it's a simple, logical matter: there is room, or there isn't room." He claimed that he had "never lost sleep over" the TRC exhibit, because the terms of the debate were already set when he and the current High-Level Commission came to the project. After saying a word about Yuyanapaq's significance and pointing out that they were taking relevant steps with the Museo de la Nación, García-Sayán added that he was somewhat puzzled by the "polarization" that some wanted to create around the issue: "It's like someone wanting us to store an elephant here in this room (his office in the Andean Commission of Jurists [CAJ]). There's nothing to discuss in this respect because the elephant won't fit."

The latter part of 2013 also witnessed the rise of a clearly defined institutional position at the LUM with respect to Yuyanapaq and the TRC. The truth commission and its exhibit would be represented as "historical milestones" (*hitos históricos*) in the new museum—a vision ultimately borne out in the museum's permanent exhibition (see chapter 6)—and LUM representatives became more explicit in framing the project as a post-TRC enterprise. Some of the project's officials spoke of a need to "strip [themselves], a little, of the TRC's armor and look toward the future" (Ideele 2013); others noted, rather plainly, that the LUM was "not a TRC museum." The declarations almost always incorporated some level of praise for the truth commission and its impact ("Yuyanapaq changed the way we viewed the violence," "the TRC *Final Report* is the most comprehensive account of what happened," etc.). These expressions of approval, however, were inevitably qualified by phrases like "ten years have passed and the moment is different now." A key discursive effect of the caveats and qualifications was a subtle but firm dismissal of the notion that the TRC and Yuyanapaq's ritual work could serve as a basis for the new national museum. Displaying the previous rite as a historical milestone at the LUM would reinforce this dismissal, positioning the museum as an initiative that could encompass (rather than merely complement or serve as a continuation of) the TRC's work.[10]

CONCLUSION

Always at the center of the debate about Yuyanapaq's potential inclu-
sion in the LUM was the question of whether the Peruvian TRC should be
viewed as a historical source or as a historical event, *as* the archive or as *part*
of the archive (Hunt 2004).[11] For the LUM initiative, a small but significant
departure from the TRC became the order of the day, even as the circum-
stances that resulted in Yuyanapaq not fitting in the new museum (concep-
tually or physically) were historically contingent. Lerner and his team left,
and supporters of Yuyanapaq came to view the LUM as something distinct
from, and perhaps at odds with, the TRC. Within the museum project, it
became increasingly convincing, with the passage of time, to narrate the
Yuyanapaq dispute as belonging to the LUM's distant past.

It is tempting to use the LUM-Yuyanapaq case to call attention to how
truth commissions contain the seeds of their narrative destruction. As insti-
tutions, they produce comprehensive historical accounts and moral messages
for the nation, but there is a way that commissions' finite period of activity
can abandon the people and artifacts through which they accomplish such
tasks. Individuals' proximity to the truth commission can make them suscep-
tible to allegations of moral superiority or self-righteousness.[12] And the repre-
sentations these individuals produce can lose their potency and come to stand
as much for the commission's shortcomings or lack of fit with present-day
realities as they do for the hopeful, anticipated future associated with a past
national ritual.

A more nuanced reading of the discussions surrounding Yuyanapaq and
the LUM, however, reveals that a number of individuals who disagreed with
the notion that the TRC photo exhibit should be the centerpiece of the
national memorial museum did not view Yuyanapaq or the Peruvian TRC as
"failed rituals" as such. Rather, they considered these productions to be con-
text bound. Fernando acknowledged that Yuyanapaq "showed [Peruvians]
the war [they] didn't want to see"; Macher recognized the meaningful impact
of the TRC, but did not think that the LUM should be "a repetition of the
Truth Commission." Taking Yuyanapaq as the basis for a museum to be
inaugurated in 2015 was, for such observers, a "misapplication" (Austin 1962):
an infelicitous attempt to take what was an appropriate rite for a certain con-
text (Peru at the time of the TRC) and apply it to another.[13] Especially when
they were expressed from positions of power and influence, such assessments
had the potential to shape the post-transition aftermath they described.

An additional feature of the LUM-Yuyanapaq dispute worth emphasiz-
ing relates to how representatives of the museum project came to define
(and ultimately marginalize) the bearers of a historical perspective by way
of the "negative" regulation of that vision. That is to say, for much of the

project's history, officials and representatives claimed a certain authority through criticizing alleged desires to "repeat the truth commission" or "stay in the year 2003" rather than through the positive articulation of a coherent post-TRC position. This was the case even as "adherence to the TRC" always existed as a relative rather than absolute condition (no one, not even Salomón Lerner, wanted *only* the Yuyanapaq photo exhibit in the new museum).

As the following chapters illustrate, a desire to "go beyond the TRC" would mark the LUM project's trajectory in crucial ways. The implications of an emergent post-TRC identity were particularly evident in the initiative's interactions with two key sectors: victim–survivors and armed state actors.

CHAPTER 4

"There Isn't Just One Memory, There Are Many Memories"

MAY 19, 2013: I arrive in the city of Ayacucho in the morning by bus. Cruz del Sur is the name of the bus company. It is one of the handful of names that inspires trust among Peruvians, with riders paying a premium for consistent service and assurances that drivers work in shifts and are given breathalyzer tests. Bus crashes are common on Peru's mountain roads, with "driver error" being a cause often cited. Concerns over security extend to one's fellow travelers, and Cruz del Sur staff perform a perfunctory screening—in my case, briefly peering in a backpack and lightly patting me down—before passengers enter the bus, where they are filmed in their assigned seats by a man with a handheld camera who moves briskly up and down the aisle.

The company-run bus station in Lima on Javier Prado was filled with its usual clientele the night before: young backpackers from Europe with varying amounts of experience in the country, some mountaineering types, and Peruvians (many of them middle-class or from the upper echelons of provincial cities) returning home from the capital or heading out for business and tourist excursions into the country's interior. The nine-hour ride itself had the delights one becomes accustomed to when traveling on luxury double-decker buses through the Andes: a promotional video that encouraged Peruvians to experience their country's diverse regions and cultures, a punch-card Bingo game, and a second-rate American film dubbed in Spanish.

Arriving in the regional capital (also known as Huamanga), I look forward to the social aspect of the trip even if my goals as a researcher are not as well defined. At this stage of my fieldwork I feel more comfortable and socially connected in the highland city—where I conducted my MA research on the Museo de la Memoria de ANFASEP in 2009, and returned in 2010 and 2011—than I do in Lima.

A few months later I will come across a brief report written by a representative from the LUM. Commenting on the ANFASEP museum, a small memorialization initiative that was inaugurated in 2005 through the efforts of

ANFASEP (National Association of Relatives of the Kidnapped, Detained, and Disappeared of Peru) and a German development agency, the author remarks that the museum "does not offer a balanced vision of the violence our country experienced." Describing the museum's texts and chronology as "rigorous and precise," the report suggests that a site such as this one, established by relatives of disappeared persons, "intrinsically has a bias that is not favorable to the recognition of all victims."

June 21, 2013: I ride with Fernando Carvallo from his Miraflores condo to downtown, where he has been working part-time at a position in the Ministry of Foreign Relations that he will take after officially leaving the LUM by the end of the month. He has been using a private driver lately, it seems. Planning a trip for the weekend, he asks the chauffeur—a middle-aged man whom Fernando tells me is former military—about good bus companies (Cruz del Sur, Ormeño, etc.) that offer trips to Ica. At one point during the car ride, Fernando instructs us to be quiet so we can hear the latest news on the radio about a horrific bus crash. The bus driver had reportedly fallen asleep at the wheel (who really knows?). The vehicle went off the highway and plunged into the Tarma River in Junín. Thirty-five are confirmed dead, the report states.

We arrive downtown and Fernando and I continue speaking informally about issues related to the LUM as we make the short journey on foot from the parking lot to his office. The Yuyanapaq disagreement comes up. Something I should take into account, Fernando suggests, is how these Lima disputes have little relation to what is going on in the rest of Peru—in the Andes, for instance. "We are a fragmented country," he declares, adding some critical musings about sectors in the capital that purport to speak for certain types of victims.

Then, up ahead on Jirón Ucayali, we see a woman in her thirties take a horrible fall, her feet slipping out from under her. Wearing a black dress and pointed-toe black high heels, the woman looks to be a professional who was on her way to work. The early morning *garua* (mist) must have made the pedestrian-only walkway more slippery than usual. Sitting on the ground, her male companion and others trying to comfort her, the woman has a look of pure anguish on her face. There is no tinge of embarrassment, and the woman does not engage in the apologetic and self-deprecating gestures that are commonly employed in the United States to save face in such situations (shaking one's head and saying something like "I'm so clumsy"). There is just the pain of having dropped to the ground. Three or four people approach her; one of them is a man who brings a plastic flask of rubbing alcohol for the cut on her left hand.

Fernando and I stop as well. He asks her twice if she is okay. She does not respond either time. Fernando invites her to his office building where

she can sit down and have a cup of coffee if she wishes. Again, no response. We decide to move on, not wanting to add to the small crowd that is gathering around the grimacing woman.

The opportunity to connect this occurrence to the topic of our conversation is not lost on Fernando. Maybe she does not want to be a victim. Maybe she does not want our help or our attention. He refers back to the potential lack of correspondence between Lima-based discussions about managing the memory of the armed conflict and what people in Ayacucho might want.

This chapter examines the LUM's encounters with two groups whose participation was considered vital to the success and institutional legitimacy of the national memorial museum: victim-survivors and the armed forces. My analysis is informed by Didier Fassin and Richard Rechtman's (2009) genealogical study of the trauma concept, which traces the recent historical emergence of the traumatized victim as a figure who embodies experiential truth and commands moral recognition. Fassin and Rechtman (2009:28) argue that a key consequence of trauma's arrival—a development they attribute to social phenomena of the 1970s and 1980s such as the suffering of Vietnam War veterans and feminist critiques of psychoanalysis—is that "authority to speak in the name of victims is now measured by the speaker's personal proximity to the traumatic event." The logic of trauma, though validating victims' experiences, typically does not account for the differing positions subjects occupy in relation to the traumatic event. Moreover, doubts concerning victims' sincerity or authenticity are typically muted in trauma-informed discussions (2009:77).

In the world of memorial museums, the participation of victim-survivors (and in some cases, veterans) responds to discourses and assumptions about trauma that Fassin and Rechtman historicize. Edward Linenthal's (2001:xv) landmark study of debates surrounding the United States Holocaust Memorial Museum, for example, reflects critically on how phrases like "survivors think" and "victims were angered by" positioned victim-survivors as a kind of "voter's [bloc]" endowed with unquestionable moral authority when it came to certain decisions about the museum's content (e.g., the display of human hair in the permanent exhibition).[1] Similar concerns over discursive authority and the place of expert knowledge have come to the forefront in other types of museums in recent decades (Shannon 2014), particularly as memory discourses (Arnold-de Simine 2013) and the new museology (Message 2006) have made their imprint on museum practice. Some observers might point to museums as key sites where "appeals to the ontological primacy of victimhood or suffering" are displacing notions of objectivity and neutrality as a mode of depoliticizing debates about inequality, exclusion, and representation (Jeffery and Candea 2006:289).

I find Fassin and Rechtman's insights concerning the rise of a new "victimology" convincing, and especially useful for interrogating the assumptions that guided the LUM's efforts to include perspectives from victims' organizations and sectors of the armed forces ("all of the victims," as we recall from chapter 1). My specific focus in this chapter is on situations where this valorization of experiential authenticity produced contradictions, relations of distrust, and forms of regulation—in short, instances where the accusation of egotism and insincerity retained its force. The LUM was not a museum initiative defined by principles of decolonization where rural and indigenous victim-survivors would be described as "experts" or become cocurators (Shannon 2014).[2] Representatives of victims' organizations, cognizant of the image of the subjective, self-serving victim, displayed a sensitivity and openness to a plurality of experiences as they struggled to engage with the LUM project on the institution's terms.[3] LUM workers and decision-makers, for their part, were wary of repeating a Truth and Reconciliation Commission (TRC) model they perceived to be overly centered on victim experiences, and expressed concern over what they viewed as the conceptual and practical difficulties of taking into account the emotionally charged perspectives of this group.

Military participation, considered a core feature of the museum project's post-TRC identity, presented a different but parallel set of conundrums. As I conducted fieldwork in 2013, it was apparent that expressions of military victimhood could be subsumed within prevailing, trauma-focused logics of memorialization while "heroism" would require bracketing and containment. Planners generally considered this latter sentiment biased and potentially problematic but, consistent with notions of neutrality and inclusivity, acknowledged a need to depict military valor *somewhere* in the national museum.

I conclude the chapter's discussion by reflecting on crucial differences between the nature and contours of military and victim-survivor interactions with the LUM during this stage of the project's history. I also spotlight how representatives from these two groups came to embody the excesses of the salvation memory and human rights memory camps that the national museum project sought to define and encompass.

DIFFICULT EXCHANGES

"Well, at first we said, 'why do they want to make the museum there [in Lima]?' Because the violence mainly took place in the provinces." Adelina García, president of ANFASEP, spoke with me at her home, a concrete building on a dirt road in one of the outlying districts of Huamanga. Our conversation took place ten days after I had arrived in Ayacucho on the Cruz del Sur bus. "Why not instead of doing this, the different departments

[regions of Peru] could do it? . . . But in the end we realized that yes, there should be memory there [in Lima] as well, and maybe not a lot of people can make it out [to the provinces]. . . . So maybe the people who cannot come to Ayacucho can visit that museum."

García is a founding member of ANFASEP, joining the organization following the December 1983 disappearance of her husband, Zósimo Tenorio.[4] She was nineteen at the time and remains one of the younger members of ANFASEP. The organization leader wore a purple cardigan over a black sweater that day as we talked at her dining room table. She periodically rubbed her hands together during the interview, with her squinted, kind-looking eyes often gazing down toward the black surface of the table, where there stood a thermos and a jar of Altamayo brand coffee.

"We have asked for a site, a bit of space that maybe [the LUM] can give us, as ANFASEP we can put some photos there and other things." It was not a formal request in writing, she clarified, but they had been asking for this "since the [LUM] began, years ago" and "they have never communicated anything to us." Indeed, during the initial stages of the project, shortly after the German donation controversy, Adelina offered the following reflections on the national museum in a special issue of the journal *Argumentos* (2009) that solicited ideas for the LUM:

> Here we have suffered in our own flesh. There are thousands of disappeared, thousands of people who were murdered by Sendero or by the military. In that museum [in Lima] they need to put the facts of what happened. . . .
>
> Maybe we [*nosotras*] should also offer there some of the experiences that have happened to us, having some space with the ANFASEP name—maybe two or three meters in that space [of the national museum]. To show how the mothers suffered during that time, with that violence, to tell the mothers' stories. Here [in Ayacucho] we don't have a big space, we have objects that still have not been put in our museum. (Argumentos 2009:40)

Adelina was president of the organization when she made these comments in 2009 and was ANFASEP's official head again in 2013. I had seen her a few months before in Lima at a LUM-sponsored event that featured representatives from various museums and memory sites throughout the country. The goal was for the institutions to "share experiences" with one another, with the LUM also benefiting, in theory, from learning about the successes and difficulties of local and regional initiatives. Few real decision-makers from the national museum project attended the event, which took place at a small hotel in Magdalena del Mar operated by the German philanthropic organization that provided funds for the participants' food, lodging, and bus

tickets. Adelina wore traditional Huamanguina dress for the Lima gathering—a brimmed hat with a white band, a rayon blouse, and a pink shawl—and looked more like one of the senior members of ANFASEP (perhaps strategically so) than she did when I first interacted with her in 2009.

Her presentation centered on the Museo de la Memoria de ANFASEP: its history, the types of people who visit the museum (mostly local school-children and Peruvian and foreign tourists), and the challenges it faced (lack of funding, upkeep of the exhibition, etc.). She provided a short summary of the museum's contents, mentioning pieces like the banner that ANFASEP used in its early marches to denounce war-era abuses, a short note written by the disappeared son of Angélica Mendoza de Ascarza (ANFASEP's iconic founder, who was widely known as Mama Angélica) shortly after he was detained, and a reproduction of a torture room. The presentation also included a short video that dealt with La Hoyada, the land adjacent to the infamous Los Cabitos military base that had been proposed as a memorial site. In addition to offering a glimpse of the significance of this place for family members of the disappeared (a large wooden cross had been erected there), the video illustrated how the integrity of the site was being challenged by recent settlements (Rojas-Perez 2017).[5] As a concluding note, Adelina deferentially inquired—as she had before—about whether it would be possible for there to be a small space in the LUM dedicated to ANFASEP, perhaps with some photos or articles of clothing. They had asked for such a space long ago, she stated.

ANFASEP members had grown accustomed to waiting on, and expecting rather little from, the government officials and institutions with which they engaged. As scholarship on memory activism in the Peruvian Andes has illustrated, the accomplishments of victims' organizations have often been associated with appeals and representations that position them as "deserving victims in need of outside help" (Weissert 2016:301) or as the embodiment of "proper" victimhood (Theidon 2013).[6]

The delegation's disappointment with the dismal attendance at the event that day would be transmitted to me only later, and indirectly, by an ANFASEP member I spoke with in Ayacucho (*"Para cuatro gatos han hablado"*). That experience was not atypical, however. Adelina told me that ANFASEP representatives had been invited to several events organized by the LUM over the years. They always participated—even if it meant making the trip to Lima—though she felt it would have been better if the museum project had started working directly with *afectados* (the affected) earlier. "Even the museographers, the professionals, get confused."

The activist's comments also evinced a subtle awareness of ANFASEP's status as the emblematic victims' association in the region. ANFASEP is an organization that is mentioned extensively in the TRC *Final Report*, one

that has historically received recognition and support from international NGOs, and one that has been the subject of numerous scholarly publications and student theses. The group's prominence has generated a certain degree of tension over the years. As an experienced, Ayacuchano NGO worker put it, "Who represents victims for the Place of Memory? In Ayacucho, it's ANFASEP, the executive committee of ANFASEP . . . nothing more." Even the Museo de la Memoria de ANFASEP, which is widely recognized for its historic and symbolic importance, is critiqued by some sympathetic observers for what they perceive as excessive attention to ANFASEP's history as an organization (Feldman 2012; Milton and Ulfe 2011). Cognizant of such concerns, Adelina and other ANFASEP activists with whom I spoke emphasized that the La Hoyada sanctuary project involved a number of other victims' and human rights organizations in the region and that it would not center on their own experience as an association.

When I asked about the types of messages the LUM ought to present, García first emphasized the importance of reaching young people and adolescents, alluding to MOVADEF's troubling inroads among this demographic. She later referenced the value of reaching "Limeños who often didn't really live the violence." They too "need to reflect [on the war], not just about the role of the terrorists but also the role of the state," Adelina asserted.

These aspirations intersected with objectives and justifications typically offered by workers at the LUM. It was evident, however, that the institution's creation would also be informed by critiques of the Peruvian TRC (and its victim-focused representation), along with contemporary discussions among scholars and activists that frequently referenced the need to consider "gray zones," and the blurriness of categories of victim and perpetrator.[7]

Heeder Soto, a founding member of ANFASEP Youth (Juventud ANFASEP), emphasized the relative lack of dialogue between victims' organizations and the LUM, calling attention also to the terms on which the museum project interacted with different sectors. In his thirties, Heeder was one of a number of ANFASEP Youth activists who became influential in regional victims' and human rights networks. An artist and anthropologist by training, he contributed to the process of making the Museo de la Memoria de ANFASEP and, in recent years, had sought to combine his artistic and intellectual talents as a documentary filmmaker. He had also traveled to Cambodia, Colombia, and Kosovo as part of programs focused on memory and transitional justice.

At the time I began my fieldwork, Heeder was living in Lima, renting a second-floor apartment in Chorrillos. He was a regular attendee at memory-related events in the city and, early on, Fernando Carvallo named him as someone who "it would be important for [me] to talk to." Heeder and I had been meeting up socially from time to time during my first few months in

Lima, sharing developments from our respective projects (he was working on a documentary) and comparing notes on the LUM. He was an unpaid "advisor" for the museum project, but downplayed the significance of the title. He told me that aside from some interventions at events and a few informal meetings with LUM representatives, he had done very little to contribute to the initiative.

Heeder felt that the LUM should be a space for "all of the memories" to be displayed even if, "academically-speaking," some had greater veracity than others. He viewed the museum project's overtures to the military and police as positive developments, for instance, but noted the glaring omission of former members of militant groups in the museum project's outreach efforts. When pressed about what kinds of messages the LUM ought to present (Heeder told me he preferred to ask such a question rather than put forth his own views), he would underscore indigenous Amazonian experiences, describing Peru as an "Amazonian country." There would also be significant emphasis on the historical conditions that contributed to the rise of Shining Path, along with post-TRC developments such as victims' struggles for reparations and the MOVADEF phenomenon, in Soto's LUM.

Over time, Heeder became frustrated with his irregular contact with the institution. Although he was effective in providing the kind of critical commentary he felt was lacking in meetings and events, he noticed that LUM representatives would keep him at arm's length when it came to certain discussions, such as the opportunity to meet with members of a foreign delegation. As one LUM employee put it, Heeder was seen as "someone who is important for the human rights associations because he's very well connected and his opinion is listened to." Perhaps above all, the worker told me, people at the LUM knew he could be "reactionary" and wanted to have him as an "ally" rather than as an "enemy." Without referring to Heeder specifically, an anonymous LUM worker once related to me that people from Ayacucho and the Andes often sought to "gain something" (*ganar algo*) in their dealings with Limeños, and this phenomenon was evident in the context of the national museum project.

Heeder's inconsistent contact with the institution likely reinforced the activist's view—one expressed in a paper he presented in Colombia on the "Elite-ization of Memory in Peru"—that projects like the LUM were only interested in victims as testimony givers, as opposed to knowledge producers in their own right. This would be a major theme in one of Heeder's last efforts to engage with the project, a debate he organized between Fernando Carvallo and Gisela Ortiz, a well-known human rights activist whose brother was a victim of the La Cantuta massacre in Lima.[8]

At that July 2013 event—which took place in a classroom at the Antonio Ruiz de Montoya University in Pueblo Libre—Ortiz challenged Carvallo

on several points, recalling some of her early encounters with LUM repre-
sentatives and stressing that victim-survivors' perspectives had not been
accounted for in any meaningful way by the project. She asserted that victims
should be a "fundamental part" of the decisions being made at the institu-
tion. "And when I am talking about victims," she added, "I'm not just talk-
ing about victims of state forces; I'm also, of course, talking about those who,
being part of the state—among them police officers and soldiers—who became
victims in the course of this conflict." Ortiz listed a diversity of experiences
to consider, including those of relatives of the disappeared, women who
were sexually assaulted, displaced people, survivors of torture, and child sol-
diers. "We're all thinking people; we can contribute something," she declared.
"We know that the idea of this museum is not that we'll go there and visit
[as relatives] and feel represented there, but that those who don't know the
history will go, that young people go, that high school students will go and
ask themselves, 'What happened in the country?'" Whereas Fernando had
reminded the audience that the LUM was not a "memorial" and that victim-
survivors were one among several groups with which the project had to
maintain a dialogue (mentioning donors, artists, intellectuals, and different
entities of the Peruvian state), Ortiz's discourse was consistent with what
seemed to be one of the unstated requirements for victim-survivor participa-
tion in the LUM initiative: victims needed to make it clear that they could
see beyond their subjective wants and experiences.

Some weeks earlier, a middle-aged Ayacuchana interlocutor I inter-
viewed made sense of the lack of victim-survivor participation at the LUM
in the following way: "They think that we talk just to talk. For example,
[there is the notion that] if I'm speaking about the military, I'm speaking
because I have hatred for them, or that I'm not being analytical. . . . That
we're guided by hatred and resentment and all that." She suggested that
LUM workers and officials probably thought, "No, we can't have them par-
ticipate because they're afectados or children or siblings of afectados and
they will always act with partiality."

In a blog post written shortly after the debate held in the university
classroom, Heeder emphasized the lack of political power that victims had
in comparison to other sectors, such as the armed forces. The activist also
criticized the way the exhibition script draft had been "kept in secret,"
observing that "the first to find out about the script were foreign advisors"
(which was, essentially, correct). When I finally sat down to formally inter-
view Heeder in Ayacucho, this time during a second trip I made there in
September 2013, I was half-expecting him to launch into a scathing critique
of the LUM and all that it represented (centralism, intellectual elitism, and the
like). Instead, Heeder's perspective on his interactions with the national museum
was nuanced, even self-critical: "The most fundamental thing, I think, is

that it's a museum that is going to talk about the political violence, that is going to talk about cases of human rights abuses, but there is no direct participation of the victims. . . . It's a museum that is saying that it will be in favor of, or that it is going to speak about victims, but without entering into relations with them." He reflected on the ineffectual nature of most of the LUM events he attended, referring back to the meeting where Adelina presented on the Museo de la Memoria de ANFASEP:

> That too was palliative. It also confirmed that . . . they weren't inter-ested in the victims' presentations at all. . . . With that [event] you can take an image, or a summary, of the entire process that is going on. There wasn't any process of registering the [perspectives] that were coming out. This seemed absurd to me, even now.
>
> Now it makes me think too that I participated in this and fell into that, right? Because now, given more reflection, viewing things from here, that's what happened, right? That there wasn't respect for the things that [the participants] were saying.

According to Heeder, the LUM seemed to be saying "we're doing this, stay calm . . . and don't say anything more." Or, as Ortiz put it during the unof-ficial debate, the LUM apparently had as its final assessment: "We aren't going to enter onto a marshy ground where we really aren't going to be able to manage the discussion."

CONDITIONS OF DIALOGUE

What this "marshy ground" might look like remained uncertain, though it was safe to say that the figure of the emotionally charged victim framed imaginings of scenarios for dialogue. By mid-2013 it was unclear what the role of victim-survivors and other sectors would be in subsequent stages of the museum project. Responses from LUM officials were inconsistent. Some noted that they had already held a number of meetings with victims' organ-izations and other groups, implying that this process was more or less com-plete (they would neglect to mention the general lack of formal documentation of the perspectives expressed at such events). Others said it did not make sense to distribute the exhibition script until they had a complete draft. I knew there was international funding set aside for the purpose of sharing the docu-ment with groups from civil society, but with another leadership change on the horizon, it was difficult to envision what this might entail.

Pedro Pablo Alayza, the only member of the LUM's High-Level Com-mission with extensive museum experience and a passionate advocate for the notion that representing Peru's cultural diversity could be linked to goals of promoting social justice in the country, shared his perspective on the participation question in a June 2013 interview. Alayza supported the

victim-centered account of the TRC, was sympathetic to the position that the LUM should house Yuyanapaq, and thought the museum's permanent exhibition needed to situate the political violence within broader histories of racialized exclusion in the country. Above all, however, he stressed the importance of compromise.

"I try to transmit what I think is valid. But I also have to understand that I must force myself to accept things that I'm not 100 percent in agreement with." Alayza, the director of cultural affairs for the Municipality of Lima, noted the absence of an equivalent national museum in countries like Argentina and Spain, reminding me that memorial sites and museums in the United States "have sometimes taken decades to be made."

> So, I'm very realistic. If something can be done with certain concessions from both sides and a place exists . . . it would be, in my opinion, absolutely fantastic.
>
> My conviction, to do it this way, goes beyond my own intentions or desires. I need to overcome my own ideas, and my ideas can't take precedence over the common good. . . . I calculate the margin of which I consider to be tolerable or intolerable. Then, it's either "I stay" or "I go."

Alayza added the following statement concerning the possibility of further dialogue about the LUM exhibition script.

> I sincerely don't think that the [exhibition] script should be publicly debated. It doesn't seem like a good idea to me. Because it would be pandemonium.
>
> We have met with people from the armed forces, with the affected people . . . we've met with everyone. We've received information from everyone. . . . Opening this to a public debate, I don't think this should be done. Maybe it's the most appropriate thing to do, in broad terms, but if we want this to happen, [we can't].

"If we don't do what we need to do," Alayza told me toward the end of our conversation, "that site will become a *chifa* [Chinese restaurant] with an oceanfront view . . . or offices for whichever ministry is lacking work space."[9]

The discourses of LUM officials such as Alayza and Carvallo—which can be understood primarily, if not exclusively, in relation to these individuals' positions as representatives of an official museum project—could have the effect of reminding victim-survivors that they were one group among many, imploring them to recognize the state as a legitimate arbiter. More explicit declarations of this underlying logic can be found in memory debates elsewhere. Jens Andermann (2012a), for example, analyzes the rhetoric of center-left intellectual Hugo Vezzetti in discussions about the management of Argentina's notorious ESMA (Navy School of Mechanics) detention

center in Buenos Aires. Vezzetti criticized what he perceived to be victims' shortsightedness and self-interest in attempting to preserve the site as a minimally elaborated place of reflection. As Vezzetti's "very language of 'imperatives' and 'State decisions' [made] only too clear," Andermann (2012a:90) claims, "inclusiveness only comes about, and is subsequently warranted by, an institutional mandate granted by the State . . . that pre-establishes the limits of this very multiplicity." Victims and their relatives became constructed as bearers of a "partisan" memory who believed—wrongly, in Vezzetti's view—that they should have a monopoly on sites such as ESMA.[10]

A feature of the LUM initiative's initial exchanges with victim-survivors I have sought to underscore relates to how figures like Gisela Ortiz, Adelina, and Heeder, though refusing to be icons of experiential authenticity that the LUM might incorporate or co-opt through "palliative" events, nevertheless appeared to acknowledge and respond to the image of the biased, unreasonable war victim. Adelina and her ANFASEP colleagues only wanted two or three meters of space and a few photos in the LUM; Gisela Ortiz was "not just talking about victims of state forces" when she said the museum should serve as a symbolic reparation for victim-survivors; Heeder questioned the Andean core of the postconflict nation. This pattern coexisted with the rhetoric of LUM officials who reminded victims that they were one of a plurality groups, feared the potentially chaotic nature of open debate, and had the authority to say how much dialogue was enough. Planners and victim-survivors alike took pains to clarify that they did not envision the LUM as a temple at which relatives would come to mourn the dead and disappeared.[11]

MILITARY ENCOUNTERS

Exchanges with armed state actors presented a different, if overlapping, set of challenges for the LUM. Not unlike in the case of victim-survivors, the museum project aimed to capture the passions and narrative authority of this group even as LUM workers could be distrustful, and sometimes openly critical, of positions and worldviews associated with those sentiments. A discourse of neutrality among LUM representatives when it came to the management of different perspectives could also mask the significant power differentials between victim-survivors and the armed forces as consulted groups.

The issue of military participation at the LUM in a post-TRC political climate came up several times in my September 2013 interview with Diego García-Sayán, president of the LUM's High-Level Commission. As justice minister during the transition government of Valentín Paniagua, García-Sayán played a vital role in establishing the TRC. He also took the lead in expanding a program developed in the latter years of the Fujimori government that released prisoners wrongly convicted on terrorism charges (Manrique 2014).

As a result of this work, García-Sayán had spent much of the previous decade addressing accusations—from the tabloid press, right-wing politicians, and inquiring news show hosts—that he was a "terrorist liberator." He commanded respect in human rights circles and even García-Sayán's detractors would acknowledge his intellectual acumen. The commission head wore black-rimmed glasses, a light blue tie, and a white shirt the day we met at his office in Lima. Born in New York—the son of a Peruvian minister who was living in exile—García-Sayán played drums in one of Peru's earliest rock bands, Los Hang Tens. I was reminded of this rock-and-roll past when a call interrupted the interview and the Rolling Stones' "(I Can't Get No) Satisfaction" blared as the former minister's ringtone.

In addition to his post at the LUM, García-Sayán served as president of the Inter-American Court of Human Rights between 2010 and 2012. He traveled frequently throughout the Americas, he told me, and tried to take advantage of this by scheduling visits to memorial sites and museums in various Latin American countries. He had been to Chile's Museum of Memory and Human Rights three times, for example, but emphasized differences between the Peruvian experience and those of authoritarian rule in Southern Cone countries. García-Sayán also referenced a meeting he had with representatives from the United States Holocaust Memorial Museum:

> One of the things they were telling me at the Holocaust Museum, a minor thing, but from the practical point of view it is important. . . . What makes [the museum] successful? They gave me three reasons: First, where it is. It's on the Mall, and all of the people who come to Washington pass through there. . . . Second, that the Jewish community is there and contributes money that puts new energy into the topic. And the third reason . . . I had not expected it . . . the restaurant.

He smiled and compared this institutional scenario to the one they faced in Lima. "We don't have a good location" (he mentioned the lack of foot traffic and limited access to the site via public transport). "The Jewish community is not there—there isn't a community of anyone—the NGO community is there, and the victims community, but their influencing capacity is minimal." And there was no space for a restaurant. "So, that's the situation we're in." In light of these disadvantages, García-Sayán stressed the importance of having twenty-first-century technologies at the LUM and making it an interactive institution that would pull people in (*jalar mucho*), especially younger Peruvians.

At the time of our interview, there were rumblings in the human rights community that the LUM would present a triumphalist narrative that would potentially contradict the TRC's account. Concerned observers could point to meetings with representatives from the military and police reported on in

the national media, Vargas Llosa's guarantees that the "heroism" of armed state actors would be displayed at the site (see chapter 1), and for those who were in the know, the Yuyanapaq controversy (see chapter 3). Some saw García-Sayán's repeated calls for "rigor" and "objectivity" as code for ceding ground to the armed forces. Others were wary of language found in statements such as the LUM's expressed intention to "avoid equating the actions of the Armed Forces or of the Police with those of the terrorist groups."[12]

García-Sayán brushed off "gossip" he had heard on the subject of military participation in the LUM, explaining to me that this sort of chatter was normal in a "viceroyal city such as Lima." Power and reputation in the capital still often depended on news circulating within relatively small social networks, if to a far lesser degree than in the colonial era. "It's nonsense and it makes me laugh, because no one . . . no one . . . no one . . . has even insinuated, 'you should not put this, you should only put this.'" García-Sayán pointed to the many who died "doing what they had to do." There were others who were justifiably being accused, tried, and convicted, the lawyer added.

"This can't be viewed as a project against the police or against the military," García-Sayán stated matter-of-factly. "Because there, too, there are victims." He mentioned police officers killed by Shining Path, families left behind, and ex-members of state forces who suffered from war-related injuries. That was not to say that military and police-perpetrated abuses would be minimized in the LUM's representation. "They are historical facts, there's no way that these things cannot be expressed." García-Sayán used the first-person plural when describing "[their] conviction" that it was not through such abuses that Shining Path was defeated; he cited the role of intelligence work, the rondas campesinas, and societal resistance to the insurgent group.

"So, looking for that equilibrium and that objectivity is not [a matter of] placing oneself between the water and the oil to be comfortable," but accepting that the final product "probably won't express one hundred percent of what some on the extremes might want." He gave the example of the 1997 Chavín de Huántar rescue, to illustrate how such a balance might be struck:[13] "It's important that there are officials who decided to be volunteers for an operation [where] . . . the estimate said 60 percent could die—they were all volunteers. And they left letters [before the raid] that could only be opened if the person died. So that is important." Whether or not human rights violations took place during or after the raid—whether or not "Tito" was extrajudicially executed—could be left to the courts, García-Sayán stated. "[Juan] Valer didn't kill him because Valer was dead."

"This is part of a reality that the human rights discourse doesn't tend to incorporate." The result of such omissions, he claimed, was increased polarization.[14]

"DIALOGUES FOR PEACE" AND VIEWS
FROM WITHIN

Approximately six months prior to my interview with García-Sayán, in January 2013, an event took place that represented something of an intellectual coming-out party for the military. It was the presentation of the second edition of *In Honor of the Truth* (*En honor a la verdad* [CPHEP 2012]), a book published by the Standing Commission of Peruvian Military History (CPHEP).[15] The venue was crucial: the Institute of Peruvian Studies (IEP), a private research institution that supported numerous investigations on topics of memory, political violence, and human rights, and one that was the intellectual home of several researchers who contributed to the TRC. The military-produced report, which is subtitled *The Army's Version of Its Participation in the Defense of the Democratic System against the Terrorist Organizations*, is widely viewed as an institutional response to the TRC *Final Report*. There was no equivalent event for the publication of the book's first edition in 2010, and CPHEP, an entity that employs both military officials (some of them trained historians) and civilian researchers, had organized the forum with support from IEP-affiliated scholars. Also discussed that evening was Lurgio Gavilán's *Memories of an Unknown Soldier* (*Memorias de un soldado desconocido* [2012]), the testimonial account of a former child soldier in Shining Path who later served in the Peruvian military before becoming a Franciscan monk.[16] The book was published by IEP the year before and was already considered mandatory reading for those interested in the history of Peru's internal war.

Diego García-Sayán and other representatives from the LUM attended the "Dialogues for Peace" event. As he arrived, during Gavilán's presentation, García-Sayán altered his course to shake hands with a high-ranking military official from CPHEP who was in civilian dress. One of the CPHEP presenters made reference to the LUM—an institution they were in sporadic communication with—in her comments. Earlier that month LUM officials held a private meeting with Peru's minister of defense, the head of the joint chiefs of staff, and other high-ranking officials (the meeting was reported on in the national news media), though CPHEP represented a lower-level, less formal contact for LUM staff.

The first CPHEP representative who spoke about *In Honor of the Truth* connected his presentation with the event description's call to question a "tendency to impose a single memory of the conflict." He described the report as representing "the voice of those who, in those moments [of the Peruvian TRC], could have been called those who didn't have a voice" and referenced soldiers' fears of prosecution as a methodological challenge the research team confronted in their oral history work.[17] The uniformed panelist

closed his talk by quoting Desmond Tutu, "who was in charge of the South African TRC," he explained: "The truth hurts . . . but forgetting kills."[18] Later, responding to concerns expressed by academic historians at the event who suggested that *In Honor of the Truth* lacked self-critique on issues such as military-perpetrated human rights abuses and corruption during the Fujimori government, the representative read the following passage from the report (CPHEP 2012:311). It offers a tepid and ultimately partial acknowledgement of wrongdoing:

> The Peruvian Army laments that officials and sub-officials in its ranks have participated in acts not guided by the law, which has cast a shadow over the brilliant work of many of its members, who renounced life, their youth, and the warmth of their homes in order to end the terrorist scourge. In the same way, it thanks the citizens of our country for the shows of trust and affection for their soldiers and offers most sincere apologies for all of the wrong that some of its individuals may have committed against any citizen and the society in general.

Not mentioned in the official's remarks was that this passage is buried in a discussion about the infamous Grupo Colina death squad (active in the 1990s) that distances the armed forces from that group's actions or that the book, on the whole, offers no real acceptance of responsibility for the institutional and systematic nature of military-perpetrated abuses (Milton 2018:94–96).

A female member of CPHEP, focusing on epistemological challenges the team of researchers faced, asserted that "there is not *a truth* about what happened in those years between 1980 and 2000, but rather there are various truths." She cited the importance of "us working from the perspective of memory," mentioning a seminar she had attended on the subject. "This book, *In Honor of the Truth*, does not attempt to be an absolute truth. . . . We know very well that it's the military's truth, their version, their perspective, but it's also valid and needs to be listened to." Truth, in more scientific terms, could only come with time, she suggested.

The deployments of memory rhetoric by representatives from the armed forces were similar in effect to the Colombian military's appropriations of human rights discourse, so deftly analyzed years before by Winifred Tate (2007:256–289). Tate's ethnography illustrates how that institution evolved from viewing human rights as a "politically motivated war against them" (2007:256) to employing the concept in various arenas, including positioning military officials as victims of rights abuses and incorporating human rights language into psychological operations. In Argentina, Valentina Salvi (2015) has examined how military rhetoric about that country's Dirty War (1976–1983) has undergone a shift "from victors to victims" in recent decades. Since the mid-2000s, retired military officers, civilian supporters, and relatives

of individuals killed by guerrillas in the 1970s have mobilized around the slogan of "complete memory," demanding recognition for their "victims" in the name of "national reconciliation."

These phenomena notwithstanding, it is worth noting that some of the CPHEP presenters were less than savvy in their efforts to employ a language of memory and human rights. One representative asserted that atrocities committed by members of the military were "reflections" of Peruvian society as a whole (mentioning abuses committed during the Amazonian rubber boom and sexual violence perpetrated against domestic workers in Lima). This claim was sternly rebuked by an academic historian (Lourdes Hurtado) who specialized in the Peruvian armed forces. The same official expressed his view that the "bad ones" of the military were well known and being prosecuted, assuring the audience that, "if someone acted badly, in one way or another, it was due to his own judgment." The problem, according to the military official, was that "we have forgotten the good ones."

Despite such references to heroism and individual excesses—likely read as boorish by many in attendance—the event almost certainly fulfilled its intended function for CPHEP participants: legitimizing the military history commission as an interlocutor in intellectual and activist debates about memory and transitional justice in Peru.[19] Additionally, the event served as a site for rehearsing victimhood tropes that would eventually become a core feature of the military's efforts to engage with the LUM (see chapter 5). CPHEP-affiliated researchers emphasized *In Honor of the Truth*'s attention to the effects of the "counter-subversive war" on soldiers' physical and mental health. They also reminded attendees that most of the troops who served during the conflict came from the lower echelons of Peruvian society. Gavilán's depiction of hungry, poor soldiers stationed in emergency zones, along with his observations concerning the demographic similarities between Shining Path militants and rank-and-file members of the Peruvian Army fit well with a narrative of *militares'* plight. "Gray zones" was a term heard with regularity throughout the evening.

When asked about the LUM's contents in a radio interview the next day, Diego García-Sayán spoke of a "very important encounter" that took place the night before at the Institute of Peruvian Studies. Focusing on points of convergence between the two books presented, the LUM president said that the dialogue demonstrated "that there is not one truth, and that there are various perspectives, and one has to proceed constructing a truth with the goal of reconciliation." García-Sayán marveled at Gavilán— once an illiterate, Quechua-speaking child soldier—citing Nietzsche and at the military officer employing the words of Desmond Tutu. He asserted that the kind of discussion he witnessed the day before likely would not have been possible ten years earlier. The LUM was well positioned to take

advantage of these "new, much more favorable conditions" for dialogue, he added. García-Sayán later remarked that the museum needed to represent the "noble, heroic activity" of the majority of those who served.

Privately, opinions within the project were mixed. A LUM representative who preferred to remain anonymous, for instance, expressed the view that there simply was not much heroism to commemorate when it came to the armed forces.[20] One would not dare say so publicly, the worker added, but it was the police and the rondas campesinas who really won the war, with the military's role a supporting one at best.[21] The individual mocked the "obsession" military officials had with accusations of human rights abuses, along with the institution's glorification of the 1997 Chavín de Huántar rescue, an impressive operation to be sure, but one that took place long after the insurgent groups had ceased to pose an existential threat to the Peruvian state. Others expressed a pragmatic view regarding dialogue with the military, noting that it was necessary to "give them a space" in the permanent exhibition. Having meetings with this powerful interest group also meant that "they will not be able to say that they weren't consulted."

Although some at the LUM sincerely embraced the notion that the museum should take into account the perspectives of armed state actors and eagerly presented this engagement as evidence that the project was moving beyond the TRC's alleged divisiveness, workers also knew the LUM could potentially be shaped by political forces outside their immediate control. "The president [of Peru] is a militar" was a refrain I heard almost as often from individuals within the project as from concerned activists inclined to believe that the LUM would house a sanitized depiction of the political violence. "We have a militar as president and he has acted like a militar as president," a member of the LUM's curatorial team told me. While I found no evidence to suggest that Ollanta Humala was especially preoccupied with the LUM's progress at that time (or ever, really), the concern had basis in reality. Humala served in a conflict zone during the violence and had repeatedly fended off accusations that he was implicated in war-era abuses (e.g., Kernaghan 2009:288–289). As I moved forward with interviewing Peruvian military officials, Humala was attempting to push through a proposal for mandatory military service that many viewed as discriminatory (college students and those who could pay a hefty fine would be exempt) and making guarantees that none of the Chavín de Huántar commandos would go to jail.

My conversations with CPHEP representatives in 2013—including meetings at their headquarters at the General Base of the Peruvian Army (referred to colloquially as El Pentagonito)—reinforced a sense that the institution was grappling with how to best represent their interests to the LUM. On the one hand, CPHEP members consistently presented their

work as a modernizing force within the military when it came to discussions about the political violence. A representative described the commission's goal as "disseminating this part of history . . . with total transparency." If "errors" had been committed, he added, CPHEP needed to acknowledge them. He contrasted the approach of *In Honor of the Truth*'s approach with that of previous efforts that did not necessarily seek to whitewash history, he claimed, but perhaps "minimized this or that excess or defect." "The mentality now is a little more modern," he told me.[22]

Similar narratives of reform and generational difference could be found in descriptions of CPHEP's interactions with the LUM. The figure of García-Sayán served as a case in point. Whereas many in the military—and especially older-guard members—would reflexively dismiss the idea of a museum project headed by the former justice minister, CPHEP officials assured me, the commission was cautiously optimistic regarding the LUM's "neutrality" and the institution's apparent willingness to take military voices into account. Commission members also distanced themselves from self-appointed military spokespersons like former vice president of Peru, Luis Giampietri, who tended to view the LUM as little more than the latest scheme of the caviar left, and characterize García-Sayán as a clever, unscrupulous liberator of terrorists. The significant presence of female historians among CPHEP's ranks—visible at public events such as "Dialogues for Peace"—only added to this image of institutional change (Milton 2018:68–69).

On the other hand, as in the case of *In Honor of the Truth*, it was easy to find elements of a more conventional military narrative amid CPHEP members' references to themes of dialogue, memory, and reconciliation in my interviews.[23] One representative spoke of "victims who weren't so 'victim-like'" and the lawyers who had turned "dead terrorists" into "victims of the state." Others made appeals to military expertise and firsthand knowledge of the conflict—a common feature of armed state actor critiques of the TRC (Milton 2018)—while stating categorically that the armed forces "won the war." A female official expressed her puzzlement at what she perceived as a lack of recognition for this accomplishment. "It's sad because in no other part of the world, I think, except some countries where there have been military coups and open violence against civilians, has the military not received any recognition, at least symbolically, in a case where the pacification was a 'won war.'" Employing the suffering soldier trope (evident in accounts such as that of Lurgio Gavilán) as well as an association of military service with rural and working-class sectors (Hurtado 2006), she argued that it was "elites" who did not recognize soldiers' contribution to the war effort or the suffering that members of the armed forces endured. "In Yupanayaq [sic] it's the opposite," adding that the TRC exhibit made soldiers out to be the "wicked ones" and "looked for 'victims' and 'victimizers' . . . [when, in

fact] victims were everywhere. . . . How, in a state museum (the Museo de la Nación), is there going to be images that go against the image of [that state's] own army? It's a contradiction. No one wants for there to be some kind of censorship, just for them to be a little more proportional."

It was often difficult to surmise what, exactly, the military officials *did* want from the LUM, aside from general recognition of their heroism and suffering as an institution (I eventually discovered that LUM workers faced the same dilemma that I did as an ethnographer).[24] Still, there was acknowledgment among CPHEP representatives that the LUM had the potential to correct perceived shortcomings of the TRC and Yuyanapaq. And like virtually every sector I interviewed during the first half of 2013, CPHEP wished for greater transparency in the making of the national museum. "The truth is," stated one official, "I don't expect that that memory [depicted at the LUM] will speak very well of us. Hopefully I'm wrong."

CONCLUSION

A brief comparison of these two groups' participation at this stage in the LUM's history reveals the differential constraints placed on victim-survivors and representatives of the armed forces as interlocutors. These constraints had much to do with the inter-group inequities that notions of neutrality, inclusion, and civic dialogue tend to conceal (Fraser 1990).[25] Whereas conversations about victims' participation typically evoked the figure of the biased, self-serving testimony giver and prompted planners and victim-survivors alike to gesture toward plurality or the interests of a broader political community, these "rules of the game" did not apply as consistently to the armed forces. In the case of representatives like the CPHEP historians, LUM officials and workers tended to demand little reflexive awareness of others' experiences or of the partiality of military understandings. The adoption of memory rhetoric and the gestures toward changing institutional sensibilities were typically sufficient. Leaders like García-Sayán acknowledged that ideals of heroism and valor needed to have a space in the permanent exhibit, with many at the LUM viewing the inclusion of such themes as a kind of politically pragmatic form of containment. It was as if to say, "Let the armed forces have their heroism in the section on the Chavín de Huántar rescue, as long as we make sure this sentiment doesn't affect the central narrative of the exhibition." (A retrospective account written by former LUM workers, when discussing later efforts, stated that military points of view were taken into account "as long as they contributed to and did not enter into conflict with" the museum's principal objectives [Ledgard, Hibbett, and de la Jara 2018:36].) The firsthand experience of suffering soldiers was potentially less contradictory with the LUM's goals, but attention to this theme nevertheless raised questions about moral differences between harms inflicted upon

soldiers and those inflicted upon civilians (Fassin and Rechtman 2009) as well as the immense power asymmetries between victims' organizations and the armed forces when it came to their influence in Peruvian society. As I document in the next chapter, these differences and power asymmetries arguably became further obscured as the two sectors became assembled as interest groups in a formal consultation process the LUM carried out.

Finally, despite the LUM's consistent appeals to a plurality of experiences and project representatives' assurances that the initiative was an opportunity to move beyond the TRC and clashes it provoked, the primacy of victim-survivors and militares as sectors to be consulted evidenced the continued relevance of a salvation memory–human rights memory divide (Milton 2014c). The participation of victim-survivors evoked the perceived excesses of a TRC narrative that needed to be complicated (e.g., through attention to gray zones) rather than reproduced. Conversations with and about militares conjured the emotional-political excesses of a salvation memory, especially the problem of speaking of heroism in a conflict characterized by massive and systematic human rights violations perpetrated by the military. How to navigate, manage, and—in some cases—contain, the passions associated with these opposing memory camps was a concern that continued to shape the process of creating the LUM's permanent exhibition.

CHAPTER 5

Memory under Construction

THE LUM HAD a new national director in July 2013. A lawyer by training, Denise Ledgard also had expertise in public administration, holding a degree in the field from the University of California, Berkeley (her studies were supported by a Fulbright Scholarship). "Executive" and "professional" were words I often heard to describe Ledgard during her first weeks at the museum project. Others noted the administrator's energetic, driven style—"super charged" (*super pilas*) was how one LUM worker put it. Perhaps they saw a lack of congruence between the actions of a young female leader committed to principles of efficiency and transparency and the LUM's reputation as a slow-moving initiative managed by an older band of (mostly) male intellectuals. It was clear that Ledgard knew how to get things done, and the director carried herself in a pleasant, if deliberate, fashion as she began the work of transforming the national museum project.

In addition to her more easily identifiable credentials, she had proven her bona fides as a human rights advocate over the years. Ledgard served as a legal advisor at the Peruvian embassy in Japan as part of an effort to extradite Alberto Fujimori in the years following the president's November 2000 departure from office. She later worked in the anticorruption unit of the Ministry of Justice and Human Rights. The museum director had friends in the human rights community and could convincingly use "we" in meetings with representatives from this group. The first-person plural seemed to align the LUM's goals with an identity forged through decades of activism (Youngers 2003). It was Diego García-Sayán, a figure still highly regarded in these circles, who approached Ledgard in May 2013 about the LUM position.

The museum world was new to Ledgard—who dressed sleekly and was rarely without a tablet or her smartphone at hand—but managing projects and navigating Peruvian debates about the country's violent past was not. As with any other public management endeavor, the LUM's *process* would be as important as its results (she told this to her students at Lima's Catholic University, where she continued to teach a class as she pushed the museum

project forward). Idealism needed to be blended with a healthy measure of pragmatism. Ledgard expressed puzzlement, for instance, at an artist-activist's questioning the notion that members of Lima's business community should represent one of the LUM's "interest groups." How, from a public management standpoint, could a national museum wholly ignore the private sector? And when it came to discussions about the LUM's future institutional home, Ledgard was not, in principle, opposed to the Human Rights Ombuds Office (Defensoría del Pueblo) as an option, but knew from her time working at the *Defensoría* that the agency's resources were limited and likely to be further depleted in the coming years.[1] It was this combination of savviness, credentials, and political realism that marked her as belonging to a new class of public-sector administrators that had attained significant influence following Peru's neoliberal turn in the 1990s (Vergara and Encinas 2016).

One of the main initiatives Ledgard spearheaded during the first months of her tenure at the LUM was a "participatory process" aimed at sharing a draft of the museum's exhibition script with representatives from different sectors. The construction of the building had been steadily advancing and the High-Level Commission had recently approved a preliminary version of the exhibition script. Miguel Rubio, the theatre director who was brought on in late 2012 to draft the document, had been working with others on the curatorial team to further elaborate the script and "ground" (*aterrizar*) his vision in the building's architectural space. The participatory process would, in the words of Ledgard, "open up the script, gather opinions, and validate [the museum's] contents" (Ideele 2013). It also represented a coordinated effort to identify and map key actors while legitimizing the institution as a whole (Ledgard, Hibbett, and de la Jara 2018:34).

This chapter examines the LUM's participatory process and initial debates surrounding the museum's exhibition script. After identifying some of the main points of contention in deliberations involving planners and the curatorial team, I analyze how practices of sharing the script with different groups established a form of discursive authority that was based on the LUM's capacity to access and encompass the various perspectives surveyed (Ferguson and Gupta 2002). These acts of circulation, guided by the notion of transparency but also revealing this concept's impossibilities (Ballestero 2012), would serve to distribute accountability for the exhibition and its potential shortcomings. Although there were ways that participants and critical commentators questioned the logic of participation at work in the LUM's consultation process, I argue that the initiative (and references to its implementation and findings) played an enduring role in cultivating the museum's image as an institution that could manage divergent memories of war in a skillful, democratic, and thereby authoritative fashion.

UNA MEMORIA EN CONSTRUCCIÓN

The speed and effectiveness with which Ledgard moved the LUM forward prompted observers—and Ledgard herself—to underscore differences between her managerial style and that of her predecessor. She noted in interviews that, before she arrived at the LUM, the focus had been almost exclusively on construction issues; when the subject turned to the museum's permanent exhibition, the new director claimed they would be beginning "almost from zero" (Ideele 2013). Ledgard acknowledged the work that Fernando Carvallo and others had done but stressed the lack of a concrete proposal for the museum's contents or "a participatory process that would validate it" (Ideele 2013). Fernando was well-intentioned, she noted, but it was effective management skills that would translate activity into results.[2]

Ledgard also appeared in the media with greater frequency than Fernando had, which supported a broader push to make the national museum initiative more visible. The air of secrecy that had developed around the LUM troubled her. It was an institutional image that played into fears that the museum had forged undisclosed pacts with the military or would advance with an exhibition script without input from civil society. Still, Ledgard and others were optimistic that the LUM's auditorium could be inaugurated by 2014, with the full exhibition opening to visitors later that year. New requests for government funding were pending.[3]

The participatory process took place mainly during November and December of 2013 (toward the end of my main period of fieldwork), with several national news outlets reporting on the initiative as it unfolded. Meetings were carried out in Lima, Ayacucho, and Satipo (located in the region of Junín) and counted on the participation of various interest groups, including victims' organizations, the police and armed forces, artists, human rights organizations, and journalists.[4] The LUM project hired two social scientists from the Institute of Peruvian Studies Memory Group (Grupo Memoria), Ponciano del Pino and José Carlos Agüero, to direct the effort and submit a report based on their findings.[5] As a condition of their participation, the researchers were assured that the investigation's findings would be taken seriously and that there was still considerable potential for the script to be modified (it was not simply a matter of validating the existing proposal). Del Pino and Agüero would remain self-reflective about their position as researchers throughout the consultation process, viewing their work as part of a political and ethical commitment to further democratize the LUM and disrupt prevailing logics of participation and decision-making in Peru more generally.

At the same time, there was the basic reality that the LUM initiative was behind schedule and, as Ledgard explained to a group of artists at one of the preliminary meetings, no one "[wanted] to go backward" with the

participatory process. Participants and everyone involved were well served to
keep in mind the "how" (to change the proposal) and not just the "what" (they
did not like about the proposal), she added. The rhetoric bore some resem-
blance to the language of a neoliberal audit culture (Strathern 2000) that has
developed around extractive industries in Peru (Li 2017) and elsewhere in the
Andes (e.g., Perreault 2015), wherein corporations produce impact assessments
and consult with local communities even when the general assumption is that
projects will proceed with few meaningful changes.[6]

Transparency emerged as the dominant idiom through which planners
described the collaborative effort, with a focus on listening and documenta-
tion signaling a kind of ethnographic turn for the LUM initiative.[7] Sessions
with different groups would be audio recorded (in some cases, video recorded)
and researchers and facilitators carefully registered the opinions, critiques,
and perspectives that participants expressed. The effort would align the LUM
with institutions like the 9/11 Memorial Museum in New York, which
included a multiyear "conversation series" involving various stakeholders as
part of its curatorial process (Sodaro 2018:141–142). It also reflected a more
general trend toward consultation and collaboration in museums around the
world (Clifford 1997; Karp, Kreamer, and Lavine 1992; McMullen 2008;
Shannon 2014). As del Pino and Agüero (2014:30) would eventually state in
their final report, the process "had, as its premise, the idea that the con-
struction of the LUM can only gain legitimacy if it receives the contribu-
tions of different interest groups that are most directly tied to the process of
political violence that the country experienced." Thus, reflecting themes
developed in chapter 4, the museum project required contact with groups
imbued with this experiential authenticity in order to arrive at an authorita-
tive account (Fassin and Rechtman 2009). Although the term "validation"
appeared less frequently as the participatory process unfolded, LUM work-
ers were cognizant of the effort's potential to "[give] a solidity and a legiti-
macy to whatever proposal [they] might make" (as Ledgard told me in an
interview).[8] The museum's High-Level Commission expressed support for
the initiative, as did members of the curatorial team.

The script distributed to meeting participants was authored by Miguel
Rubio, the longtime director of Yuyachkani, an internationally renowned
theatre collective based in Lima that is known for its engagement with social
issues and the legacy of Peru's internal war (e.g., Garza 2014). In my inter-
views with him, Rubio expressed a certain ambivalence about being involved
in an official, state-sponsored production like the LUM. He accepted the
invitation and continued to work on the project because he felt the initiative
was important, but remarked that it would be much easier to make a museum
of this kind if he were doing so at the Casa de Yuyachkani. One had to
remember: *el emisor es el Estado* (the broadcaster is the state). Still, the worst

thing they could do, in Rubio's estimation, was present a "definitive" or "triumphalist" account. His favorite section of the proposed script, for example, was a small transitory space designed to look like the basement of the Public Ministry. Boxes of evidence would be stacked on shelves that reached the ceiling. The installation, which would include little or no textual accompaniment, was intended to give the visitor a sense of the overwhelming amount of work that remained pending in Peru's effort to provide truth, justice, and reparations for the war's victims.

The central theme of Rubio's script was "A Memory under Construction" (*Una memoria en construcción*), a concept that gestured toward the unresolved nature of Peruvian memory struggles and invited the visitor to actively participate in the process of coming to terms with the past.[9] Among the rooms proposed were "Media Context of the Violence," "Faces and Voices of the Victims," "Perpetrators," "The Disappeared," "Forced Displacement," and "Civil Society Organized." For Rubio, the LUM's focus needed to be as much on generating "sensations" in the visitor as it was on strictly pedagogical concerns—an emphasis characteristic of a new class of memorial museums (Sodaro 2018).

Shortly after the script was approved (in July 2013), he invited Karen Bernedo from the Itinerant Museum of Art for Memory (briefly profiled in the introduction) to assist him in the development of the LUM's contents. Rubio and Bernedo were receptive to preliminary findings and suggestions coming out of the participatory process research team's work and looked forward to implementing relevant changes. In reality, they both felt the process of consulting with different groups should have begun much earlier.

The LUM's High-Level Commission was also involved in discussions about the exhibition script. Rubio and his team had taken into account a set of guidelines the commission drafted for the exhibition in 2012 and, the script—still a rough schematic of eleven general topics to be addressed in the display—was only approved after three months of debate among the commissioners. Members of the García-Sayán-led High-Level Commission included a religious leader (Monsignor Luis Bambarén), a former congressperson and indigenous rights advocate (Hilaria Supa), a business leader (Leopoldo Scheelje), Lima's director of culture (Pedro Pablo Alayza), and a former minister of education (Javier Sota Nadal). Including a diversity of viewpoints was by design, and García-Sayán told me and others that a "plural" commission was one of the conditions he insisted on when accepting the position. Even as the participatory process began to take shape in the latter months of 2013, LUM officials stressed that it was the High-Level Commission that ultimately would assume responsibility for what the museum displayed; representatives scoffed at the notion that there could be a kind of public "referendum" on the script.

The curatorial team and participatory process researchers therefore had to consider certain parameters put forth by the presidentially-appointed body, even as the commissioners—who served on an *ad honorem* basis and met no more than one or two times per month in practice (biweekly in principle)—did not participate in the day-to-day life of the LUM. Discussions in the purview of the High-Level Commission imposed real and imagined limits on the creative-investigative work of drafting the script. Among the most sensitive topics discussed during the initial process of approving the document, for instance, was the depiction of Alberto Fujimori's government. A point of contention was whether or not the LUM should devote significant attention to Fujimori-era corruption (their decision was "no," owing to the risk of equating corruption with state-perpetrated atrocities). Although virtually no one involved in the project was sympathetic to Fujimori, there was an awareness that focusing too much on *fujimorismo* (or former president Alan García, for that matter) could jeopardize the institution's long-term sustainability.[10]

Another official position of the High-Level Commission (related to me by Ledgard, members of the curatorial team, and participatory process researchers) was that the exhibition should not address the historical antecedents of the armed conflict in an explicit way. Here, the LUM faced a curatorial dilemma common to virtually any memorial museum: when did the violence begin and when did it end? In neighboring Chile, for example, a notable feature of the national Museum of Memory and Human Rights (inaugurated in 2010) was the exhibition's delimited focus on rights abuses and political repression during the military dictatorship of Augusto Pinochet (1973–1990). Limiting its historical representation to this period allowed the museum to sidestep more politically contentious discussions about the socialist presidency of Salvador Allende (1970–1973) and conditions leading up to the 1973 military coup that toppled the democratically-elected Allende government.[11] In Peru, the Truth and Reconciliation Commission (TRC) analyzed numerous factors that contributed to the violence, even as the commission's *Final Report* declared unambiguously that the "immediate and decisive cause" of the conflict was Shining Path's decision to initiate its armed struggle (CVR 2003:Tome VIII, Chapter 1).

Javier Sota Nadal, a member of the LUM's High-Level Commission who served as minister of education during the government of Alejandro Toledo (2001–2006), told me that the issue of historical conditions was already implicit in the project's "last name" (Tolerance and Social Inclusion) and that on this topic and others, it was imperative that they avoid a representation that would sow further division among Peruvians. Commission member Pedro Pablo Alayza, speaking with me in June 2013, offered something of a dissenting view, observing that the period of violence "has to do with much

deeper sociological problems," and underscoring a lack of substantive citizenship in the Andes. "The most fundamental thing is the social contract—basic Rousseau," he added, noting that even after the war, the state's presence in rural Ayacucho was not satisfactory. Alayza, who was head of cultural affairs for the Municipality of Lima, described the LUM as "the great cultural project of the country" insofar as it represented an opportunity to promote mutual respect among Peruvians and raise questions about why the violence occurred.

Rubio, Bernedo, and their counterparts on the research team also had concerns about the commission's official position and were sympathetic to the notion that the historical context of the war needed to be displayed. The question became how to navigate the proscription: Could they include relevant historical information in the exhibition's timeline? In life histories? Perhaps in an introductory video that visitors would watch before entering the first room? Likely referring to such constraints, Rubio would later describe the High-Level Commission's stances and guidelines as a "straitjacket" (Ledgard, Hibbett, and de la Jara 2018:42).

Also controversial, and especially troubling to members of the human rights community, was Diego García-Sayán's and others' stated reluctance to cite the Peruvian TRC's estimate for the total number of war dead (69,280), along with the LUM's tepid stance regarding the depiction of "systematic" human rights abuses perpetrated by the military. "The 70,000 of the TRC or the 15,000 that the Army says it was . . . this is not our topic. Whoever wants to investigate it can investigate," García-Sayán explained to me. "There are so many deaths, a lot of suffering, and that is enough. There isn't a need to gouge each other's eyes out over a total I don't know is correct or incorrect." Ledgard offered a similar reflection on the question of depicting systematic human rights abuses: "If we speak of 'the systematic violation of human rights' . . . and we put it *like that*, obviously we're creating a front that's maybe unnecessary." Perhaps there were ways of representing this idea without using the specific term, she noted. Concerning the issue of totals, Ledgard thought a potential solution might be to cite the different sources, with the TRC's figure appearing alongside others.[12]

Showing Progress

There would be few pronouncements in the news media about what the LUM would show in its permanent exhibition until the lead-up to the museum's inauguration in 2015. The participatory process and its selective acts of concealment and revelation arguably enhanced the fetish-like qualities of the exhibition script as a document forged through the kinds of "backstage" practices that are often central to cultivating the very idea of the state (Taussig 1991). When it came to the institution's goals and overall

approach to representing the violence, however, LUM representatives began to develop a clearer, more consistent discourse by the second half of 2013.

The vision of the museum as a vibrant, interactive institution that would serve as a meeting ground, rather than project a consensus historical representation, became a point of emphasis. The LUM needed to "become a living, dynamic public place that is not just a repository of objects or photographs that give an account of a determined period," Ledgard told one interviewer (Felices 2013). An open space of encounter and debate—more a "cultural center" than a "museum," according to established Limeño taxonomies—was what she and others advocated. The talk of dialogue and plurality was consistent with the move to carry out the participatory process, and perhaps deflected attention from continued concerns about institutional limits and bureaucratic opacity in the making of the script.

In interviews, public events, and in the participatory process workshops, the LUM's observers and interlocutors heard a similar set of messages. Workshop attendees learned that the LUM "was not just a museum," or that it would "go beyond" being a museum. Workshop facilitators described the exhibition script as "only a proposal," a working document meant to be a "point of departure." Participants were sometimes reminded that the permanent exhibition was "not going to tell us everything," and LUM researchers and staff often mentioned the 30 percent of the museum's exhibition space that would be used for temporary exhibits. Elements other than the permanent exhibition, including (yet-to-be-determined) temporary exhibits, the museum's digital archive, and the LUM auditorium, increasingly become talking points in declarations to different groups.

Conventional notions of history, reconciliation, and collective memory (not to mention the museum concept itself) became models to be avoided. LUM workers described the institution's goals as inconsistent with the promotion of "rigid" memories or historical accounts while offering reminders that "there [was] not just one truth" about the violence. Event attendees and inquiring interviewers were told that a "collective memory" of the war did not exist and that no consensus was going to be reached through the participatory process or, later, in the LUM's permanent exhibition. Participatory process researchers later expressed similar views in their final report, a document that presents findings from the various workshops and surveys relevant scholarly areas to chart a "conceptual foundation" for the memorial museum (del Pino and Agüero 2014). The LUM would not seek to "bring different memories into agreement," del Pino and Agüero asserted (2014:17)—the authors identifying and rejecting the possibility of a synthesizing, reconciliation-oriented mode of historical representation. The national museum project would instead take conflict between different historical memories as a "point of departure."[13] The state could be a "facilitator" of encounters involving bearers of different

memories rather than a "broadcaster" of its own, dominant narrative (del Pino and Agüero 2014:80). Anthropologist Camila Sastre Díaz (2015:151), commenting on this period of the project's history, describes planners' "constant opposition . . . to assuming a place of enunciation"; it was as if "'nobody' would tell the stories that would be displayed in the [LUM]."

Both implicitly and explicitly, project representatives differentiated the LUM from Peru's previous state initiative focused on truth and reconciliation. The TRC and Yuyanapaq were "historical milestones" that commanded respect—and would be displayed as such—but were not productions that the LUM should seek to emulate (recall chapter 3). Consistent with a recurring theme in the project's history, victimhood emerged as a terrain upon which LUM officials could mark departures from the TRC and its divisive legacy. No longer a "victim-centered" institution as such, the LUM would take victims as an "ethical point of enunciation," a phrase that appeared regularly in workshop meetings as well as in the participatory process report (del Pino and Agüero 2014:21).[14] Ledgard would make waves when she stated in an interview (Núñez 2014) that the museum's concept was not that of a "commemorative monument to victims," but this was little more than an explicit articulation of the prevailing thinking within the LUM.

The research design for the participatory process could also be held up as evidence of the LUM's desire to represent a plurality of victim experiences, including those of groups perceived to be underrepresented in the TRC's work. The research team held separate workshops in Lima with victims' organizations associated with rights abuses perpetrated against civil society and with military and police-affiliated victims' groups. For the Ayacucho meetings, researchers emphasized that the participatory process would not merely consist of "talking with ANFASEP" (National Association of Relatives of the Kidnapped, Detained, and Disappeared of Peru, the iconic regional victims' organization) and would involve groups of different ideological orientations, along with lesser-known organizations not based in Huamanga.[15] There was a consensus among researchers, the curatorial team, and administrators that the armed forces and police needed to be included in the LUM's representation of victimhood.

FINDINGS, AUDIENCE, AND A REJECTED OFFERING

Findings and suggestions emerging from the participatory process raised additional questions about who the LUM would serve and how the exhibition script might respond to the demands and sensibilities of different publics. The reporting of such insights also established the (quoted) voices of session participants as a force that could be mobilized in deliberations involving the curatorial team, the High-Level Commission, and LUM researchers and staff. I offer a sketch of how the insertion of these external perspectives

shaped discussions about the script—focusing on one section in particular ("La Ofrenda")—before reflecting further on the consultation process's performative dimensions.

Several of the research team's principal recommendations related to the need for the national project to "*prove* the violence" as a lived, personal experience (del Pino and Agüero 2014:16). Abstraction and generalization, though inevitable at some level, were to be avoided in favor of specific cases, local histories, and named victims and perpetrators, the researchers concluded. The LUM needed to "personalize" victims of the country's political violence (2014:43).

The del Pino and Agüero report, which is entitled *Each Person, A Place of Memory (Cada uno, un lugar de memoria)*, offered this central recommendation amid a wealth of information and empirically-grounded interventions: Virtually no one expressed outright opposition to the LUM in the meetings; participants exhibited an active interest in contributing to the museum's creation.[16] Victim-survivors in Ayacucho tended to prefer realism and feared history's "distortion" at the hands of artists and intellectuals (2014:47).[17] Gender, the researchers argued, should be a cross-cutting theme in the script (rather than potentially limited to a room entitled "Women and Organization"). "Memory under Construction" was deemed ineffective as a narrative arc for the exhibit, with del Pino and Agüero reporting that the script failed to present a convincing, unifying message for participants. The authors recommended a relatively minimalist permanent exhibition and raised concerns about "In Search of Hope" being the final theme visitors encounter (2014:64). Also included in the text were suggestions made by participants to enhance specific sections of the exhibit (e.g., information provided by Ayacucho participants on Andean traditions and beliefs surrounding the dead, which could improve the room on "The Disappeared").

A section of script that became the focus of much attention as Rubio and Bernedo attempted to implement findings from the participatory process was the exhibition's first room, "La Ofrenda" (The Offering). It was a discussion that prompted reflection on the LUM's intended audience and depiction of victimhood, but also illustrated epistemological tensions surrounding the deployment of findings from the participatory process workshops.

"La Ofrenda" was intended as a tribute to the war's victims. Its basic design was as follows: As visitors came into the room their attention would be directed to a single article of clothing illuminated in an otherwise dark space. Shortly thereafter, as more light entered the room, visitors would realize that the piece of clothing they gazed upon represented just one element in a wider assemblage of garments suspended before them. Exhibit designers were to select articles of clothing that would reflect the diversity

Participatory process meeting with representatives of victims' organizations in Ayacucho.

of sectors affected by the violence (rural and urban, civilian and military, etc.), with the overall goal of the installation being to convey the war's massive human cost.[18]

The problem, according to the participatory process researchers, was that victim-survivors the team consulted with in Ayacucho did not respond well to La Ofrenda. Del Pino and Agüero (2014:38) discuss this finding in their report: "The victims of the violence did not develop a liking for the space referred to as 'Ofrenda,' that for the script's authors worked as a dramatic rupture in the spatial and emotional staging of the display. They feel that the impact is very strong. They suggest beginning the script with 'before the violence . . .'"[19] The authors return to this point in the report's conclusion, asserting that the opening section of the script "[had] been strongly critiqued" (2014:60): "The beginning ('Ofrenda') does not seem to respond to the needs of any of the actors consulted; its commemorative nature has not been accepted by the victims, it does not generate attachment, and more tangible proposals are preferred, such as the use of proper names or, if it were the case that the installation is already defined as unmovable [from the script], that articles of clothing donated by relatives [of the victims] are used"

(2014:60). As referenced in the above summaries, researchers identified several sub-critiques of La Ofrenda, which I condense and synthesize here: (1) Victim-survivors were concerned over the emotional-sensorial impact of the room; (2) Victim-survivors expressed a preference for the use of authentic articles of clothing in the museum and indicated their willingness to provide such materials;[20] (3) Victim-survivors preferred the depiction of named rather than anonymous victims; (4) Victim-survivors considered it relevant to show the war's "causes" and felt that a room focused on this topic would be a better way to begin the exhibition than La Ofrenda.

On the one hand, such critiques could be traced in a straightforward fashion to observations from the workshops. A participant in the meeting with local authorities in Ayacucho, for instance, described the section as "gloomy." Another person in the same meeting shared her view that the script seemed to be oriented more toward foreigners and individuals who were not affected by the violence (she herself did not want to "relive" the war and would not go to a museum like the LUM). It was also true that several Aya-cuchano participants raised concerns, in a general way, about a lack of repre-sentation of "living victims" in the exhibition script (del Pino and Agüero 2014:38). Even more called attention to the violence's "causes," underscoring also the persistence of poverty, exclusion, and state neglect in the region. "What is the state doing so that history is not repeated?" ANFASEP president Adelina García asked in the meeting she attended (2014:40).

At the same time, the reactions to La Ofrenda reported by del Pino and Agüero resonated with conceptual positions that were more difficult to ground in specific observations or "patterns in the data." Naming victims, for example, could be presented by the researchers as a recommendation that responded to ethnographic findings ("when we find the name . . . we feel good," said Adelina García [del Pino and Agüero 2014:37, 70]), but could also be viewed as a necessary moral-political act. Del Pino, Agüero, and others involved in the project expressed concern over the possible repre-sentation of war victims as an anonymous (Andean) mass, an image that could inhibit rather than promote (coastal) identification with populations most affected by war.[21] In a similar fashion, participants' suggestion that "living victims" be represented in the permanent exhibition resonated with desires to show the agency of individuals affected by the violence and, in doing so, provide a counter to the depoliticizing tendencies of a victim-centered transitional justice paradigm (2014:38; recall chapter 4).

Not unlike the scenario of planning meetings for the National Museum of the American Indian analyzed by Shannon (2014:86–95), references to "community wishes" (gleaned from separate meetings with consulted groups) had rhetorical force and established the LUM researchers as mediators, even as the specific content of such "wishes," or how they might be expressed in the

permanent exhibition, remained somewhat open to interpretation.[22] Although there was evidence to suggest that participants' views on La Ofrenda were considerably more nuanced than wholesale rejection, an "opposition to La Ofrenda" narrative took hold.[23] This was one of several preliminary observations researchers shared with the curatorial team upon returning to Lima. The irony was inescapable: victim-survivors were dissatisfied with a feature of the exhibit (La Ofrenda) that was supposed to be devoted to them.[24]

Karen Bernedo, who was by then well into her work on the script with Miguel Rubio, viewed the La Ofrenda issue as rooted in unresolved questions about the LUM's audience and goals. "We ought to define a priority," she told me. Based on what she had seen and read about memorialization, "a memorial museum almost always has to sacrifice [either] its pedagogical function or its function as a symbolic reparation [for victims]" (e.g., White 1997). Both could exist at the same time, "but they cannot coexist in the same form or with the same intensity." (I recalled that she had detected this ambiguity in the LUM's mandate even before she joined the project). Either you make a museum where "victims feel completely represented and identified," the activist-curator submitted, or you make a museum "so that people who don't know the topic learn about the history of the violence."

> So, for example, these comments in which the first space, La Ofrenda, was strongly critiqued . . . I was already commenting to Miguel that it has to do with this [issue]. . . . I remember that [Miguel and I] had this discussion about the clothing and the ways of placing them, and the value of clothing in Andean culture. And eventually we decided that that space wasn't really for the victims. It was a space for people who didn't know the topic. . . .
>
> So, this space of La Ofrenda that, for us, was the sensitive introduction for the citizen who *never* has known anything about the topic and was going to feel overwhelmed by the articles of clothing . . . not making any sense for the victims. Like . . . "prop" articles of clothing that aren't theirs? There aren't names? And on top of everything you put "ofrenda" there and it's supposed to be a tribute to [the victims]? Of course. I completely understand why they don't identify with [the display].

Either the pedagogical or the commemorative function would inevitably be prioritized, Karen felt. Later in the interview, commenting on the LUM's image as an elite and inescapably Limeño institution, she returned to the "Ofrenda" question.

> It seems to me the issue is, "who is this museum made for?" The truth is that I really liked the meeting today with Ponciano [del Pino] and the suggestions [from the meetings in Ayacucho]. . . . It seems interesting,

and it struck me as cool, even moving, the way in which [the Ayacuchanos] understand that they're far away and even still, they take on the work and make the effort to contribute to the script because they know that there is an importance and a political relevance in how their issue is made visible [at the LUM].

But again, we're talking about the fact that they . . . and they're aware of this too . . . it's very probable that they aren't going to this museum.

As del Pino and Agüero would emphasize in their report, a number of participants in the Ayacucho meetings, despite voicing strong critiques about the LUM's location in Lima (and in the *pituco* [posh] neighborhood of Miraflores at that), believed it was vital that residents of the nation's capital know what happened during the war.

TRANSPARENCY AND PARTICIPATION

Anthropologists studying the construction of bureaucratic authority have analyzed how official claims to modern, rational governance cannot be disentangled from the materiality of documents (Hull 2012) or the ritual repetition of bureaucratic procedures (Feldman 2008). The circulation of documents—be they files, policy proposals, or in this case, an exhibition script—is often linked to ideas of collaboration and accountability (Li 2017), yet the communicative effects of such practices are often considerably more complex. As Matthew Hull (2003:288) illustrates in his ethnography of government agencies in Islamabad, bureaucratic writing can attain a collective voice through the "documented participation of different actors," as papers and files pass through the hands of, and come to bear distinctive markings from, various functionaries. According to Hull's analysis, it is largely through individuals' acts of negating principal authorship that a collective agent becomes ritually constituted in bureaucratic settings, with a crucial outcome being the diffusion of accountability across different actors. In a similar way, the LUM initiative's efforts at greater transparency and public engagement in the script-making process would establish an authoritative institutional voice that foregrounded access to different perspectives, distributed accountability, and diverted attention from existing and emergent forms of opacity. Practices of registering and circulating information from the various sessions proved critical in this process.

As a news story put it—in a somewhat approving tone—the participatory-process workshops were "carefully documented" (Espacio360 2013). The team audio recorded every meeting and a project assistant produced a detailed, stenographer-like log (*relatoría*) of all relevant interventions. Researchers took their own, extensive field notes as well. Toward the end of each session, the meeting's facilitators would share a LUM email address to which participants

could send additional ideas or concerns. One could assume that feedback was also recorded. Condensed versions of the meeting logs would appear in the researchers' final report as appendices (del Pino and Agüero 2014).

The copious amounts of material produced from each session were eventually processed and synthesized in an interpretive fashion consistent with prevailing norms in fields like history and sociocultural anthropology. Researchers and facilitators worked diligently to produce an accurate and useful account based on the information obtained. Yet it was evident that the note-taking, audio recordings, standardized meeting procedures, and ritualized unveiling of the script also completed the important performative function of showing participants that their voices were being heard by the LUM. These actions reinforced the project's status as an effective and legitimate vehicle for managing the diversity of views expressed. Indeed, it was likely that the absence of such documentation practices at the LUM (or at least their lack of presence for interested publics) played a significant role in cultivating an institutional image of secrecy in previous years.

Information and perspectives registered at workshops tended to circulate beyond their primary intended audience (the project's staff and the curatorial team in particular). A LUM worker posted excerpts from the sessions on the museum project's Facebook page ("Tito Bracamonte from MHOL [The Homosexual Movement of Lima] mentioned the importance of presenting the history of the LGBT population during the armed conflict").[25] In interviews, LUM representatives would highlight diverse groups' willingness to volunteer ideas for the script. Officials such as Ledgard could also report confidently that people who attended the participatory process meetings were not necessarily clamoring for Yuyanapaq to be displayed at the LUM.[26] Not unlike the case of consultation efforts associated with mining projects in Peru (Li 2017:256), the public sharing of plans and findings from meetings could take precedence over their specific content.

Especially powerful were researchers and facilitators' acts of referencing perspectives gleaned from one group during a session with a different group. Human rights activists in Lima, for instance, heard about Ayacuchano victim-survivors' critiques of La Ofrenda, or the importance that participants in those meetings placed on depicting the rondas campesinas as perpetrators. Other groups might learn that their reading of a particular aspect of the script was "totally different" from that of another sector, or be made aware that a suggestion they put forth contradicted one that the team had previously encountered. In a meeting with Ayacucho-based human rights activists, for example, a researcher pointed out that participants' focus on reconciliation as a possible concluding theme for the script contrasted with that of participants in the workshop with victim-survivors, who felt the exhibition should end by making demands on the Peruvian state. By citing

such information, project representatives conveyed their access to and aware-
ness of potential critiques while demonstrating the validity of the consulta-
tion process they were carrying out. The referencing of information from
other sessions positioned the LUM as "above the fray"—or at least as having
a superior capacity to encompass different perspectives (Ferguson and Gupta
2002)—while reinforcing the partiality and equivalence (Feldman 2008) of
victim-survivors, artists, journalists, or human rights activists as interest groups.

Findings that were particularly useful for LUM representatives to trans-
mit to a broader audience related to perceptions of the museum project among
members of the armed forces (and, to a lesser extent, the Peruvian National
Police).[27] Consistent with the "interpretative labor" (Graeber 2015) double
standard outlined in chapter 4, LUM workers typically pointed to the exis-
tence of military officials eager to contribute to the memorial museum as
significant in and of itself. The participatory process report states, "the fact
that [the armed forces] participated in the process and accepted the rules of the
game, and that they recognized that there were disappearances that were their
responsibility, is a sign of a change" (del Pino and Agüero 2014:49). It helped
that by this time, representatives from the armed forces had shifted their focus
to advocating for the depiction of military victimhood at the LUM, likely
realizing that a heavy emphasis on heroism was untenable in a human rights–
oriented museum (Granados n.d.; Milton 2018:155).

In a manner similar to how LUM researchers cited insights shared by
"victims" or "Ayacuchanos" in their meetings with other groups, the proj-
ect's planners and workers could reference sessions with armed state actors
and associated victims' groups as further evidence of the LUM's effort to
include diverse voices. Alluding to information from those sessions, Ledgard
and others remarked that members of the armed forces consistently expressed
a desire to speak about military experiences of victimhood, or had articu-
lated concerns about their institutions being put "in the same category" (en el
mismo saco) as the insurgent groups (e.g., through the use of terms like "per-
petrators"). LUM representatives could authoritatively preface their com-
ments with phrases such as "we have spoken with relatives of the victims,
NGOs, relatives of victims from the armed forces . . . journalists, artists,
businesspeople, and what this has shown us is . . ." (Cabrera Espinoza 2014;
emphasis added).

This is not to say that participants uncritically accepted the procedures
and logics of the LUM's participatory process. The experience of Sandra, a
middle-aged woman who was a particularly active contributor in the "mili-
tary and police victims" meeting in Lima, is illustrative. The leader of the
Association of Widows, Mothers, and Survivors of Members of the Armed
Forces and National Police (AVISFAIP), Sandra offered her opinions freely,
sometimes interrupting other participants and the workshop's facilitator. A topic

that became the focus of her and others' attention was the "Perpetrators" section of the proposed exhibition—which would display human rights violations committed by state forces alongside information about Shining Path and the MRTA (Túpac Amaru Revolutionary Movement). ("It hit me right in the eye!" she later told me). Watching Sandra work in her subgroup, it was evident that she was versed in the skills necessary to succeed in the workshop-style meetings that Peruvian NGOs and state agencies typically organized: assiduously taking notes, keeping peers on topic, and preparing talking points to be shared with the larger group.[28]

Despite her savvy navigation of the session's format, Sandra was doubtful that the LUM in general or the participatory process specifically would usher in a new, more open approach to the state's management of the country's recent past. In an interview conducted shortly after the participatory process meeting, Sandra lamented the lack of transparency in her country, mentioning her and her AVISFAIP colleagues' struggles with Peruvian bureaucracies for pensions and other services, but also critiquing the military's consistent refusal to provide information that could assist in human rights cases (Burt and Cagley 2013). She told me that she and her colleagues appreciated the invitation to participate in the LUM workshop, though they felt the process of dialogue and consultation should have begun much earlier. "That day they surprised us because they told us that everything [was] already done," Sandra recounted, rubbing the palms of her hands together as if to dust them off after a day's work. "This will go here, that will go there. . . . What do you like? What don't you like?" Sandra stated, mockingly reenacting how the workshop went. (A woman in the meeting with victims' organizations in Ayacucho had expressed a similar sentiment, sarcastically congratulating LUM representatives on the progress they had made on their "already completed" museum).[29]

Not unlike other activists who become enrolled in state initiatives premised on notions of democratic engagement (e.g., Paley 2001), Sandra and her peers critiqued the logic of participation at work in the consultation effort.[30] They wanted sustained dialogue and inclusion in the decision-making process, not a focus group-like activity. Sandra's comments highlighted the potential for secrecy and opacity despite the existence of a mechanism for promoting transparency and engagement. She called for evidence that their suggestions would be "expressed in the museum" and that script creators were not merely doing "what they wanted to do"; assurances from the LUM staff that "we listened, we took it down, everything is recorded" (as she put it), were not sufficient. Sandra's concerns echoed those heard in extractive industry–oriented "participatory processes" in rural Peru (Li 2017) as well as in museum consultation efforts the world over (McMullen 2008; Smith and Fouseki 2011).[31] Members of Afro-Caribbean

LUM representative explains aspects of exhibition proposal to members of Peru's human rights community.

communities in Britain being consulted for an exhibit on the trans-Atlantic slave trade (Smith and Fouseki 2011), for instance, initially viewed this participation as an opportunity for recognition, but came to perceive museum representatives (themselves, mostly concerned with producing "balanced," controversy-free displays) as merely "ticking a box."

There were other subtle ways that individuals and groups undermined the image of the LUM's participatory process as a straightforward mechanism for communicating the preferences of different groups to the curatorial team. Several participants in the meeting with Lima-based human rights activists, for instance, expressed frustration over not knowing the institutional-political limits within which the curatorial team and participatory process researchers were operating. In doing so, the activists—many of them affiliated with NGOs whose national and international connections and organizational capacities rivaled those of state initiatives like the LUM (Ferguson and Gupta 2002)—positioned themselves as potential authors, rather than as interest group representatives offering their "memories" or perspectives. Further, given the familiarity of members of Lima's activist and artistic communities with the LUM, the lack of social and political distance between researchers and these populations, along with the fluid interactions between

state and civil society (Alvarez, Dagnino, and Escobar 1998; Bueno-Hansen 2015) that characterized Peruvian engagements with themes of memory and human rights, the LUM research team tended to engage with these groups in a more horizontal fashion, as peers. Small group discussions and bullet points written on butcher paper were eschewed in favor of a more open, seminar-like format. A few participants from the meetings with Lima-based artists and intellectuals would later find themselves working for the LUM in some capacity.

These phenomena notwithstanding, a principal outcome of the participatory process was to establish the LUM as an institution aligned with principles of transparency and dialogue. The effort proved effective in diverting attention from forms of opacity that continued to characterize the project, such as the specific uses of information obtained from the participatory process, the work of the curatorial team, or the nature and extent of limits imposed by the High-Level Commission.

CONCLUSION

Fears that the LUM's consultation effort would result in little more than superficial changes to the exhibition script were not borne out. During the early months of 2014 planners elected to move forward with a new script and curatorial team rather than attempt to overhaul the proposal authored by Rubio and Bernedo, a decision informed by findings from the participatory process. Del Pino would come to form part of the curatorial team, which included artist Natalia Iguíñiz, literary scholar Víctor Vich, and art critic Jorge Villacorta (see chapter 6). The guidelines and prohibitions issued by the High-Level Commission and other authorities remained unchanged. Although there would be no equivalent "participatory process" for this next (and indeed, final) attempt to represent Peru's political violence in the LUM, dialogue and consultation with different groups continued during the process of making and implementing the exhibition script.

How, and to what extent, formal consultation efforts contributed to the LUM's permanent exhibition continued to be the subject of some debate. In late 2015, for instance—shortly before the museum's inauguration—Miguel Rubio (2015) offered a defense of the script he authored with Karen Bernedo and responded to issues raised in del Pino and Agüero's (2014) report. The theatre director critiqued the "veil of mystery that has covered this long process of implementing [the LUM]," a lack of transparency that "[includes], for certain, the current script, which only seems to be known by those charged with implementing it." Others who followed the LUM closely had similar concerns.[32]

Less ambiguous was the place the consultation effort came to occupy in the memorial museum's institutional narrative. References to the participatory

process, along with principles of dialogue and transparency in the creation of the script, became common in the period leading up to the LUM's inauguration. Representatives like Ledgard could proclaim that the document had "passed through a wide, participatory process" (Agencia EFE 2015). In a speech given at the museum's December 2015 inauguration, Diego García-Sayán made explicit mention of the consultation initiative's importance for developing the permanent exhibition. The afterlife of the participatory process continues in the present, as it is not unusual to find descriptions of the LUM in diverse media (news stories, academic publications, etc.) that underline the project's meetings with various sectors in different parts of the country. The process also figures prominently in accounts of the museum's history appearing in promotional materials and on the LUM's website. Perhaps unsurprisingly, such depictions rarely address the details of the consultation effort or the nature of its contributions to the curatorial process.

Following anthropological scholarship on transparency, democratic participation, and the construction of bureaucratic authority, I have argued that the LUM's participatory process contributed significantly to the institution's claim to be an appropriate vehicle for producing a responsible and authoritative representation of the political violence. The form of discursive authority that emerged from the participatory process was based mainly on planners' ability to access, manage, and synthesize different perspectives on the conflict, as opposed to the LUM making appeals to historical knowledge, curatorial expertise, or moral principles.[33] Though some of the consulted individuals and groups questioned—and even pushed back against—the logics and assumptions that guided the participatory process, an enduring feature of the LUM's effort to listen to, record, and presumably incorporate a diversity of views was the distribution of authorship and accountability across a range of actors (including the High-Level Commission, the curatorial team, participatory process researchers, and interest groups themselves). The collective voice established through this dispersion persists in the permanent exhibition and continues to be referenced in discussions about the LUM and its significance.

CHAPTER 6

Memory's Futures

ETHNOGRAPHERS DOCUMENT LIVES in motion and are often reminded of ways that their accounts register historical processes that are contingent and unfolding. This is perhaps especially evident when an institution-in-the-making is the object of study. Though I made it back to Lima for a brief follow-up visit in 2014 and was able to attend the LUM's inauguration in December 2015, I mainly watched from abroad as a number of key developments took place in the period leading up to the museum's opening: the emergence of a new curatorial team and exhibition script, campaigns to make the institution more visible and to share the exhibition plans with different groups, the abrupt and unjust dismissal of the project's director (Denise Ledgard) midway through 2015, and the rush to inaugurate the LUM by the end of that year. The short trips I have made to Lima since the inauguration (in 2017 and 2018) were focused primarily on fleshing out debates and dynamics that shaped the permanent exhibition's creation, as opposed to chronicling more recent developments. The problems that animated my work quickly seemed to become historical in nature rather than of the present.

This concluding chapter is meant to give the reader a sense of how issues explored in previous chapters became expressed in the representations one finds at the LUM today. Following a brief overview of the permanent exhibition and some of its conceptual underpinnings, I focus on three aspects of the exhibit that relate directly to themes developed throughout the book: the Peruvian Truth and Reconciliation Commission (TRC) and Yuyanapaq, depictions of victimhood, and the incorporation of perspectives from the armed forces. In each of these sections I complement attention to specific features of the exhibition with insights and reflections from individuals who were involved in the curatorial process. Though much of my discussion emphasizes continuity with earlier periods in the LUM's history, I spotlight efforts to creatively navigate—and in some cases openly question—norms and discourses that had sedimented within the museum project over time. Interviews and observations from the postinauguration period also inform some reflections on the LUM's place in contemporary Peru—including concerns raised by

controversies of recent years. These reflections necessarily remain provisional. The last part of the chapter returns to the book's central problem: the use of memory as a framework for representing the violent past at a national museum project.

A SKETCH OF THE LUM EXHIBITION

The LUM's final curatorial team was assembled during the first part of 2014 as administrators concluded that it would be better to begin work on an entirely new proposal rather than make changes to the existing script (e.g., Ledgard, Hibbett, and de la Jara 2018:33). The team included historian Ponciano del Pino, artist Natalia Iguiñiz, literary scholar Víctor Vich, and art critic and curator Jorge Villacorta. This formally appointed group was complemented by other employees who engaged in tasks such as directing outreach efforts, conducting research and obtaining materials for the exhibition, and keeping a record of issues discussed in the curatorial team's meetings. Artist Eliana Otta served as coordinator of the curatorial team and Alexandra Hibbett, a literature professor, contributed to the group's work as well.

The relatively small number of individuals charged with drafting, preparing, and implementing the script (fewer than ten for much of 2014 and 2015) meant that "everyone did a little of everything" in practice. Several interviewees recalled that the idea of distributing authorship across a team or group was viewed as preferable to relying on a single individual or voice. Further, the organizational structure of the LUM at that time likely helped the institution avoid the kinds of inter-departmental conflicts (e.g., between curatorial and marketing teams) that often arise in the development of exhibitions for major museums (Bunzl 2014; Handler and Gable 1997; Macdonald 2002; Shannon 2014).[1]

The curatorial team worked within the framework of the eleven-topic scheme approved by the High-Level Commission that had guided the creation of the Miguel Rubio-authored script. The list included broad themes such as "Origin of the Violence," "The Disappeared," "In Memory of Victims from the Armed Forces and Police," "The University Community at the Crossroads," and "The Defeat of Terrorism" (Ledgard, Hibbett, and de la Jara 2018:25). Curatorial team members developed the script internally and made revisions based on feedback from different sectors in Lima and Ayacucho, including the communities profiled in the exhibit, members of human rights and victims' organizations, and representatives from the armed forces. In contrast to the earlier, participatory process meetings, the LUM's consultation efforts during this period took place after a full draft of the final exhibition script was completed and approved by the High-Level Commission (during the second half of 2014) and were focused on receiving suggestions and soliciting materials for specific sections of the exhibit. A retrospective

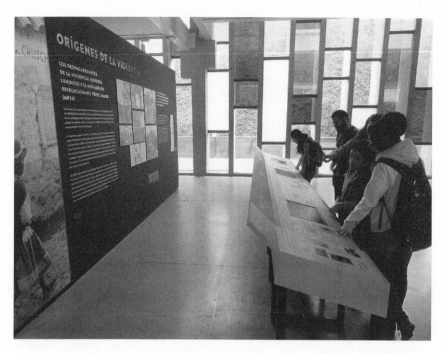

Timeline and "Origins of the Violence" section of LUM permanent exhibition.

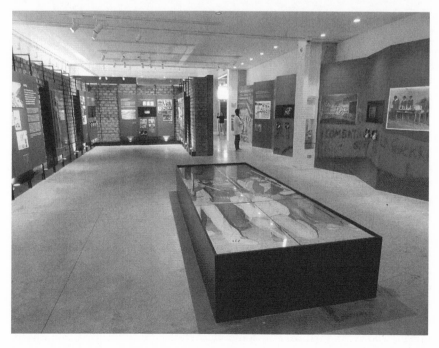

First-floor exhibition hall of LUM.

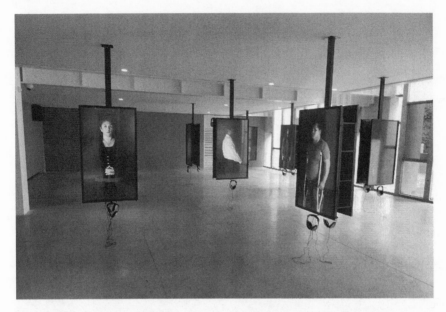

"One Person, All People" section of LUM exhibition.

publication describes one of the main goals of this "validation process" as mitigating expectations of "direct inclusion" in the exhibition (2018:51); no one involved characterized such efforts as resembling a "community curating" model (Shannon 2014).

Consistent with ideas that began to coalesce during the participatory process, the LUM exhibit places emphasis on specific historical experiences and how violent pasts are narrated in the present. Upon entering the exhibition, the visitor encounters a brief chronological overview of the conflict, along with a wall devoted to "Origins of the Violence" that presents information about Shining Path and the MRTA (Túpac Amaru Revolutionary Movement). After that, the first-floor displays focus on particular experiences of violence and their present-day implications. Three case studies (two from villages in Ayacucho, one focusing on indigenous Amazonian [Asháninka] experiences) document the impact of state and insurgent violence at the local level, with texts, objects, and audiovisual material illustrating also how citizens have worked to reconstruct their communities in the aftermath of war. A corridor—where displays on universities and education and on the military's "Countersubversive Struggle" are found—leads into the personal narrative-driven, "One Person, All People" space. There the visitor can view any number of eighteen video-recorded accounts from people who were personally affected by the violence, with life-sized images

of diverse individuals (including religious leaders, a politician, former soldiers and police officers, survivors of sexual violence and unjust imprisonment, and relatives of the disappeared) appearing on large screens that suspend from the ceiling.

The second floor offers a more thematic presentation of different aspects of the internal conflict, placing emphasis on how Peruvians reacted to the violence. Themes addressed include the role of civil society resistance to insurgent and state-perpetrated atrocities (such as the actions of victims' organizations, the rondas campesinas, and Lima-based activists), artistic and musical expressions, the experience of the war in the nation's capital, and the phenomenon of forced disappearances. In addition, the second-floor displays focus on twenty-first century developments such as the TRC, ongoing forensic investigations (depicted through the recreation of an excavation plot at La Hoyada in Ayacucho [chapter 4]), the pending work of reparations and criminal prosecutions, and the creation of memorials and museums throughout the country (with photos and brief descriptions of different sites found on the back wall of the second-floor exhibition hall).

The visitor exits the permanent exhibition on the third floor, where there are murals that represent Peru's coastal, highland, and Amazonian regions, along with an enclosed cylindrical structure in which the names of victims are projected (consistent with wishes expressed by relatives during the participatory process).

THE PERUVIAN TRC AND YUYANAPAQ

As Cynthia Milton (2018:161) observes, the Peruvian TRC occupies a "very discreet role" in the LUM exhibition. An introductory panel the visitor encounters before entering the first-floor displays includes a text entitled "How many died?," which presents the TRC statistical estimate (69,280) alongside the number of cases recorded by the National Victims Registry as of 2015 (31,972). "No consensus exists" regarding the total number of war dead and disappeared, the visitor learns. In other places, TRC figures appear in a less qualified fashion (40 percent of victims being from Ayacucho, 600,000 displaced in the country, 75 percent of the war dead and disappeared being speakers of Quechua or another indigenous language, etc.), though explicit references to the investigative work of the truth commission are rare (Milton 2018:162).

The LUM includes a small, two-panel section devoted to the TRC and Yuyanapaq that, following plans discussed in chapter 3, represents the truth commission and its photo exhibit as "historical milestones." Here, the exhibition text mentions the over 16,000 testimonies collected by the TRC, underscores the significance of the commission's public hearings, and presents

selected conclusions from the TRC *Final Report*, along with a sample of cases the commission recommended for criminal prosecution. A panel on Yuyanapaq features a brief paragraph on the creation of the exhibit, images of published reviews, and a video that projects reactions to the display written by visitors.

Explaining the decision regarding the TRC estimate (and perhaps responding to my somewhat critical observations on the subject in a July 2017 talk I gave at the LUM before our interview), historian and curatorial team member Ponciano del Pino noted that it was "not as if we wanted to put other totals" to signal a kind of epistemological relativism. Their intention, rather, was to point to the complexity that this history entails and to provoke reflection on the issue of estimated war-era casualties. And in cases such as the total number of burial sites, del Pino pointed out, official figures really had changed since the time of the TRC as a result of new investigations (in the LUM exhibition's section on exhumations, the Public Ministry's figure of 4,644 is cited).

No one involved seemed especially pleased with the small part of the exhibition devoted to the TRC and Yuyanapaq, however. Curatorial team member Jorge Villacorta referred to the section as one of the exhibition's major shortcomings, characterizing it negatively as a "compromise" (he used the English word). A request by the LUM to include a small number of images from Yuyanapaq was rejected by the exhibit's curators during the implementation phase, a decision understandable given the museum project's complicated history with the TRC exhibit and its advocates.[2]

The initial Yuyanapaq controversy and its aftermath continued to frame responses in interviews I conducted in 2017 and 2018. Echoing narratives I heard years before, several former LUM workers spoke of the rigidity of TRC defenders in human rights and artistic circles when discussing critiques associated with these sectors. Additionally, similar to the rhetorical strategies analyzed in chapter 5, postinauguration accounts could cite the participatory process as evidence of victims' and other groups' alleged dissatisfaction with Yuyanapaq (e.g., Ledgard, Hibbett, and de la Jara 2018:42).

Independent of such narratives or the depiction of TRC figures and Yuyanapaq at the LUM, there are significant ways that the truth commission's findings and central messages endure in the official museum. Del Pino, for instance, commented that especially in the first floor of the display, it was impossible for visitors not to appreciate the war's differential impact on Peruvian society, with a focus on racialized exclusion aligning the LUM with the TRC's narrative. This emphasis, along with other prominent themes in the exhibition (e.g., state-perpetrated atrocities, civil society resistance), represents a core element of a human rights memory (Milton 2014c) that the truth commission transfigured and disseminated. Indeed, a number of friends and colleagues who have visited the LUM have told me that they see

much similarity between its permanent exhibition and Yuyanapaq, or at least view the LUM's representation as consistent with the TRC's account.

REPRESENTATIONS OF VICTIMHOOD

An emphasis on the plurality of war-era experiences, along with attention to the agency of affected individuals and populations, is apparent throughout the LUM exhibition and particularly in the design of the museum's first floor. "One Town, Many Towns" explores the history of four communities (Putis and Uchuraccay in Ayacucho and the Amazonian towns of Puerto Ocopa [Junín] and Puerto Bermúdez [Pasco]). The video testimonies projected in "One Person, All People" include accounts from a woman who survived a military-perpetrated massacre, family members of soldiers who died in the conflict, a child of slain Shining Path militants, and a priest who accompanied indigenous Asháninka villagers as they fled insurgent violence.

Despite having goals that are broadly similar to those of Yuyanapaq—chiefly promoting awareness of how individuals and communities were affected by the violence—LUM's stylistic contrasts with the TRC exhibit are quite clear. As Jorge Villacorta noted in my interview with him, "there isn't much sorrow [*duelo*]" in the LUM exhibit, his words implicitly differentiating the memorial museum from Yuyanapaq. Curators' reflections conformed to the general view (documented in chapter 3) that Yuyanapaq was appropriate for its particular historical context, but that times had changed. Del Pino understood how critics might interpret the LUM's relative lack of graphic images from the war as reflecting official mandates or curators' "timidity," though he stressed that these decisions had to do with curators' desires to focus on how difficult histories were narrated in and from the present, a strategy that differed from the more documentational style of a truth commission or a human rights report. Members of the curatorial team also expressed skepticism about the way that striking images of violence might provoke an immediate reaction in visitors rather than promote awareness of the potential blurriness of categories of victim and perpetrator. Del Pino and Eliana Otta (n.d.) comment on the curatorial team's strategy in a coauthored publication: "Being the year 2014, we considered that the audience needed to pause, with greater calm, before the images, videos, and objects, observing them with a different openness and reacting to them not only with surprise and indignation, but with questions and an eagerness to discuss the matter."

Curators also emphasized the importance of telling histories of the violence "from the communities." The LUM's depiction of the Ayacucho town of Putis is illustrative of this approach. Putis suffered violence at the hands of Shining Path and the state, with the most notorious incident being the mass killing of at least 123 residents by members of the Peruvian armed

forces on December 13, 1984. The LUM's representation chronicles this tragic history but also documents community members' return to the town in 1998 (following its abandonment in the wake of the 1984 massacre) and subsequent efforts to exhume and provide proper burials for the war dead. Additionally, a short video includes Putis residents commenting on the community's current challenges and aspirations. "Now we have a dream," local leader Gerardo Fernández Mendoza explains, "that as a symbolic reparation of how much we lost, the district of Putis is created" (referring to the process of establishing Putis as a "district," a legal classification in Peru that has implications for accessing state services). Villacorta and others who met with *comuneros* from the Ayacucho village when implementing this part of the exhibition recounted how community members expressed a preference for the inclusion of contemporary developments and did not wish to be represented as victims (see also del Pino and Otta n.d., 2018).

A commitment to the principle of telling the war's history from the present also informed aspects of the curatorial process, such as recording and editing the brief life histories that appear in the "One Person, All People" room. Elaborating on this decision, Del Pino and Otta (n.d.) note that the curatorial team was sensitive to how the image of the "bereaved, passive victim who is trapped in the past" could serve to reproduce stereotypes and inhibit recognition of Peruvians whose lives were deeply affected by the violence. Georgina Gamboa, for instance, tells the visitor of how she gradually came to terms with having a child who was the result of sexual violence perpetrated by police forces in the Ayacucho town of Vilcashuamán, but also speaks about her ongoing search for justice and the experience of being a grandmother (see also Silva Santisteban 2008:69–92). Pascual Romaina, a soldier who was disabled in an MRTA attack in 1992, recalls feeling embarrassed to go out in public upon returning to his hometown of Iquitos until a former classmate (who would later become his wife) summoned him out for her birthday party. He currently works making prosthetic devices for people who cannot afford them.

Although such aspects of the permanent exhibition convey the artificiality of delimiting the violence to events occurring between 1980 and 2000, members of the curatorial team and other former LUM workers have noted that the High-Level Commission remained adamant in its decision regarding the depiction of historical conditions that contributed to the armed conflict.[3] Reflecting on the inclusion of "structural causes" in the LUM exhibit at a 2016 roundtable, literary critic and former LUM employee Alexandra Hibbett observed that "we did it a little, with a text or a photo, but of course, it's not at the center of the space," as she and others would have liked.[4] Some interviewees mentioned subtle stylistic decisions, such as

the use of adobe for the exhibition wall in the "One Town, Many Towns" section, which was meant to portray an atmosphere of rural abandonment.

Education emerged as a theme through which the LUM display could gesture toward how historical legacies of exclusion—ones that continue to characterize Peru today—contributed to the rise of Shining Path and the conflict's escalation. Del Pino commented on the team's approach in my interview with him, observing that one could be "smart" when it came to the High-Level Commission's prohibition. With education, "you open up a space to [discuss] the context, because the violence can't be understood without the process of political and ideological radicalization" that led to Shining Path's emergence. He elaborated on this point:

> So when you see that room, this part on education ("Violence and the Educational Sphere"), it has the university (San Cristóbal University of Huamanga), [Abimael] Guzmán is there in the 1960s, there are two emblematic works (studies) that are like insurgent omens . . . and later you see [rural] schools in a state of poverty and abandonment. And on the other side [of the exhibition hall] you have the fingerprints of the Uchuraccay villagers [indicating illiteracy], which shows you a little bit of that other state of abandonment . . . of the countryside, where the violence is going to be concentrated.

Tactics such as the ones described by del Pino for education were ways of navigating, even resisting, the High-Level Commission's official position.[5]

The exhibition also includes the theme of political mobilization among victim-survivors. A second-floor panel on ANFASEP (National Association of Relatives of the Kidnapped, Detained, and Disappeared of Peru; recall chapter 4) describes the organization's founding in 1983 as well as the group's establishment of a cafeteria to feed the children of those affected by war. The text appears over a large, black and white image of ANFASEP members protesting in the main plaza of Ayacucho to demand the return of their disappeared relatives. The display is sonically accompanied by the arresting looped audio of ANFASEP mothers singing the organization's hymn, "Until When, Lost Son" (*Hasta cuando, hijo perdido*). In a video-recorded account on the first floor, the organization's late iconic leader Angélica Mendoza de Ascarza declares in Quechua, "What I want to know is why they disappeared my son."

ARMED STATE ACTORS

In line with earlier declarations made by authorities such as Diego García-Sayán, the LUM includes a section on the Chavín de Huántar rescue operation, along with other representations that convey themes of heroism

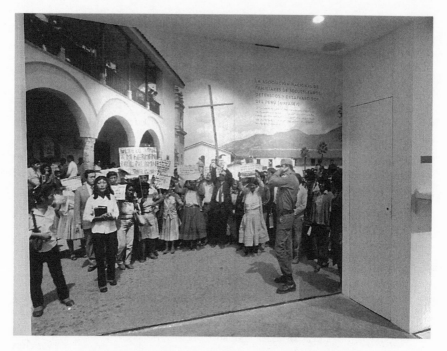

Display on ANFASEP in LUM permanent exhibition.

and sacrifice. A panel on the second floor includes a description of the 1997 raid of the Japanese ambassador's residence and a reproduction of the letter deceased commando Juan Valer wrote to his family before the operation (chapter 4). The inclusion of the display was an "explicit request" of the High-Level Commission (Ledgard, Hibbett, and de la Jara 2018:49) and could be understood within the commission's requirement that the LUM show the "defeat of terrorism" (one of the body's eleven approved topics). Members of the curatorial team were ambivalent about devoting a significant section of the museum to the Chavín de Huántar rescue and were concerned about the potentially celebratory tone of such a display. Something of a middle ground is reached, if awkwardly, in this section: a text declares that the Chavín de Huántar operation is "recognized the world over as a strategic model for hostage rescue," but mentions judicial processes stemming from alleged extrajudicial executions committed during the raid (Milton 2018:157).

Elsewhere, one can find references to the armed forces' "fundamental role" in defeating the insurgent groups and to the military's civic works projects in rural communities ("in some parts of the country the armed forces were for a long time the only connection between the state and the population"). A panel on "Responses to the Violence from the State" includes a

direct quote from the Standing Commission of Peruvian Military History (CPHEP)–produced *In Honor of the Truth* (2012:331) report that declares, "The Peruvian Army condemns acts against the law committed by certain members of the armed and police forces who acted individually and not as part of an extermination policy dictated by a military authority."[6] Critics have commented on potentially-exculpating language, such as a reference to the armed forces' "slow learning process" (*lento aprendizaje*) in combatting the insurgent groups—the text appearing below a photo from a highland stadium that served as a site of torture and executions in the 1980s (Milton 2018:156–157). In these instances and others, it is hard not to interpret the LUM's content as reflecting sustained efforts undertaken by the Peruvian armed forces to advocate for their vision of the internal war (Milton 2018). A military narrative seeps into the human rights-oriented museum, if only in select panels and testimonies.[7]

Several curatorial decisions emerged in and through dialogue with representatives from the armed forces. As Ledgard, Hibbett, and de la Jara (2018:36) state in a report published after the LUM's inauguration, the views of entities such as CPHEP (chapter 4) were "taken into account" by the curatorial team, though armed state actors did not "dictate the content" of any particular display. In a meeting with the General Commanders of different branches of the Peruvian military, representatives asked for the withdrawal of a photo where General Nicolás Hermoza Ríos (convicted on corruption charges and for involvement in the 1991 Barrios Altos massacre in Lima) appeared in a military uniform (2018:52). The curatorial team acceded to a request that a photo in which Hermoza Ríos appears in civilian dress be used.

Another instance where military perspectives had an identifiable effect on the curatorial process related to the incorporation of Mauricio Delgado's artistic work, A Day in Memory (Un día en la memoria), which presents war-era abuses that took place on nearly every calendar date of the year.[8] Curators nixed plans to include this work after a representative from CPHEP objected to the disproportionate representation of state-perpetrated atrocities in Delgado's production (Ledgard, Hibbett, and de la Jara 2018:52). The decision could be situated within a climate where members of the curatorial team (notably Villacorta and del Pino) had been wary of the use of art—and activist or "ideological" art in particular—in the permanent display. With few exceptions, such as an Andean retablo produced by Edilberto Jiménez and ceramic pieces crafted by Rosalía Tineo, the LUM exhibition features few artistic works.

In other cases, LUM staff and curatorial team members stood firm in decisions that were unpopular with military representatives. A key example was the inclusion of Putis as one of the communities profiled in the "One Town, Many Towns" display. CPHEP requested that Putis be replaced by

the experience of Accomarca, an Ayacucho community that was the site of a 1985 massacre that had long been recognized as an example of army-perpetrated atrocities in the Andes. Recounting this moment in the project's history, Ledgard, Hibbett, and de la Jara (2018:52) underscore the intervention of High-Level Commissioner Hilaria Supa who, "speaking in the name of victims and from the authority she had being a representative of the most affected regions and sectors, declared the necessity of Putis being represented in the exhibit."[9]

Representatives from the armed forces also expressed disapproval of the curatorial team's decision concerning the use of the word "terrorism" in the permanent exhibition. Following internal discussions on the topic (del Pino and Otta n.d.) the curatorial team decided to employ the term to describe actions as opposed to individuals or an era (e.g., "the years of terrorism"). The position generated resistance from the military and among some members of the High-Level Commission (Ledgard, Hibbett, and de la Jara 2018:50), but the final exhibition script reflected the curatorial team's conclusion, which was grounded in a sensitivity for the way that "terrorist" could dehumanize members of insurgent groups and "years of terrorism" could minimize the violence of armed state actors (recall chapter 1). The exhibition uses terms such as "years of the violence" and "the cycle of political violence" to describe the historical period it depicts, avoiding "terrorism" as well as the polarizing "internal armed conflict" used by the TRC (Milton 2018:161).[10]

Where the curatorial team took much care in preparing texts and selecting images for the exhibition, an awareness of potential distortions or misinterpretations extended to those charged with implementing the team's vision. Museographer Juan Carlos Burga recounted a telling example of how this sensibility informed the process of assembling the exhibit.

> When we were filling the acrylic urns that are around the space for the disappeared with the belongings of the disappeared, there's that passageway. And one of the faces of the cube goes directly to the passage. I remember that we were deciding how to fill the slots on the cube, because there were more slots than belongings—some of them were going to remain empty. So we were selecting where things would go and I remember that in the staging we decided to locate the belonging of a naval officer toward the passageway because we saw that there were too many possessions from civilians there . . . as if we hadn't balanced it out.
>
> So we said, "better to put the belonging"—I think it was a uniform—"better to put a uniform from this naval officer here." To balance it out a bit.
>
> We didn't have any reason to. But already within the [computer] chip here (signaling to his head)—so that they don't think we're privileging

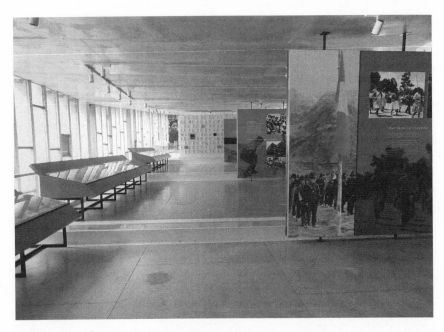

LUM second-floor exhibition hall.

Tomes of Peruvian TRC *Final Report* displayed alongside *In Honor of the Truth* in LUM section on TRC and Yuyanapaq, December 2015.

civilians who can be confused with terrorists—we decided, "better to put someone from the military." . . . In a museum of this kind one has to be careful with everything.

Thus, minor, "devilish details" of exhibition design (Moser 2010), such as the placement of an article of clothing or the prominence given to a particular photo, demanded a degree of care that was informed by knowledge of the fault lines of Peruvian memory debates.

Some of the depictions of the military sketched above, which can be understood with reference to institutional positions and discourses documented in previous chapters, have prompted critics in Peru's intellectual and human rights communities to consider the LUM a significant step backward with respect to official representations of armed state actors' role in the violence. As Milton (2018:198) observes, "that the Armed Forces can claim their own victimization and argue the shared responsibility of all society in the violence in a national place of memory" is indicative of the extent to which institutional representatives "have successfully curated a past that is much less damning than that present in the [TRC] *Final Report*." To former workers and those more sympathetic to the LUM, however, the incorporation of military and police perspectives in the exhibition—often couched in the language of memory and plurality—continued to be a feature that differentiated the museum from the TRC in a positive sense.

It can also be noted that, consistent with tendencies documented in the introduction and in chapter 5, the representation of the police's role in the conflict is marginal in the LUM in comparison to that of the armed forces. (The former is more or less limited to a panel on the capture of Abimael Guzmán and a few accounts appearing in the "One Person, All People" section). It is a disparity that is symptomatic of differences in institutional power and prestige as well as a tendency to subsume police perspectives within those of a "militares" interest group in discussions about the museum's contents. Some "dangerous objects" from the DINCOTE collection were eventually shown at the LUM as part of a 2016 temporary exhibit (Shards of Hate [Esquirlas del Odio]) (Quintanilla 2017), apparently without event. No pieces from the police museum appear in the LUM's permanent exhibition.

PERCEIVED FLAWS AND THE EXPERIENCE OF INSTITUTIONAL AND POLITICAL LIMITS

Perhaps owing to my previous conversations with Miguel Rubio and Karen Bernedo, I expected the accounts of former curatorial team members to center on themes such as institutional constraints and the challenges of working within a state museum project. I instead encountered a quite different set of narratives. In a 2016 roundtable on the LUM at Lima's Catholic

University, curatorial team member Víctor Vich noted that he and others on the team were cognizant of the possibility of having to modify their positions in accordance with state discourses or parameters set forth by the High-Level Commission. The cultural critic emphasized an unexpected degree of autonomy, however. "In the end . . . I think all of us said, 'What we've done, yes, it is what we wanted to do."[11] In a 2017 interview, Del Pino similarly downplayed the difficulty of having to operate within official guidelines. He could see, for example, how outsiders might perceive decisions concerning the non-use of terms like "perpetrator" as the result of pressure exerted from the High-Level Commission or the armed forces, but such choices, in reality, had to do with intellectual positions and representational strategies established within the curatorial team. An advantage they had, del Pino told me, was that the existing scheme was general ("it was like two little pages," with broad topics like "'Offering,' 'Education,' 'Origins'"), which meant that the curatorial team had considerable flexibility in deciding on the specific content for different topics. Several interlocutors also emphasized the relative lack of a uniform state narrative on the violence, a reality that made finding an appropriate curatorial voice difficult (see, for example, Ledgard, Hibbett, and de la Jara [2018:60–62]) but allowed for more creative freedom than some had initially envisioned.

These accounts are, of course, "after the fact" and can be understood within a particular phase in the LUM's history. A consequential decision made by the curatorial team, for example, was to approach the commission-approved list of eleven topics in a less direct fashion than Miguel Rubio had, with curators later conveying to the High-Level Commission how each of the topics were expressed in the script (at times indirectly and across various sections). Further, some interviewees observed that the High-Level Commission appeared to ease up on certain guidelines and prohibitions as the project evolved. A sense of urgency likely combined with a certain degree of fatigue following years of deliberation about the script ("they got tired," was how one interlocutor put it). Another member of the curatorial team told me that had the right-leaning Leopoldo Scheelje continued to play as active of a role in the High-Level Commission as he had in earlier stages, decisions such as the one regarding the use of the word "terrorism" likely would have faced greater resistance. Nearly all members of the curatorial team I interviewed underlined Denise Ledgard's role as an intermediary between them and the High-Level Commission, with the national director intervening at critical junctures to advocate for the team's positions.

It is also possible that curators' accounts of relative autonomy and independence can be understood, at least to a limited degree, as reflecting their early awareness of "common sense" assumptions that had emerged within the LUM prior to their work on the exhibition script (e.g., about the relationship

to the TRC, the need to display military heroism, the absence of perspectives from insurgent groups, and so on.) Indeed, nearly all of the official positions the curatorial team had to navigate could be understood in relation to earlier discussions documented throughout this book. Perhaps sensing how certain conventions and ingrained assumptions might have affected the curatorial process, Jorge Villacorta expressed regret over the lack of explicit attention to former president Alan García's role in the political violence. This could be contrasted with the LUM exhibit's extensive documentation of crimes perpetrated by Alberto Fujimori. The curator told me he viewed El Frontón (the 1986 massacre of prisoners following Shining Path-orchestrated riots [e.g., Feinstein 2014]) as a decisive moment in the political violence and that, as the eldest member of the curatorial team, he felt personally responsible for not representing this event adequately. It was not even that the LUM exhibition placed García in hot or "lukewarm water," when it came to the (now deceased) leader's first presidency; "it's cold water," Villacorta lamented.

In a somewhat similar way, Juan Carlos Burga, whose involvement in the project dated back to my main period of fieldwork and the Rubio-authored proposal, talked about the progressive disappearance of "the enemy" in exhibition proposals over time. He recalled that early drafts included a panel that displayed Shining Path paraphernalia and iconography prominently, almost "like an altar"; however, the presence of such images passed through different stages, "from being something totally frank and direct to something more subtle—like in a text—to something that's not there." The museographer did not critique this curatorial decision but found it curious, commenting that the representation of enemies is a recurring issue at memorial museums dedicated to events like the Holocaust or the September 11 attacks.[12]

As is evident in Burga's and Villacorta's recollections, members of the curatorial team and others were aware of the significance of their work, and were quite candid with me when sharing their views on the LUM's potential shortcomings. For example, several curators and former LUM employees indicated they were more pleased with the exhibition's experience-focused first floor than they were with the implementation of the more thematically organized second floor. Del Pino described the first floor as the "heart" of the exhibition and sensed that visitors responded most strongly to this part of the LUM. Some observers interpreted the second floor's shortcomings as being rooted in the lack of a focused curatorial message for this section, with an attempt to include diverse historical events and phenomena resulting in a less than coherent representation. It is perhaps the case that, as Erica Lehrer (2015:1199) describes for the Canadian Museum of Human Rights, "inclusivity takes precedence over coherence" in the LUM's second-floor displays.

A number of perceived flaws and deficiencies, including the LUM's relative paucity of objects, were viewed as the outcome of a rushed implementation of the exhibition script. LUM workers faced an "immovable" December 2015 deadline (Ledgard, Hibbett, and de la Jara 2018:56) that reflected the wishes of international donors, along with an awareness of risks associated with not having the institution inaugurated before the presidential elections of 2016 (Keiko Fujimori would narrowly lose a runoff election to the more moderate Pedro Pablo Kuczynski that year). There was virtually no time to correct any potential errors, and funding shortages were particularly acute during the latter stages of the project. A few texts were not installed, and one of the life histories for the "One Person, All People" room could not be recorded in time to be included in the display (Ledgard, Hibbett, and de la Jara 2018:58). Juan Carlos Burga amusingly recalled his experience at the inauguration as a juxtaposition of everyone around him being happy and him constantly thinking of the tiny "mistakes" he saw everywhere.

The museographer also commented that he would have liked the LUM to have included a greater number of original objects—estimating that some 80 percent of items displayed were replicas or copies—but that it was impossible to obtain such objects in time for the inauguration. As Ledgard, Hibbett, and de la Jara (2018:57) point out, the LUM lacked protocols and staff for receiving donations from relatives of victims and other groups, and the museum project's relationship with different organizations was affected by Ledgard's sudden dismissal in June 2015.[13] Moreover, some groups that were willing to collaborate, such as CONAVIP (National Coordinator of Organizations of Those Affected by the Political Violence, the national consortium of victims' associations discussed in chapter 1), were contacted too late in the process to respond to LUM requests (Ledgard, Hibbett, and de la Jara 2018:57). Thus, many of the objects, artifacts, and documents displayed on the LUM's second floor were last-minute acquisitions of convenience. (Del Pino smiled as he recounted the rush to obtain materials to fill a second-floor display case "the week before the inauguration," with him and other members of the curatorial team scouring downtown Lima for display-worthy items.)

A small section on sexual violence, which includes short, printed quotes in Spanish and Quechua from victim-survivors and perpetrators was also the subject of self-criticism among curators. Devised in the later stages of the curatorial team's work in response the perceived absence of explicit attention to this issue, the display is less prominent than others appearing on the second floor. Curatorial team member Natalia Iguíñiz told me she was sympathetic to critiques she had heard about the display's location and the inadequacy of the photo appearing above it (which depicts urban segregation in Lima), though she felt the testimonies' diversity was effective in illustrating

the cross-cutting nature of sexual violence during the internal war. Another former LUM worker noted that the panel perhaps failed to show the agency of survivors of war-era sexual violence.

Some interlocutors' reflections pointed to a lack of institutional continuity following the museum's 2015 inauguration. The design of the "One Town, Many Towns" section, for instance, was intended to facilitate the periodic rotating in of exhibits on other affected communities (replacing the current display on Putis, Uchuraccay, and Asháninka communities) but this part of the exhibition has remained unchanged. The second-floor section on the disappeared (referenced in the Burga quote above) was meant to encourage the display of objects donated by relatives; however, many of the small glass cases that cover the exterior of this enclosed space remained empty at the time of my 2017 and 2018 interviews. Former curators and LUM workers interpreted this lack of appropriation largely in terms of the institution's failure to promote this feature of the exhibit during the museum's initial months of operation.

Other initiatives that fell by the wayside during the transition from project to functioning museum included the establishment of a board of trustees and developing a network with other memorial sites and museums in the country. Seemingly minor loose ends continued to affect visitors' experiences in the years following the LUM's inauguration, such as the museum's lack of audio guides and foreign language translations. Expressing concern over such issues in a 2018 interview, Ledgard told me that the LUM "was born, but it needs to grow."

POSTINAUGURATION LIFE, CONTROVERSY, AND NORMALIZATION

The incendiary rhetoric and smear campaigns that characterized the period of the TRC *Final Report*'s publication (Degregori 2011) were mostly absent as the LUM opened its doors and began to receive its first visitors. During the final stages of implementing the exhibition, planners sought to maintain a "relatively low profile" for the institution in order to avoid public criticism that could lead to further delays (Ledgard, Hibbett, and de la Jara 2018:58).[14] Although it was possible to find blogs and social media posts decrying the newly inaugurated LUM as a "terrorist" or "caviar" museum, there were no incidents or critiques that became elevated to the level of national scandal during the museum's first year of operation.

Reviews published in national media outlets generally corresponded with the expressed goals of planners and curators. In a column published in *El Comercio*, former minister of foreign affairs José García Belaúnde (2016), whose narrative appears in the "One Person, All People" room, contrasted the LUM's subtleties and attention to complex experiences of tragedy with

Yuyanapaq's more forceful depiction of the violence. Another reviewer wrote approvingly of how the LUM, "offers us not a place of certainties or that official truth that some require," but a representation that recognizes that, "divergences in ways of seeing and giving meaning [to the war] are part of today's reality and that one cannot claim the uniformity of all memories or try to generate a univocal one" (Jáuregui 2016:4).

The assessment that came up in more than one of my conversations with former curators and staff was that of Aldo Mariátegui, the right-wing pundit and perpetual critic of the "caviar left" who happens to be the grandson of Peruvian socialist thinker, José Carlos Mariátegui. The popular weekly magazine *Caretas* profiled Mariátegui as he visited the newly inaugurated LUM for the first time (Prado 2016). Though the article included some of Mariátegui's barbs (about the cost of the museum project, its location in Miraflores, etc.), the right-wing commentator seemingly found little objectionable in the permanent exhibition's content. "They've received the devil well," Mariátegui declared, adding that it was evident that the museum's planners had "decaffeinated the topic a little."

In my 2017 interview with Jorge Villacorta, the curator drew attention to Mariátegui's decision not to skewer the LUM in the *Caretas* piece, despite having had a prime opportunity to do so. Ledgard similarly recalled that Mariátegui had pilloried her and the LUM in articles published prior to the inauguration, but that his critiques ceased once he saw the final product. She knew that some Peruvians still viewed the LUM as a "caviar" institution or conflated it with the TRC, yet she was hopeful that this perception was changing as more people visited the museum. Former workers and curators generally shied away from using terms like "consensus" or "reconciliation" even as they expressed confidence that the LUM was more likely to create points of connection among Peruvians of diverse political-ideological leanings than an exhibit like Yuyanapaq.

The extent to which the average visitor's reactions to and interpretations of the LUM's permanent exhibition correspond with aspects of the curatorial vision (e.g., narrating the past from the present, attending to the pending work of justice and reparation) and recognize departures from a more documentational approach is a question that merits further research.[15] Consistent with the expectations of planners, visitors to the museum tend to be young people from Lima and the LUM routinely hosts visits from school groups. It is likely that a significant portion of LUM visitors, including adults who experienced the political violence during their lifetime, view the official museum's texts, images, and audiovisual materials as comprising an authoritative temple as opposed to the more open-ended space of reflection (Karp, Kreamer, and Lavine 1992) that planners envisioned. Alternatively, a number of visitors from activist and academic backgrounds I have

spoken with critique the LUM's relative lack of a central moral-historical narrative in comparison to other, similar sites such as Chile's Museum of Memory and Human Rights.

Perhaps more consequential than the LUM's permanent exhibition in terms of impact has been the museum's emergence as a hub for cultural activities and events that relate broadly to themes of diversity, inclusion, and human rights. Though the museum's esplanade never became a "truly public space" (contra the vision of figures like Fernando Carvallo) and its location in a section of Miraflores with little foot traffic remains an impediment, the LUM has become a vibrant center that regularly organizes film screenings, book presentations, talks and conferences, and commemorative events involving sectors affected by the violence. As predicted by planners, and consistent with trends in the museum world (e.g., Bunzl 2014), temporary exhibits (on topics ranging from the war's disappeared to Aymara agricultural rituals) have been vital for attracting repeat visitors and maintaining the LUM's relevance as a cultural institution.[16]

The topic of temporary exhibits and cultural events has also stimulated reflection about the LUM's goals and purpose among observers. During my brief visits to Lima in 2017, for example, several friends and interlocutors spoke of a temporary exhibit on Memories of the Rubber Boom (curated by Wilton Martínez) as a case in point. It was possible to establish links between this brutally violent period in the Peruvian Amazon (which began during the latter decades of the nineteenth century) and the country's late twentieth-century war, but to what extent did this exercise risk diluting the museum's commitment to promoting reflection on the history displayed in the LUM's permanent exhibition? Some interlocutors (commenting in 2017) expressed concern over the relative infrequency of exhibits and events at the LUM that related directly to Peru's political violence or themes of transitional justice.[17]

Later that year, it was a temporary exhibit of this kind that sparked the LUM's first major postinauguration controversy. Although critiques from right-wing sectors eager to brand the institution antimilitary or sympathetic to Shining Path had been diffused during the LUM's first eighteen months of operations, this changed rapidly in August 2017. A Fujimori-allied politician (Francesco Petrozzi) created a storm on social media when he critiqued the alleged anti-Fujimorista bias of Visual Resistance 1992, an exhibit produced by Karen Bernedo. Fallout from the episode would ultimately result in the dismissal of LUM director Guillermo Nugent.

Denise Ledgard found herself on the "other side of the desk" (Milton 2018:184) amid the controversy, working as chief of staff for the Ministry of Culture at the time. Like minister of culture Salvador del Solar, she opposed

any effort to censor the exhibit—Visual Resistance 1992 was displayed for the duration of its scheduled run at the LUM—but expressed her personal view that the display lacked historical rigor and evidenced a need for the LUM to develop protocols for its temporary displays.[18] The opinion was consistent with discourses emerging over the course of the project's history that positioned the LUM in contradistinction to the alleged *"panfletario"* (demagogic, literally "pamphlet-like") tendencies of artistic interventions like those of the Itinerant Museum of Art for Memory.

In less than a year the LUM experienced a new scandal, which came in the aftermath of political crises that resulted in President Pedro Pablo Kuczynski granting a pardon to Alberto Fujimori in December 2017 (eventually annulled by Peru's supreme court in October 2018) and leaving office in March 2018. In May 2018, conservative congressperson Edwin Donayre released video footage from a visit he made to the LUM (disguised as a victim of the Colombian armed conflict) that he presented as proof of the institution's supposed "apology for terrorism" and antimilitary bias. The video went viral despite offering no real evidence of such sympathies in the LUM exhibition or among the institution's staff.[19]

The scandal resulted in hateful, uninformed attacks against the LUM. These included an odious defamation campaign against participatory process researcher José Carlos Agüero, whose personal history as the child of deceased Shining Path militants was used to characterize him as a supposed Senderista collaborator within the LUM initiative. Right-wing politicians called for the construction of a "Heroes of Democracy" park in Lima that would pay homage to victims of "terrorism," a proposal that bore similarities to ideas floated nearly a decade before by the LUM's early opponents. President Martín Vizcarra's tepid response to the polemic (appealing to the memorial museum's need to be "plural, democratic, and tolerant" [Álvarez Rodrich 2018]) did not inspire confidence among the LUM's supporters. Former members of the museum's curatorial team drafted an open letter to the president in which they defended the LUM exhibition's neutrality and urged the executive branch to respect the institution's autonomy (La Mula 2018). Former High-Level Commission president Diego García-Sayán (2018) wrote a column entitled "LUM, Product of Peruvian Society," where he underscored the "intense process of dialogue with the most diverse sectors" that helped produce the institution.

Although opinions about the LUM in activist and intellectual sectors had vacillated for years between critical assessment of the institution and appreciation for having a permanent space in Lima devoted to memory and human rights, the Donayre controversy prompted even the LUM's most persistent critics to occupy the latter position, if only momentarily.[20] Former

TRC president and High-Level Commission member Salomón Lerner (chapter 3), whose absence at the LUM's 2015 inauguration ceremony was noteworthy, penned a column in defense of the institution, stating that protecting sites like the LUM was a "patriotic act" and "especially urgent when our government assumes a concessive attitude . . . in the face of a new campaign against memory" (Lerner Febres 2016). He added the suggestion that Peruvians complement their visit to the LUM with one to Yuyanapaq.

Not unlike processes of segmentation and fusion documented by an earlier generation of anthropologists studying lineage-based societies, the maximal threat of a right-wing campaign against the LUM engendered a collective response that transcended differences of opinion within progressive and human rights circles. "It's what's there," Ledgard told me in our 2018 conversation, adding that even critics from this sector understood that having a space like the LUM in Peru was no small achievement.

The controversies also revealed the limits of long-standing efforts to position the LUM as a neutral space that could serve to promote dialogue among different perspectives on the war. All the careful actions of planners, curators, and staff to account for military narratives or acknowledge perceived limitations in the TRC's work quickly became irrelevant in the maelstrom of controversy. Right-wing critics were able to place the LUM in the same category as the truth commission or productions like Yuyanapaq and the Ojo que Llora monument with relative ease. The LUM's institutional discourse on dialogue and multiple memories was drowned out by vociferous appeals from the usual *dramatis personae* of Peru's dominant memory camps.

Reflecting on the LUM's postinauguration trajectory and recent controversies, the observations of historian Kirsten Weld (2014) on Guatemala's Historical Archives of the National Police, which houses materials documenting state repression and rights abuses from the era of that country's civil war, are resonant. Not unlike the LUM initiative, the archive's development in the nation's capital faced an uncertain political climate and relied largely on funding from international donors. Critics and even some allies viewed the making of the police archive as an urban, elite endeavor whose relevance to pressing needs of justice and reparation in the country was not always immediately evident. Yet, similar to the experience of the Historical Archives of the National Police, the LUM's eventual normalization in Peruvian society could ultimately end up being one of the institution's main accomplishments (Weld 2014:249–250). A former member of the curatorial team described the LUM's existence and success as a "permanent surprise," given the country's political context. Visits to the museum reached record highs following the 2018 Donayre controversy and the LUM became registered in the Ministry of Culture's national system of museums later that year. This

increased visibility and institutional support by no means makes the LUM immune from political attacks and threats to its survival—a former employee was likely correct when he assured me that if a "slightly fascist" (*un poquito facho*) government came to power, the LUM would disappear. But a steady flow of visitors and broad engagement with different sectors of Peruvian society are helping sustain the memorial museum's intervention in public culture.

Beyond Peru, the LUM has become a reference point in an ever-evolving assemblage of memorial sites and museums in Latin America. The institution has hosted events such as a 2018 "International Meeting of Spaces of Memory" (with representatives from institutions in Argentina, Chile, Colombia, and Spain) and current and former LUM employees have participated in similar exchanges abroad. Moreover, the history of the LUM's construction, along with features of the museum's institutional discourse, is informing how other initiatives are creating representations of past violence. In Colombia, for example, planners at the National Museum of Memory (a state initiative currently in development), speak of the need to avoid institutionalizing an "official memory or an account of closed off truths" (CNMH 2017:27) and envision a "space that values dissensus and the plurality of voices" (2017:14). The authors of a report presenting conceptual guidelines for this memorial museum cite del Pino and Agüero's (2014) publication on the LUM when discussing themes such as the importance of representing a diversity of victim experiences and showing the agency of affected individuals and communities.[21] It is likely that future resemblances between Colombia's National Museum of Memory and the LUM will have as much to do with this cross-fertilization of approaches and curatorial strategies as they do with shared characteristics in the countries' experiences of armed conflict.

FROM DARKNESS TO LIGHT

A feature of the LUM's architectural concept, one that designers Sandra Barclay and Jean Pierre Crousse have expounded on in interviews and presentations, is that the visitor to the memorial museum takes an ascending route that begins at the ground floor and culminates at the building's rooftop. The visitor therefore has to make a decision to continue exerting the effort necessary to move up the structure's ramps and see the full exhibition. The open-air ending, complete with a view of Lima's cliffs and the Pacific Ocean, is meant to symbolize the country's present, with a "*desde abajo hasta arriba*" (from below to above) circuit standing for Peru's transition from a dark, violent history to the light of peace and democracy.

Although a number of early contributors to the project embraced this idea (the first exhibition script [chapter 1] being an example), by the time of my main period of fieldwork LUM workers were more likely to speak of

how the building's narrative presented a challenge or impediment. How could the LUM be a celebration of democracy when the violence took place during three democratically elected governments? What about present-day legacies of the armed conflict and ongoing forms of violence? How could the curatorial team avoid presenting a "happy ending" to the war but at the same time give the visitor a sense of hope for the future?[22] To what extent would exhibition designers remain limited by, or perhaps even trapped in, the architecture's narrative? The final curatorial team would ultimately attempt to "interrupt" the visitor's ascending route with dark, enclosed spaces on the second and third floors as part of an effort to complicate a simplistic reading of the nation's present. Commenting on the process of designing the enclosed commemorative space on the third floor, for example, Natalia Iguiñiz recalled the team's intention to "break up" the building's narrative of an "overcome reality," so that the exiting visitor would experience the light more as a shock than as a smooth transition.[23] One of the final displays the visitor encounters on the second floor ("Facing the Future") includes quotes such as, "The state doesn't listen to us," and, "Forty graves have been found in Putis but only three have been exhumed."

This book has documented some of the ways that individuals in and around the LUM sought to avoid a darkness-to-light tale of modernity that would present the history of Peru's violence in an authoritative and univocal fashion. At the same time, it is my hope that this study has demonstrated some of the challenges—perhaps even the impossibilities—of escaping this mode of representation in the context of a national museum project. The LUM initiative, like memorial museums throughout the world, struggled to channel the difficult past into a national future that would be premised on respect for human rights and recognition of past injustices. In doing so, the project called on the participation of different groups and the incorporation of diverse narratives, with memory being the principal framework for organizing such efforts. Rather than seeking to produce a definitive synthesis of the conflict's history, workers and intellectuals at the LUM came to direct much of their attention to the management of diverse memories of the war, guided by the assumption that the proper arrangement of narratives and perspectives would allow Peruvians to identify with—if not agree upon—the account presented in the permanent exhibition.

An argument I have sustained throughout the book is that the LUM initiative's embrace of memory discourse can be understood as a reconfiguration of state power as opposed to evidencing a decline in the relevance of the nation-state in an age of globalized human rights museums. In the absence of official perspectives or forceful assertions about the war's history, the work of creating a national representation at the LUM operated to a great extent

through the definition and regulation of different memories and their bearers. As Ledgard, Hibbett, and de la Jara (2018:62) acknowledge, the museum project "could have neither the voice of the armed forces nor of civilian victims"— nor, for that matter, that of the TRC—in developing the permanent exhibition. Victim-survivors, representatives from the armed forces, and Yuyanapaq advocates became constructed as valued but subjective interlocutors, a process that was often enacted through authoritative languages of encompassment and appeals to international principles and norms.

At the same time, my investigation has sought to locate broad questions of memory and state power in the actions, decisions, and perspectives of specific individuals, many of whom knew or interacted with one another in some way. The book has given a sense of how these people have engaged with dilemmas associated with the making of inclusive national representations and have often done so quite thoughtfully, and with an abiding concern for justice, human rights, and Peru's future. To dismissively characterize the LUM as a hegemonic "state project" or its development as an elite Limeño affair can erase the seriousness with which planners and workers approached their task, not to mention the diversity of those who contributed to the initiative.

It is also reasonable to ask how and to what extent the strategies and rhetoric adopted by planners and workers were structured by political and economic conditions surrounding the LUM's creation. Would it have been politically possible, for instance, to produce an exhibition focused on "national history" or "truth" given the polarized nature of Peruvian memory debates and elites' continued refusal to acknowledge basic historical realities of the war? Was there something inevitable about the way that memory came to be associated with plurality as much as it was with notions of justice, accountability, and intergenerational transmission at the museum project?

Taking into account such considerations, it remains important to reflect on the implications of the LUM's approach. That is to say: What were some of the principal consequences of the museum project's use of memory as a framework for addressing the violent past? What phenomena did "memory" potentially obscure or push to the sidelines? In these concluding paragraphs I try to synthesize some relevant observations from my research.

Perhaps most immediately, the rhetoric and practices I have analyzed raise fundamental issues about who is ultimately accountable for the representations that appear in the LUM's exhibition halls. The participation of different actors in the making of the script (the curatorial team, the High-Level Commission, participatory process researchers, and consulted groups)—along with references to this participation—created a situation where authorship and accountability became dispersed in ways they would not have been had the project advanced with a more clearly identifiable curatorial-institutional

voice. Questions of coherence aside, one can imagine a quite different scenario had the LUM's workers embraced the role of broadcasters rather than managers.

The LUM's emphasis on dialogue, plurality, and the incorporation of diverse memories could limit critical reflection on moral and epistemological differences among the perspectives the institution surveyed; this emphasis also served to naturalize foundational omissions in debates about the museum. Chapter 4 examined this first problem through attention to how victim-survivors and representatives from the armed forces became positioned as interest groups (despite clear differences in the nature of these sectors' relationship to the violence), whereas chapter 3 focused mainly on how those advocating for an authoritative, human rights-oriented account came to be viewed as bearing "one narrative among many." Those developments did not result, as some had feared, in a permanent exhibition that sought to minimize state violence or relativize truths about the war, but it is easy to envision a set of circumstances in which "memory" might have become conjoined to such agendas.

The horizontalizing tendency in discussions involving the LUM's accepted interlocutors can be contrasted with the foundational—and less often discussed—divide established between the project and perspectives considered antithetical to the institution's goals. These included the memories of (unrepentant) former insurgents, hardline Fujimori-supporters, and some of the more conservative elements within the Peruvian armed forces. Particularly in the case of former members of Shining Path and the MRTA, one can appreciate how recollections of Peru's internal war are "strongly affected by the knowledge of realized outcomes" (Kernaghan 2009:260), namely the defeat of insurgent groups and the "futures past" their actions brought about. Common sense notions about the limits of inclusion in the country's public sphere meant that LUM officials felt little need to question or justify why some memories of war or certain types of human rights abuses did not have to be considered for incorporation in the LUM's display.

Finally, another set of consequences relates to practices of distancing and idioms of neutrality that emerged as the official museum became conceptualized as an entity for managing various memories. As chapters 1, 2, and 5 documented how "history" and "museum" became ideas against which LUM representatives typically defined the project's goals, I have demonstrated throughout the book that notions of objectivity and neutrality remained salient in discussions about how to represent the violence. Instead of being directed toward the analysis of historical documents or used to refer to the account that LUM workers would eventually produce, however, these ideas were often deployed to characterize the imagined subjectivity of different groups and their narratives. The condemnations of "activist artists" reported

in this chapter represented a later instantiation of this phenomenon. Some important examples notwithstanding (e.g., Hilaria Supa's intervention concerning Putis), LUM representatives rarely spoke simultaneously from a place of personal experience and from a position of state authority. More often than not, the former space of enunciation seemingly denied access to the latter in an equation where interest groups offered experience and testimony while curators, administrators, and researchers assembled such perspectives in a detached, transparent, and authoritative fashion.

As one can observe in a general way how the memorial museum form becomes political in Peru through its association with transnational discourses and the LUM's very existence declaring that "the violent past is behind 'us' and that healing . . . can begin" (Sodaro 2018:172), this ethnography underscores how a tension between "memory" and "from darkness to light" becomes a source of reflection, debate, and creativity at memorial sites and museums around the world. The experiences and dynamics I have tried to register offer but one set of potential variations on how relationships involving politics and public culture might be unfolding as planners, workers, and members of different sectors debate similar sites and museums in places like Colombia, the Gambia, and the United States. In tracing such connections, we must appreciate the historically contingent nature of contemporary waves of memorialization (e.g., Williams 2007:22) and recognize enduring linkages between the nation-state and modernity. How long until the LUM and the memorial museum concept it gives expression to become "things of the past," the focus of people, institutions, and ideas that declare themselves to be of the present?

Acknowledgments

FIRST, I WISH TO thank the many Peruvians who shared their time and insights with me, particularly those at the LUM who made this research possible. I will always be grateful for how people whose life trajectories intersected with this initiative in one way or another allowed me to learn from their work, experiences, and perspectives. Although my decision to maintain the anonymity of many interlocutors prevents me from offering an exhaustive list of names, I hope all of these individuals know who they are and have some sense of how appreciative I am. Fernando Carvallo and Denise Ledgard deserve specific mention as national directors of the LUM who granted me access as a researcher. The collaboration of others involved in the project, including José Carlos Agüero, Karen Bernedo, Ponciano del Pino, and Miguel Rubio, was also critical to the success of my main period of research. Salomón Lerner, Sofía Macher, and Charo Narváez were especially generous in sharing their perspectives as members of Peru's human rights community.

A number of friends and colleagues from my time in Lima deserve mention as well. My experience as a researcher was enriched by an affiliation with the Institute of Peruvian Studies. Conversations with IEP-affiliated scholars, including Ludwig Huber, Ramón Pajuelo, Tamia Portugal, Pablo Sandoval, Jaime Urrutia, and Víctor Vich helped me at various stages. I also learned a great deal from attending sessions of the IEP's Grupo Memoria. The former organizers of this group, María Eugenia Ulfe and Ponciano del Pino, have both offered valuable intellectual support over the years (Ponciano doing so "from within" the LUM for a time, and later on as a colleague in Santiago). Marie Manrique became a wonderful interlocutor early on in my research, and her continued interest in this project helped propel it forward. Conversations with Alexandra Hibbett in Lima and elsewhere have also helped me think about memory and memorialization in new ways.

Patricia Fernández is a fantastic *compañera de casa*, and I thank her for many stimulating discussions as well as her willingness to share her knowledge of Peru with me. I also appreciated the company of Christin Scherer, Dave Holmes, Boris (Patricia's cat), and others at the Residencial San Felipe in 2013. Juan Carlos Callirgos, Themis Castellanos, Sebastián Aragón, Vanessa

Cuentas Portocarrero, and Juan José Callirgos made every effort to ensure that I felt at home during my fieldwork, and I thank them for their kindness and hospitality. Others in Lima whom I wish to acknowledge for a variety of reasons include Jeanine Anderson, Ruth Borja, Raúl Castro, Jorge Cornejo, Karina Fernández, Carla Granados Moya, Nathalie Koc-Menard, Iván Ramírez Zapata, and Pilar Taboada Arévalo.

Reflecting on my experiences in Ayacucho, I am grateful to Maribel Ascarza Mendoza, Roberto Ayala Huaytalla, Karina Barrientos Suárez, Feliciano Carbajal Salcedo, Jefrey Gamarra, Adelina García, Edilberto Jiménez, the late Emilio Laynes, and Heeder Soto for myriad contributions to this research. Feliciano Carbajal Salcedo also provided research assistance during the Ayacucho portion of my dissertation work.

The main period of fieldwork that led to this book was supported by a Dissertation Fieldwork Grant from the Wenner-Gren Foundation. I also received a number of internal grants from the University of Florida (UF) to support trips to Peru in 2009, 2010, 2011, and 2014. These include a Carter Field Research Grant and a Foreign Language and Area Studies (FLAS) Award from the UF Center for Latin American Studies, along with the Polly and Paul Doughty Award from the Department of Anthropology. A portion of the dissertation write-up was funded by UF Anthropology's Elizabeth Eddy Dissertation Fellowship in Applied Anthropology. One of my short, postdissertation research visits was supported by a 2017 travel grant from the Center for Intercultural and Indigenous Research (CIIR) (ANID/FONDAP/15110006).

As a graduate student at the University of Florida, I benefited from the support of friends, colleagues, and mentors. My advisor, Florence Babb, was a constant source of inspiration and encouragement. Florence's distinguished career as a Latin Americanist anthropologist and scholar of Peru, along with her generosity as a teacher, mentor, and colleague, set a high standard that I could only hope to match. It has been wonderful to keep the conversation going as our interests have evolved since our time together at UF. Richard Kernaghan's creativity, eclecticism, and exacting standards as a teacher and scholar pushed me to question, and at times move outside of, some of my intellectual comfort zones as an anthropologist. His generous and perceptive comments on my dissertation remained close at hand as I wrote this book. Mark Thurner was, like Richard, a Peruvianist anthropologist who consistently encouraged me to think beyond Peru and beyond anthropology. His support for this project meant a lot to me. Jack Kugelmass, perhaps more than anyone else, helped me begin to expect more of myself as a writer and ethnographer. Other professors at UF who contributed to my training include Sharon Abramowitz, Russ Bernard, Brenda Chalfin, Susan deFrance, Faye Harrison, Michael Heckenberger, Michael Moseley, Augusto Oyuela-Caycedo, and Tamir Sorek. A number of fellow

graduate students helped me in various ways during my time at UF: Gina Alvarado, John Anderson, Judy Anderson, Caitlin Baird, Becky Blanchard, Stéphanie Borios, Marlon Carranza, Pepe Clavijo Michelangeli, Amanda Concha-Holmes, Tatiana Gumucio, Jeff Hoelle, Justin Hosbey, Alissa Jordan, Kate Kolpan, Eshe Lewis, Ellen Lofaro, Meredith Main Sá, Meredith Marten, Rafael Mendoza, Ryan Morini, Sarah Page, Danny Pinedo, Tim Podkul, Jamie Lee Robinson, Alan Schultz, Jessica-Jean Stonecipher, Erik Timmons, Brian Tyler, Jason Wenzel, and Matt Watson. It is quite possible that I would not have made it through graduate school without the friendship of Lizzy Hare, Nick Kawa, and Camee Maddox-Wingfield.

I also wish to acknowledge the students and faculty I was able to get to know at the University of Connecticut's El Instituto: Institute of Latina/o, Caribbean and Latin American Studies, where I was a visiting scholar during the 2014–2015 academic year, and at the Department of Anthropology at Yale University, where I regularly attended the Ethnography and Social Theory Colloquium Series and other events while writing my dissertation. My first post-PhD position was coordinating a study abroad program in Quito, Ecuador (affiliated with the Department of International Development Studies at Trent University). I am grateful to Chris Beyers, María Larrea, Winnie Lem, and my Trent-in-Ecuador students for helping make that job an enriching and memorable experience.

Between 2016 and 2020 I was an assistant professor in the School of Anthropology at the Pontificia Universidad Católica de Chile, where I benefited from a vibrant intellectual environment as well as generous friends and colleagues. This position also provided me with a measure of stability in a time of increased precarity among academics, without which this book likely would not have been completed. I thank all of my Antropología UC colleagues for their support, and I wish to acknowledge Marjorie Murray specifically for her extraordinary leadership as department chair. Guidance, suggestions, and encouragement from Giovanna Bacchiddu, Piergiorgio Di Giminiani, Diana Espírito Santo, Marcelo González, Hugo Ikehara, Helene Risør, and Cristián Simonetti were particularly important as I advanced with the process of transforming my dissertation research into this book. Working with excellent UC anthropology students, including my former research assistants, Martín Aguirre Galilea, Iván Ahumada Herrera, and Francisca Moraga Núñez, also helped me think through various aspects of this research. Martín Aguirre Galilea read and provided feedback on drafts of each of the book's chapters, and his thoughtful comments improved the manuscript significantly. He even managed to take the book's cover photo when visiting Lima during the first part of 2020! Beyond Antropología UC, my colleagues in the Center for Intercultural and Indigenous Research working groups on Difference, Coexistence, and Citizenship and Cultural Heritage

provided opportunities to share versions of this work and helped ease my transition to academic life in Chile.

I am also appreciative of the encouragement and generosity of numerous colleagues outside of my immediate academic network. I offer a list of names, knowing that it cannot possibly be complete: Teferi Adem, M. Cristina Alcalde, Joyce Apsel, Jennifer Ashley, Sally Babidge, Martin Behringer, Joshua Bell, Cristóbal Bonelli, Pablo Briceño, Ronda Brulotte, Emily Buhrow Rogers, Jo-Marie Burt, Baird Campbell, Eric Carbajal, Quetzil Castañeda, Kelsey Chatlosh, the late Dave Clements, John Collins, Enrique Cortez, Amy Cox Hall, Marisol de la Cadena, Alejandro de la Fuente, Paulo Drinot, Carol Ember, Jennifer Erickson, Suzanne Godby Ingalsbe, Eduardo González, Emilia González-Clements, Candace Greene, Shane Greene, Elizabeth Hallam, Richard Handler, Thomas Blom Hansen, Erik Harms, Nell Haynes, Christopher Heaney, Jane Henrici, Michael D. Hill, Carmen Ilizarbe, Jason Baird Jackson, three anonymous reviewers from the *Journal of the Royal Anthropological Institute*, Melissa Johnson, Ieva Jusionyte, Carol Kidron, Jennifer Kramer, Anne Lambright, Miguel La Serna, Jessaca Leinaweaver, Kim Lewis, Walter Little, Kyrstin Mallon Andrews, Bruce Mannheim, Kairos Marquardt, Sam Martínez, Carlota McAllister, John McDowell, Elena McGrath, Kathleen Millar, Fiorella Montero-Diaz, Jorge Montesinos, Elliott Oakley, Robert Oppenheim, Alfonso Otaegui, Mark Overmyer-Velázquez, Justin Perez, Javier Puente, Julian Rieck, Jonathan Ritter, Paloma Rodrigo Gonzales, Mónica Salas Landa, Iván Sandoval-Cervantes, Paula Saravia, Camila Sastre Díaz, Linda Seligmann, Billy Senders, Jen Shannon, Joshua Shapero, Megan Sheehan, Anthony Shelton, Ian Skoggard, Amy Sodaro, Orin Starn, Lucía Stavig, the late William Stein, Kim Sue, the Taller Team in Santiago, Kimberly Theidon, Eric Thomas, Cari Tusing, Julio Villa-Palomino, Mary Weismantel, Markus Weissert, Geoffrey White, Ella Wilhoit, Daniel Willis, Goya Wilson Vásquez, Matthew Wolf-Meyer, Anoum Wright, Amber Wutich, and Caroline Yezer. Going back a bit farther, I am grateful to Michael Sweeney for introducing me to anthropology at Lincoln High School in Portland, Oregon, and to Aletta Biersack, Philip Scher, Carol Silverman, and Lynn Stephen for helping me explore my interests in the field at the University of Oregon. I first learned about Peru's internal armed conflict in a Latin American history class taught by Carlos Aguirre at U of O and was fortunate to reconnect with Carlos as this research took shape.

There are several scholars of Peru whose interest in my work and willingness to offer insights and assistance contributed meaningfully to this book. Early conversations with Isaias Rojas-Perez helped me plan my field research and think about how an ethnography of the LUM initiative might contribute to wider intellectual conversations. María Elena García, Cynthia Milton, and Jason Pribilsky have also been models of intellectual generosity

over the years, and their feedback on my book proposal, along with their advice concerning various aspects of my research, helped make this work a reality. Sydney Silverstein became a trusted friend and interlocutor as I began the process of writing the book. She and Nick Kawa read several chapter drafts, the two of them always seeming to strike a perfect balance between encouragement and constructive criticism. Olga González's scholarship has contributed significantly to my understanding of violence and its aftermath in Peru and our conversations in Lima and at conferences over the years have helped me think about the LUM in more productive and intelligent ways. Thus, I was very pleased to learn that Olga was a reviewer for the manuscript. Her suggestions have enabled me to sharpen my analysis and avoid several missteps. The comments of the second, anonymous reviewer also improved the book considerably. Ponciano del Pino was kind enough to read an advanced version of the full manuscript and provided numerous useful suggestions that informed my revisions.

At Rutgers University Press, I thank Lisa Banning for her guidance as an editor during all stages of the process, and Kimberly Guinta for her initial interest and continued support for this project. I also wish to acknowledge the careful copyediting of Stephanie Cohen and John Donohue at Westchester Publishing Services and Amron Gravett's (Wild Clover Book Services) diligent work in preparing the index.

A hazard of immersing oneself in academia—an environment that some describe as cultlike—is the effect it can have on relationships that one holds dear. Happily, my relationship with my immediate family has only strengthened over time. My brothers, Max and Mike, have always offered encouragement in their own, distinctive ways. I owe everything to my parents, Peter Feldman and Donna Strain. They were extremely supportive as I pursued my scholarly interests and an academic career, even making it to Lima for a visit during my fieldwork. Much of whatever success I have had as an anthropologist is a product of them teaching me (often unknowingly, I suspect) the importance of intellectual curiosity, hard work, and caring about people. Finally, Eric Holgate has been my most committed and engaging ally throughout the process of producing this book. He has also been the most patient and understanding one. With him, I have enjoyed anthropology more, and so much else.

A version of chapter 3 was published previously as "*Yuyanapaq no entra*: Ritual Dimensions of Post-Transitional Justice in Peru," *Journal of the Royal Anthropological Institute* 24(3):589–606 (2018). Portions of chapters 1 and 5 formed part of "Memory as Persuasion: Historical Discourse and Moral Messages at Peru's Place of Memory, Tolerance, and Social Inclusion," in *Museums and Sites of Persuasion: Politics, Memory and Human Rights*, edited by Joyce Apsel and Amy Sodaro, 133–149 (Abingdon, UK: Routledge, 2019).

Notes

Preface

1. *Cachaco* is a pejorative term for members of the armed forces.

Introduction

1. The current name of this unit is the Executive Directorate against Terrorism of the Peruvian National Police (DIREJCOTE) but it is commonly known by its previous acronym, DINCOTE (Quintanilla 2017).
2. See Milton (2015) and Ulfe and Ríos (2016) for additional information about the museum. The DINCOTE museum lacks an official web presence, though images of the gallery are easily found on the internet.
3. Images of the objects circulated to a certain degree following the raids. See, for example, photographs attributed to Alejandro Balaguer in Poole and Rénique (1992:42).
4. The INC is now defunct. It was replaced by the Ministry of Culture in 2010.
5. Kratz (2011:25) examines how exhibition design and display techniques participate in the creation of museum objects' value through "powerful persuasions that draw on and synthesize an array of sensory and communication resources and media." It is safe to assume that the police museum's location within the headquarters of DINCOTE also would have been a barrier to making it open to the public. Monica Eileen Patterson's (2011) case study of the Jim Crow Museum of Racist Memorabilia (JCM) in Cedar Rapids, Michigan, offers interesting parallels and contrasts with practices found at the DINCOTE site. Access to the JCM is also limited to scheduled visits, for example, though this relates to the institution's goal of using racist paraphernalia to teach about tolerance and promote social justice.
6. Sánchez was not alone in his concern for the future of the DINCOTE collection. A 2009 editorial in the right-wing daily *Diario Expreso* (2009) warned of the museum's potential demise if the government forced transfer of its objects to the LUM. The editorial does not appear to have been responding to any specific proposal.
7. A detailed analysis of the police-military rivalry is beyond the scope of this discussion. Lack of coordination between the agencies hindered the state's response to the insurgent groups. In one instance, military commanders failed to respond to a Shining Path attack on a police station in Uchiza, San Martín despite having been ordered to do so by Peru's prime minister (Burt 2007:53–54, 66).
8. Milton (2015:369), analyzing the DINCOTE museum, describes "a near hagiographic relationship between DINCOTE and their prized adversaries." Sharp's (2014:158) case study of a military museum in Mexico that displays objects confiscated from drug traffickers reports a similar institutional justification at that

site: "We need to know our enemy to be able to combat it effectively." Sánchez's and other police discourses on Shining Path bring to mind Edmund Leach's (1965) structuralist analysis of war in small-scale societies. Enemies in war are not the absolute Other, but belong to the "immediate out there" of trade partners, affinal relatives, and wild animals that are familiar. Leach (1965:168) also observes that captures of war often "are believed to bring metaphysical benefit to the community of their captors." For analysis of "dark trophies" in contemporary wars, see Harrison (2012).

9. Although it is accurate to say that intelligence and police investigations, rather than state-sponsored torture or disappearances, ultimately resulted in Guzmán's capture, a "police work" narrative can obscure the reality of human rights violations perpetrated by DINCOTE and other police divisions during the years of the political violence.

10. Geoffrey White (2016:210), in his ethnography of the USS *Arizona* Memorial at Pearl Harbor, draws attention to three curatorial techniques found in this site's remade display that seem to be characteristic of transitions described by authors like Arnold-de Simine: the use of direct quotes from historical actors (as opposed to a synthesizing curatorial voice), a reliance on personal histories, and encouraging visitors to "make up their own minds" when it comes to the broader meaning of the events depicted.

11. Markus Weissert (2016:176) describes the period between 2004 and 2010 as the peak of memorialization activities in the country.

12. For a recent analysis of the trope of Peru as a failed nation, see Thurner (2011). A key period in the consolidation of this narrative was the aftermath of Peru's defeat by Chile in the War of the Pacific (1879–1883), with nationalist intellectuals of the era (most notably, Manuel González Prada) interpreting this outcome as the result of unresolved racial, cultural, and geographic divides that impeded the country's development. To be sure, anxieties persisted within the recent sense of optimism I describe. Natural resource disputes involving mining companies and local communities (Li 2017) have perhaps been the clearest manifestation of contradictions of the country's neoliberal present, as they place Peru's engine of economic growth vis-à-vis the livelihoods of those who are promised inclusion in a march toward development.

13. Isaias Rojas-Perez's (2017) ethnography of exhumations in Ayacucho carefully considers the relationship between transitional justice and state power I present below. Rojas-Perez examines how a "necro-governmentality of post-conflict" centering on the state's use of humanitarian discourse in efforts to recover the bodies of victims becomes destabilized by alternative visions and practices in Quechua-speaking communities and among relatives of the disappeared.

14. Although social scientists have long recognized the empirical difficulties of separating the people and entities belonging to "the state" from those that do not, authors such as Timothy Mitchell (1991) have argued that the state-society boundary and the effect of externality it creates is part and parcel of state power. "The apparent boundary of the state does not mark the limit of the processes of regulation," the author asserts, "It is itself a product of those processes" (1991:90).

15. The event was one of several activities the city government sponsored in August 2013 to commemorate the *Final Report* anniversary; other productions included memory-themed bus tours of Lima ("Memory Routes") and an art exhibition at the Metropolitan Museum that highlighted the truth commission's impact. It was unusual for the Municipality of Lima to support such initiatives, but Mayor Susan Villarán (2011–2014), the embattled progressive leader of an atypically conservative Latin American city, had a background in human rights activism.

Artists, intellectuals, and activists I spoke with generally viewed her administration as sympathetic to their goals.

16. "Victim" and "victims' organizations" are terms that are regularly used in Peruvian discussions about the political violence and its aftermath, though this language can be historicized (see chapter 4). Consistent with other scholars, I generally use "victim-survivors" when referring to individuals whose lives were directly affected by the violence. In some cases, I employ "victim" to convey the social and political relevance of that category.

17. The Itinerant Museum's visions and practices are broadly consistent with what Buntinx and Karp (2006:207) describe as "tactical museology," in that they draw upon the "symbolic capital associated with the idea of the museum" while presenting alternatives to the authoritative, universalizing accounts of official institutions.

18. In an op-ed column published on the news site Diario Altavoz, Gonzalo Zegarra (2013) used the occasion of the TRC's anniversary to critique those who defended the TRC as an unimpeachable "official history." He described the LUM as a "TRC 3.0" that would need to be broader than the "undoubtedly useful" TRC, concluding with a note that welcomed the inclusion of perspectives from "those who fought against the terrorism." The new national museum would exhibit "not one, but many memories."

19. For a recent, insightful overview of the "memory turn" in Latin American studies that includes significant discussion of Peru, see Lazzara (2017).

20. As Kimberly Theidon's (2013:34–35, 42, 269–276) research illustrates, the focus on trauma and redemptive memory that guided state and NGO efforts to attend to the psychosocial effects of violence in rural Andean communities—in addition to failing to grasp local idioms and experiences of suffering—could often clash with desires to forget memories of war. "Too much memory" was a source of concern in villages that had been divided by violence.

21. The ways that this emphasis responds to ethnographic realities will become clearer in subsequent chapters. A working paper (Ledgard, Hibbett, and de la Jara 2018:9) authored by individuals who participated in the LUM's creation describes "memory" as referring to "activities of cultural representation, research, and dialogue that gather, express, analyze, and disseminate specific and diverse memories about the period of political violence." My approach as a researcher follows work in memory studies that "attempts to problematize the very subject" by attending to "memory discourses" as opposed to memory as such (Antze and Lambek 1996:xv). The relevant critiques of memory as an analytical concept are too numerous to cite. Sharon Macdonald (2013:10–17) expertly reviews some of the principal issues and conundrums (individual vs. collective, cultural vs. social, memory vs. history, etc.), arriving at "past presencing" as an alternative for framing her study of museums, memorials, and heritage sites in contemporary Europe. Other anthropologists (e.g., Schwenkel 2009; Yoneyama 1999) have employed "historical memory" to disrupt the history-memory opposition. Like Macdonald (2013:13), I continue to use "memory" throughout the book despite the concept's shortcomings, as the term was central in my research.

22. I do not intend to suggest that said memories exist prior to, or independent of, interactions with the state. On "state," see my discussion below.

23. Nancy Postero's (2017) recent ethnography of Evo Morales's MAS (Movement for Socialism) government in Bolivia examines the tensions and contradictions that emerged as MAS sought to enact an emancipatory politics of decolonization through liberal-democratic mechanisms while negotiating the country's position in the global economy. Engaging with Jacques Rancière's (1999, cited in Postero 2017) distinction between politics and policing, Postero's (2017:19) analysis

reveals how "the state can utilize the ideas and rhetoric of decolonization to legitimate its own power, turning decolonization from a call for alternative epistemologies into a state-sponsored form of multicultural recognition." Here, the *descolonizado permitido*, the acceptable decolonized subject according to MAS definitions (Postero 2017:83, 129), became a means of classifying different groups and their demands. In museum studies, Kelsey Wrightson (2017:37) argues that recent institutional changes at Canadian museums are emblematic of a "move toward affirmative and conciliatory forms of domination, or a shift from viewing Indigenous peoples as 'wards of the state' to seeing them as 'subjects of recognition.'"

24. I borrow this phrasing from Richard Handler's (1988:152–158) discussion of notions of "having a culture" among Quebecois nationalists, a construct that can be understood within the nation-as-individual model the author critically analyzes. See also Clifford (1997:218). On the possession of history as a hallmark of modernity, see Chakrabarty (2000), Dirks (1990), and Kirshenblatt-Gimblett (1998). Reinhart Koselleck (2002) historicizes the temporality of modernity and devises a metahistorical vocabulary that aims to capture its experience in different places and historical moments. In "The Eighteenth Century as the Beginning of Modernity" and other essays, Koselleck argues that the Enlightenment-era concept of modernity engendered new ways of conceiving historical events and experiences, with the "new time" of modernity declaring itself fundamentally different from that which preceded it.

25. This is not to imply that temporal discourses of modernity are absent in, or not relevant to the study of, small-scale memorialization initiatives or those emanating from civil society. Leslie Dwyer's (2010) analysis of the creation of a peace park in Bali to commemorate the victims of state-sponsored massacres perpetrated in 1965–1966 serves as an example. The author focuses on frictions that developed between young promoters of the site, who positioned themselves as embodying progress and international norms, and an older generation of survivors, whom some advocates viewed as conservative.

26. Williams (2007:162), in dialogue with Koselleck (2002), observes that memorial museums often serve to discredit the "former futures" envisioned by defeated groups. Lessie Jo Frazier's (2007:197) analysis of the concept of reconciliation in post-dictatorship Chile attends to how subjects such as former political prisoners and unrepentant military officers become constructed as "vestiges of prior conflicts" who, in embodying past violence, "cannot fit neatly into the neoliberal present." At times, it is the researcher who declares that memorialization is producing "too much memory" and keeping people "locked in the past" (Clark 2013:134).

27. Noted memory studies scholar Elizabeth Jelin (Badaró 2011:108) has commented on "a certain lack of attention to [the] state and institution dimension" in research on memory politics in Latin America.

28. Prominent examples of state-managed memorial museums in Latin America include Argentina's ESMA Site Museum (inaugurated in 2015), Chile's Museum of Memory and Human Rights (2010), Colombia's National Museum of Memory (in progress), and Uruguay's Museum of Memory (2007). A number of private, nonprofit institutions also reach national audiences, including the Dominican Republic's Memorial Museum of the Dominican Resistance (2011) and El Salvador's Museum of the Word and Image (1999).

29. The new museology emerged in the 1980s in response to critical and postcolonial perspectives on the relationship between museums and society. It typically advocates for principles of inclusivity, collaboration, and public engagement in exhibition design and museum practice. See Andermann and Arnold-de Simine (2012) and Message (2006) for analysis of contemporary deployments of discourses

associated with this movement within museology. There are, of course, important exceptions to this trend in the museum world (e.g., Price 2007). My ethnography focuses more on the problem of inclusion in exhibition development than it does on questions of audience engagement or visitor experience (e.g., Macdonald 2002), though both of these issues are central in newer approaches in museum practice that seek to transform conventional notions of curatorial authority (Shannon 2014:7).

30. Jennifer Shannon's (2014:viii) rich ethnography of an exhibition in the making at the National Museum of the American Indian (NMAI), for example, addresses the fundamental question of "whose voice is heard in museums" and "whose expertise counts as authoritative." The author examines this problem in an institutional context where collaboration with indigenous communities and a commitment to "Native voice" were central concerns, with the NMAI seeking to establish itself as a "museum different."

31. Mechanisms like truth commissions are, of course, not limited to countries of the Global South, and it is not my intention to essentialize transitional justice as a kind of "third world justice" (Dwyer 2010:229). Canada is a well-known exception to the generalization I make, and that country's truth commission (2008–2015) took place as the Canadian Museum of Human Rights (inaugurated in 2014) was being created. See Busby, Muller, and Woolford (2015); Lehrer (2015). For a critical examination of the growing prominence of memorialization in the field of transitional justice, see David (2017:304–307).

Chapter 1 Place, Memory, and the Postwar

1. This chapter does not seek to provide an original contribution to the historiography of Peru's internal armed conflict, nor to scholarship on postconflict memorialization in the country. My main objective is to present relevant information for readers unfamiliar with Peru and the contours of debates surrounding the LUM. I base my discussion of the LUM's history to a great extent on existing scholarship (Ledgard, Hibbett, and de la Jara 2018; Poole and Rojas-Pérez 2010; Portugal Teillier 2015; Puente-Valdivia 2013; Rodrigo Gonzales 2010; Sastre Díaz 2015; Ulfe and Milton 2010) as well as analysis of developments that were reported on in the Peruvian news media.

2. Olga González (2011:135) reports that residents of the Ayacucho community of Sarhua, when recalling events that took place in 1981, told her that the term "terrorist" (*terrorista*) was not known to them at that time.

3. *Cholo* is a term used in Peru to describe an urban person of indigenous descent or peasant origins. It can be used as a term of endearment—and Peru is sometimes celebrated as a "cholo nation"—but depending on social context, the word can also be a racial slur. "Decent people" and "decentness" are also racially charged concepts in the country (de la Cadena 2000; Whipple 2013). In the same passage, Silva Santisteban (2009:82) discusses the image of the female Senderista as a "tough," cold-blooded woman.

4. For an engaging and meticulously researched popular history of Shining Path, see Starn and La Serna (2019).

5. The group initiated its armed struggle in May 1980 by burning ballot boxes in the town of Chuschi, Ayacucho on the eve of the country's first presidential elections in more than a decade. According to Shining Path ideology, the overthrow of the Peruvian state would be one step in a global revolution that would usher in pure communism.

6. The historical backdrop of military dictatorship (1968–1980)—albeit one that branded itself as revolutionary and was far less repressive than many of those

found in Latin America during that period—bolstered Shining Path's claims that it was a protagonist in the struggle against "fascism."

7. Shining Path was characterized by its rejection of other leftist groups (often dubbed "revisionist" or dupes of "Soviet socioimperialism" [Degregori 1990:182]) and did not establish alliances with progressive social movements in Peru that emerged during the 1970s and 1980s. Moreover, Shining Path often targeted grassroots activists who did not share their particular vision for social change.

8. For a captivating investigation of race, education, and social mobility in the Peruvian Andes, see García (2005).

9. La Serna's (2012:165) analysis underlines an "ideological disconnect" between Shining Path leadership and local supporters in these contexts, noting that in Chuschi and Quispillaccta, "Ayacuchan peasants seemed more concerned with administering justice against moral deviants, illegitimate power holders, and longtime adversaries who had disrupted public order at the local level," than they were with broader revolutionary and anti-capitalist messages. González (2011:95, 198), in her study of Sarhua, observes that despite the dominant memory of that community emphasizing opposition to Shining Path, a number of Sarhuinos continue to view the initial Shining Path–led moralization campaigns positively.

10. For analysis of emergent cultural productions in Lima from this period that responded to realities of political and economic crisis and the city's racial and socioeconomic divides, see Shane Greene's (2016) ethnographic history of punk. Dynnik Asencios (2017) offers a thorough investigation of young Shining Path militants during the late 1980s and early 1990s that draws extensively on life histories.

11. Perspectives and experiences from the Peruvian Amazon (*selva*) remain marginal in popular and scholarly representations of the political violence. In anthropology, Richard Kernaghan's (2009) ethnography of the aftermath of the cocaine boom in the Upper Huallaga Valley—a history in which the illicit trade became intertwined with Shining Path and Peruvian military actions—provides a valuable exception. Indeed, even assumptions about the internal war's chronology become complicated if one takes the experience of the Upper Huallaga Valley (where Shining Path remained a feature of everyday experience during the late 1990s and continued to be a threat well into the twenty-first century) as the primary point of reference rather than Lima or Huamanga. I am sensitive to ways in which this chapter's brief historical account reproduces a conventional, Andes-focused narrative of Shining Path and the armed conflict. As is evident in subsequent chapters, this emphasis was relatively common in discussions I followed about the LUM. For an insightful critique of Andes-centered representations of Peru's national reality, see Greene (2006).

12. Another prominent example was the 1997 Operation Chavín de Huántar, which brought an end to an extended hostage crisis initiated by MRTA militants at the residence of Peru's Japanese ambassador in December 1996 (see also chapter 4).

13. Mutal and others involved in the project agreed that the names of dead Shining Path militants should not be included in the memorial. Today, the Ojo que Llora's list is based on the National Victims Registry (Registro Único de Víctimas), a database used for administering individual reparations that excludes former members of insurgent groups.

14. Scholars such as Feinstein (2014) have begun to examine how contemporary Peruvian debates about the armed conflict compress a diversity of positions that once circulated in the public sphere, such as those of the 1980s democratic left.

15. This donation has sometimes been referred to as a contribution of 2 million euros. Based on press releases from the German embassy and Peru's Human Rights Ombuds Office published in March 2009, it appears that the funds were

donated in euros but that the total amount (1.65 million euros) was approximately $2 million.

16. The museum component was to be underground in order to not take space away from the Campo de Marte, one of Lima's largest city parks.

17. A recurring feature in right-wing critiques of the so-called caviar left in Peru is the perception that members of this class benefit economically and politically from their advocacy of progressive causes. In the domain of memory and transitional justice, "caviar" human rights activists are often imagined as "trauma brokers" (James 2004:140) who "profit from the suffering of others."

18. The Uchuraccay massacre refers to the January 1983 murder of eight Peruvian journalists in the rural village of Uchuraccay, located in the Huanta province of Ayacucho. The event and subsequent investigation—which found that community members (*comuneros*) had killed the reporters—played a major role in making a national public aware of the violence being suffered in rural Andean communities. The Vargas Llosa inquiry became the subject of criticism for interpreting the episode as the tragic outcome of Uchuraccay's cultural isolation and placing emphasis on alleged "ethnic" characteristics of the area. Anthropologist Juan Ossio, a member of the museum project's first High-Level Commission, was also part of the commission that investigated the incident.

19. Some individuals I interviewed claimed that the name change had more to do with politics, alleging that those involved in the project feared that classifying the institution as a museum might result in the LUM coming under the control of the (now defunct) National Institute of Culture, whose director at the time likely would not have been sympathetic to the project's aims. I did not find any compelling evidence to confirm this was the rationale behind the decision and several individuals close to the situation denied this was the reason for the name change.

20. Sweden had given a smaller amount to help fund the creation of the permanent exhibition.

21. "Meme" here references the older usage of this term to denote to a unit of cultural transmission (a concept associated with evolutionary biologist Richard Dawkins) rather than the word's current, predominant use in internet culture.

22. In December 2011, Roca Rey's script was made public as a PDF document on the website of *El Comercio* (Chávez 2011). The action came as Roca Rey was leaving the LUM initiative. For a critical, insightful appraisal of this exhibition script, see Sastre (2015:138–140). Ledgard, Hibbett, and de la Jara (2018:21–23) also discuss features of the proposal, emphasizing the document's incongruity with the findings and analysis of the Peruvian TRC.

23. Luis Bambarén, Bishop Emeritus of Chimbote and a longtime human rights advocate, was the only member of the original High-Level Commission who continued to serve on the García-Sayán-headed commission. The new commission no longer included an observer from Peru's Human Rights Ombuds Office.

CHAPTER 2　ENACTING POSTCONFLICT NATIONHOOD

1. On middle- and upper-class Limeño perspectives on transportation reform, including the perception that driving in the city reflects "everything that's wrong with [the] country," see Winter (2019:87–89).

2. See Halbwachs (1950).

3. Members of the LUM High-Level Commission rarely made appearances at public events in their capacity as commissioners. Some interlocutors contrasted this tendency with the public visibility of TRC commissioners during the time of the truth commission.

4. Andreas Huyssen (Vermeulen et al. 2012:227), assessing the state of memory studies, declares that the interdisciplinary field "should become much more transnational and pay attention to the transnational effects of discourses: think of Holocaust discourse in Latin America, Nuremberg in South Africa's post-apartheid discussions, or rape-in-war discourses from the Second World War to Bosnia and Darfur." Carol Kidron's (2020) recent work on genocide commemoration in Cambodia pushes scholars to consider how instances of "successful" localization of cosmopolitan models may, in reality, be a façade if one attends to local meanings and practices as opposed to sites' stated intentions or hybrid aesthetics.

5. Lia Kent (2019:183), acknowledging the value of David's (2017) incisive and somewhat polemical critique, suggests that "close attention needs to be paid to the ways in which local actors are not only constrained by—but also navigate, adapt and transform—the power dynamics that result from the interplay between global and local discourses within specific contexts."

6. Jelin (2010:75) emphasizes the extent to which South American institutional models (e.g., truth commissions), along with symbols, discourses, and forms of activism, have become important referents for other parts of the world.

7. Benedict Anderson (2006:67) claimed, somewhat controversially (e.g., Gupta 2004), that national imaginaries forged in the Americas and Europe during the nineteenth century became "available for pirating" by subsequent generations of nationalists in other parts of the world. Reviewing the historiography of nationalism in Latin America, Nicola Miller (2006:216) observes that "Latin American nations have sought to distinguish themselves from—or, in some periods, make themselves like—various European countries (Spain, France, Britain), the United States and other—usually neighboring—Latin American countries."

8. As Shannon (2014:5) notes in her ethnography of the NMAI, the museum's planners were, in reality, quite aware of this audience-constituency distinction. Many of the internal debates surrounding the Our Lives exhibit that the author documents relate to the challenges of centering Native perspectives while taking into account the experience of the majority non-Native public that would visit the institution.

9. Roosevelt supposedly made this comment about the regime of Anastasio Somoza in Nicaragua.

10. A member of the LUM curatorial team would later comment on how support from the international community was critical for moving the museum project forward, especially at "key moments" when critics questioned the initiative (PNUD Perú 2015).

11. Though the visiting specialists certainly had relevant expertise, a word might be said about the "asymmetric ignorance" (Chakrabarty 2000:28–29) and geopolitics of knowledge that are reinforced as experts from the United States—not exactly a model case when it comes to official efforts to promote critical engagement with histories of violence—advise planners of a South American memory initiative. The scenario is akin to that of the Latin American mall professionals described by Dávila (2016:44–68), who become proficient in U.S.-dominated "global" standards and "best practices" at training programs even as the malls these individuals manage and develop are, on the whole, more vibrant and successful than those of their U.S. counterparts.

12. There were also personal, family-related reasons for Fernando's return to Peru.

13. For recent analysis of upper-middle-class and elite Limeños, see Greene (2016); Montero-Diaz (2016); Patiño Rabines (2014); Winter (2019).

14. "Peruvian limitations" is my term, not Fernando's. I share these perceived limitations not to endorse Fernando's assessment, but because of their value as the

reflections of a patriotic intellectual who (implicitly and explicitly) places his observations about Peru alongside those of other national contexts.

15. "Liberal" in Peru and much of Latin America generally refers to individuals who favor classically liberal ideals of democracy, human rights, and equality before the law, but also liberalization in the economic sphere (free trade, limited state involvement in economic affairs, and so on).

16. In the essay, Fernando discussed the history of human rights, underscoring that many on the left, in Peru and elsewhere, were dismissive of the concept during the Cold War. Coletta Youngers's (2003) study of the human rights movement in Peru observes that a number of the movement's early leaders came out of the 1970s Peruvian left, a political milieu in which "human rights" as such was not a central concern. See also Feinstein (2014).

17. M. Cristina Alcalde's (2018) study of middle-class and upper-class Peruvian migrants—including many Limeño return migrants like Fernando—presents the concept of "exclusionary cosmopolitanism" to refer to how transnational Peruvians' proclamations of having developed a more open, tolerant outlook through experience abroad can serve to distinguish these individuals from (less worldly) compatriots. Alcalde illustrates how this form of cosmopolitanism often reinforces entrenched hierarchies of race and class.

18. Fernando also told me that one of his principal motivations for becoming involved in the LUM initiative had to do with the experience of mourning the death of his brother, Constantino Carvallo, who died not long before Fernando began working at the museum project. In one of our interviews, he spoke of the identification he felt with relatives of victims when traveling in rural villages in Ayacucho. "I felt that each one of [the victims] was the same as my brother."

CHAPTER 3 YUYANAPAQ DOESN'T FIT

1. For a more detailed elaboration of this theoretical argument, which engages with J. L. Austin's notion of infelicities, anthropological perspectives on transitional justice (e.g., Hinton 2010; Shaw 2007; Wilson 2001), and scholarship on ritual failure (e.g., Grimes 1990), see Feldman (2018).

2. Although the findings and figures of the Peruvian TRC's nine-volume account are regularly cited in news stories and scholarly publications, the number of Peruvians who have read or consulted the *Final Report* is relatively small and the average citizen is, at best, familiar with the TRC's work in a general way. For systematic analysis of perceptions of the TRC in Peru, see Espinosa et al. (2017).

3. Poole and Rojas-Pérez (2010) present an illuminating critique of Yuyanapaq's reliance on witnessing and photography as a means of reproducing certain alleged truths about what it means to be Peruvian in the aftermath of the internal armed conflict. As commentators on the Peruvian TRC have noted, including former commissioner Carlos Iván Degregori (2011), male, urban, middle-class, and white-mestizo identities were overrepresented in the composition of the twelve-member commission.

4. In a similar way, Drinot (2019) analyzes how the Ojo que Llora memorial has acted as a "synecdoche" and "simulacrum" of the TRC *Final Report*, a site where subjects perform their opposition to and defense of the report's findings and principles.

5. Sastre Díaz (2015:129–135) offers a detailed account of these events as well.

6. Other differences included the Lerner-affiliated group's emphasis on the ideological foundations of the project, the need to develop the content of the LUM's permanent exhibition, and the importance of legitimizing the institution socially through dialogue and the participation of various groups (Ulfe and Milton 2010).

There was talk of establishing the LUM as a center through which a national "public policy of memory" could be developed.

7. This change can be understood in the context of the High-Level Commission's deciding, by September 2009, that constructing the museum in Lima's Campo de Marte (located in the district of Jesús María) was not feasible. Political opposition and bureaucratic foot-dragging on the part of the municipal government of Jesús María—similar to, and in parallel with, that described in the case of the Ojo que Llora memorial (Drinot 2009; Milton 2011; Ulfe and Milton 2010)—appears to have been the decisive factor.

8. The mention of Humala's potential complicity in disappearances referenced the politician's time as an army officer in the Upper Huallaga region of Peru during the early 1990s, a period when state forces perpetrated human rights violations on a massive scale in that part of the country (Kernaghan 2009).

9. In a study of the TRC's reception in the media, Zapata Velasco (2010:53) observed that "the critique offered by [the TRC's] enemies is progressively accentuated" while the defense offered by TRC advocates had become increasingly "lukewarm." Such defenders accepted "in an almost natural way . . . that there were errors and move on to explaining them, situating the Commission's contribution in its projection for the future."

10. On encompassment as a feature of statecraft, see Ferguson and Gupta (2002).

11. This question is raised in Hunt's (2004) short but provocative essay on truth commissions. Hunt advocates for the "historical event" position as a general rule.

12. Bakiner (2015:349), discussing the narrative strategies of truth commissions, observes that such bodies typically rely on the personal authority of commissioners and researchers to help establish their legitimacy, with the assumption being that "the truth value of a narrative is shaped by the moral and social standing of the narrator."

13. This assessment was closely tied to a view that underlined the TRC's "ineffectuality" (Grimes 1990:201), as commentators noted that the symbolic work of Yuyanapaq may well have succeeded in its immediate social function, but the TRC ritual had not "produced the goods" when it came to "intended observable changes" in Peruvian society, namely the emergence of a new national identity premised on recognition of past abuses.

CHAPTER 4 "THERE ISN'T JUST ONE MEMORY, THERE ARE MANY MEMORIES"

1. White (2016:237), in his ethnography of the USS *Arizona* Memorial, observes that the "ability to quote Pearl Harbor survivors opposed to reconciliation [with Japanese veterans]" remained a powerful rhetorical device in debates about the potential inclusion of this theme in a revamped exhibit, even though a significant portion of survivors were supportive of this idea.

2. As Shannon (2014:176) is careful to note, although the National Museum of the American Indian made a concerted effort to present Native co-curators as experts, audiences and reviewers did not always accept that Native voice "constituted legitimate expert knowledge for a museum."

3. I am indebted to Isaias Rojas-Perez's (2017) thoughtful and sophisticated analysis of this image of victimhood in postconflict Peru. Rojas-Perez (2017:138) focuses especially on the gendered dimensions of dismissals of victim-survivors' claims and worldviews, observing how female subjects in particular often become constructed as "possessed by passionate and irrational love for their families and therefore only able to think of politics in terms of their own lineage and descent." The author also registers how ANFASEP mothers became viewed as

"madwomen" and "terrorists" (2017:158) as they placed demands on the state and ultimately, articulated alternative visions for political community in the aftermath of violence. Feminist scholars such as Nancy Fraser (1990) have critiqued the notion that deliberations about the common good (e.g., a representation in a national museum) should be premised on the exclusion of "private interests" and "private issues." This normative conception of the (Western) public sphere can obscure the role of "bourgeois masculinist" values in defining what constitutes a matter of public concern (Fraser 1990).

4. For additional information on García's life history, see Crisóstomo Meza (2018:129–131).

5. For more on this significance and contemporary reclamation efforts more generally, see Rojas-Perez (2017), who develops the concept of "subjunctive mourning" to capture the everyday practices through which ANFASEP mothers express grief amid uncertainty concerning the fate and whereabouts of their relatives.

6. Stern (2010:176), commenting on post-transition Chile, notes that victim-survivors "had learned to use moral capital as the survivor-keepers of a sacred memory-truth to push for responsiveness by a reluctant state, yet also learned to not expect too much." A detailed examination of notions of victimhood in the wake of the Peru's internal conflict is outside the scope of this chapter, but my analysis is guided by certain points of emphasis from research on this subject. First, it is necessary to situate the victim category historically in Peru as a condition that has emerged as much from legal and bureaucratic languages (e.g., of the TRC) as from a priori identifications (Ulfe 2013b:19). "*Afectados*" (affected ones) is a term that many in the Peruvian Andes prefer to use. Further, authors such as de Waardt (2016) and Agüero (2015:36) have underlined the significance of cases where individuals identified as victims (and in some cases, who self-identify as such) reject the term's imagined association with perpetual mourning and a lack of political agency, or react against expectations that the victim identity often entails (e.g., acting deferentially toward human rights NGOs). It is worth reminding readers that the toxic nature of real and imagined links to "terrorists" frames representations of victimhood in Peru as well. See, for example, Theidon's (2013:388–392) reflections on "histories of innocence" in the narration of wartime experiences to the TRC as well as González's (2011) investigation of secrecy, absences, and strategic mobilizations of victimhood in collective representations of the violence in Sarhua. For historical and ethnographic analyses of the problem of victimhood elsewhere in Latin America—where it is relatively common to find a rejection of trauma discourses and the victim category among former members of insurgent groups—see studies such as Frazier (2007); Nelson (2009); Park (2014).

7. The relevant scholarly interventions concerning "gray zones" in Peru are numerous. See, for example, research on fratricidal violence and its aftermath in Andean communities, including del Pino (2017); González (2011); La Serna (2012). Theidon's (2004) influential study, which draws on Primo Levi's reflections on the Holocaust, likely played a significant role in popularizing the term "gray zone" among Peruvian intellectuals and activists. Del Pino's (2013:19) critical assessment of the way a "post-conflict industry" produces victim-centered accounts "that do not express the complex processes of postwar that . . . communities live"—which appears in the introduction to a collection of ethnographic case studies from Ayacucho—captures a prevailing sentiment at the time of my research.

8. The La Cantuta massacre refers to the 1992 disappearance of nine students and one teacher from the Enrique Guzmán y Valle National University of Education. It was one of the human rights cases for which Alberto Fujimori was convicted in 2009.

9. This comment likely references the transformation of large portions of the Museo de la Nación into office space for the Ministry of Culture.

10. The image of the biased, self-serving victim becomes relevant in other domains as well. Macher (2014:159), for example, describes the phenomenon of some judges in Peru discrediting the testimonies of relatives of victims due to concerns that testimony givers "have an interest in the results" and therefore lack objectivity.

11. These elements of victim-survivor narratives can be read as indicative of the "interpretive labor" (Graeber 2015) these individuals routinely perform in their encounters with the state. As I illustrate below, military representatives were rarely made to imagine experiences and desires other than their own when interacting with the LUM project.

12. This quote came from authorized guidelines for the project that were approved by the High-Level Commission in 2012. The guidelines frequently appeared in presentations by LUM representatives and in promotional materials.

13. The Chavín de Huántar rescue refers to the April 1997 operation in which commandos from the Peruvian Army raided the Japanese ambassador's residence in Lima, where MRTA (Túpac Amaru Revolutionary Movement) militants had been holding dozens of hostages for over four months. The operation took its name from the archaeological site in Ancash known for its underground passageways, as the commandos entered the residence through tunnels dug beneath the residence. The TRC *Final Report* (CVR 2003: Tome VII, 2.66) acknowledges that the rescue was a "courageous action of the Armed Forces, whose members risked their lives and fulfilled their duty by successfully confronting a complex situation for the country," but the commission urged further investigation into alleged human rights abuses committed during the raid.

 A replica of the ambassador's house that is located at the military base in Chorrillos—the structure originally constructed to rehearse the 1997 operation—has been converted into a military museum. Annual commemorative reenactments of the rescue were staged at this site in the years prior to my fieldwork. In 2013 the museum was advertised as being open to the public, though when I tried to visit the site with a Peruvian friend in February, we were informed that one needed to make an appointment in advance. I did attend the 2013 commemorative event at the museum in April, largely out of ethnographic curiosity; connections between this site and debates about the LUM were tenuous. For additional discussion of the museum, which goes by several names (e.g., "Heroes of Chavín de Huántar Museum"), see Milton (2015:369–373; 2018:145–152). Visual anthropologist Martha-Cecilia Dietrich (2018) explores the 1997 rescue reenactments, among other topics, in her film *Entre Memorias* (Between Memories).

14. Amy Rothschild (2017) presents a compelling case study (Timor-Leste) in which victim-focused advocacy in the context of transitional justice was ineffectual owing in large part to the centrality of (masculine) ideals of heroism in the aftermath of a war for independence.

15. The investigation leading to the report was commissioned by Otto Guibovich, who was commanding general of the Army during Alan García's second government and participated in early debates surrounding the LUM.

16. An English translation of Gavilán Sánchez's book is available (Gavilán Sánchez 2015).

17. The armed forces' alleged lack of participation in the country's truth commission is a recurring theme in military interventions in memory debates (Milton 2018). The TRC did solicit testimonies and information from members of the military, including those from lower ranks (Root 2012). As I discuss in chapter 3, some

human rights activists and former members of the truth commission also viewed the TRC's level of engagement with the military as one of its limitations.

18. It appears that the original Tutu quote was, "The truth hurts, but silence kills."

19. The report itself, which follows conventions of academic scholarship and cites the TRC *Final Report* in several places, might also be read as an "olive branch" to intellectual and human rights communities (Milton 2018:98).

20. Degregori (2009:8) makes a similar point, noting that critics of the TRC typically lack a positive, convincing narrative of their own. "Why do the governments and deniers only remember the dead, the disabled, and military and police 'war veterans' when Shining Path remnants return to kill or when it seems necessary to them to attack human rights organisms?"

21. This was decidedly not the case in regions like the Upper Huallaga Valley, where the rondas campesinas "enjoyed neither widespread distribution nor popular support" (Kernaghan 2009:220). The representative's statement thus reflects a Lima and Andes-centric vision of the violence that is common in depictions of the war.

22. Milton (2018:70) describes how CPHEP's *In Honor of the Truth* can be situated within a Peruvian military tradition of *libros blancos* (white papers), official reports that present "lessons learned" from military actions.

23. Jo-Marie Burt (2014:164) distills the main features of a military discourse on the violence: "The armed forces saved Peru from terrorism; there was never any systematic violation of human rights (as documented by the [TRC]) by state security forces; efforts to prosecute individual members of the military for human rights violations amounted to political persecution against the entire military institution; and such efforts must cease, via an amnesty law or other such mechanism, in order for Peru to achieve any real peace."

24. Other ethnographers of museums have noted that their research participants' knowledge practices "were much like [their own]" (Shannon 2014:15; see also Macdonald 2002:10–12). Holmes and Marcus (2006) propose that anthropologists study experts in a "para-ethnographic" fashion that accounts for such resemblances, along with shared sensibilities among ethnographers and their interlocutors. The similarity between my methods, practices, and objectives as a researcher and those of individuals working at the LUM became even more evident during the consultation initiative I examine in chapter 5.

25. The bracketing of power differentials has traditionally been considered a feature of civic debate in Western societies, despite the reality that subordinated groups' access to and ability to participate meaningfully in discussions about the common good has always been conditioned by hierarchies of race, gender, class, and sexuality in these contexts (Fraser 1990:63–65).

CHAPTER 5 MEMORY UNDER CONSTRUCTION

1. At the time the LUM was housed in the Ministry of Foreign Relations, an arrangement neither party viewed as ideal. The museum would eventually be transferred to the Ministry of Culture in 2015.

2. One interlocutor I spoke with sought to temper enthusiasm for the new director, noting that Fernando had a warmer, more personal style than his successor and that he was more knowledgeable of the LUM's subject matter. I paraphrase: "Fernando knew the topic but did not get enough done; Denise gets a lot done but doesn't know the topic as well." The individual also mentioned the relationships Fernando had forged in Lima and the provinces, along with the reality that by the time Ledgard started, the LUM's construction difficulties had mostly been resolved and the High-Level Commission had approved a draft of the exhibition script.

3. Funding for the participatory process or a mechanism like it had been provided by international donors. A representative from the European Union I interviewed in October 2013 spoke approvingly of plans to share the script with different groups, noting that the process could help guard against potential political influence. The official characterized the LUM's engagement with civil society up to that point as "poor."

4. In Ayacucho, sessions were organized with local authorities, journalists, victims' organizations, human rights organizations, and artists. In Lima, the research team met with representatives from government agencies, journalists, victims from the armed forces and police, "civilian victims," human rights organizations, artists, and members of the business community. There was one workshop in Satipo, which included representatives from indigenous organizations in the region. The process also involved focus groups in Lima with members of sectors identified as target audiences (parents, high school students, and teachers). These focus groups were conducted by a consulting firm rather than by LUM researchers. The data appearing in the final report on the participatory process (del Pino and Agüero 2014) came overwhelmingly from the workshops as opposed to the focus groups. My use of "interest group" in this chapter reflects the prominence of this term in the context of the participatory process.

5. I knew del Pino and Agüero as colleagues from my participation in the IEP working group. Both were well regarded in academic and human rights circles at the time and have achieved greater visibility in Peru and abroad in recent years, del Pino for his award-winning historical study of Uchuraccay (2017) and Agüero for his thoughtful, compelling memoir (2015), along with his poetry. I had no involvement in the participatory process as a researcher but attended and took notes on the majority of the meetings.

6. "Participatory process" is a term commonly used in environmental impact assessments in Peru (Li 2017). Del Pino and Agüero were certainly quite aware of the superficial nature of many consultation initiatives implemented by corporations, NGOs, and government agencies in the country.

7. The absence of museum-centered discourses (e.g., the new museology [Message 2006]) and strategies (e.g., "community curating" [Shannon 2014]) deserves mention, but is understandable given the backgrounds and expertise of the individuals who coordinated the participatory process. Del Pino and Agüero (2014:51) situate the consultation initiative within modernizing sectors of the Peruvian state that seek to promote transparent rather than "evasive" forms of governance.

8. Museum scholars and practitioners who advocate for consultation and collaboration as a moral imperative also acknowledge the role of such efforts in improving the image of institutions (e.g., Kahn 2000; McMullen 2008).

9. "Memory under construction" is a phrase that appeared in discussions surrounding the development of Argentina's ESMA detention center as a memory site (Brodsky 2005).

10. An exception to this generalization about the politics of individuals involved in the LUM was High-Level Commission member Leopoldo Scheelje, a business leader with right-wing, Fujimorista sympathies. Perhaps to countervail this image, LUM workers typically drew attention to Scheelje's involvement in the National Agreement (Acuerdo Nacional), a multipartisan initiative established in the wake of Fujimori's government to promote democratic governance. Although Scheelje did not respond to my interview request and has made virtually no public statements related to his involvement in the LUM, a number of people I interviewed emphasized his influence as member of the High-Level Commission at this stage in the project's history.

11. See Basaure (2014), Hite and Collins (2009), Jara (2018), and Sodaro (2018) for additional analysis of this museum and its sociopolitical implications in Chile.

12. As I discuss in chapter 6, this was the approach ultimately taken by the curatorial team. For analysis of controversies surrounding estimates of the dead and disappeared in Argentina, Chile, Guatemala, and Peru, see Stern (2015).

13. Leigh Payne's notion of "contentious coexistence" informs del Pino and Agüero's analysis (del Pino and Agüero 2014:71). Payne (2008:4) presents this concept as an alternative to "lofty and elusive goals of consensus or reconciliation," stressing how disagreement and conflict over past wrongs can reinforce and enhance democratic practices in divided societies. Del Pino and Agüero contrast the LUM's conceptual foundation with that of a "duty to remember" (*memoria deber*) that hinges on the promotion of a "correct" memory of the war.

14. Del Pino and Agüero (2014:81) caution against "victim-centered" approaches that purport to speak for victim-survivors. The term *afectados* (the affected) appears frequently in the report as a substitute for *víctimas*.

15. In the case of the National Museum of the American Indian, Shannon (2014:39) documents a desire among planners to work with individuals who were not the "usual representatives to museums"—so-called rolodex Indians (2014:110)—in the making of the Our Lives exhibit.

16. At least some of this sentiment attests to the professionalism with which the participatory process research team carried out their work. It should also be noted that the researchers faced considerable time constraints as they designed, conducted, and wrote up the research. Del Pino and Agüero drew on extensive knowledge of the subject area and, in some cases, past experience with the groups consulted. They were careful not to give participants unrealistic expectations about the participatory process or the LUM initiative in general.

17. A preference for realism among victim-survivors corresponds with observations made by other researchers studying memorialization in Ayacucho (Feldman 2012; Milton and Ulfe 2011). Similar concerns about potential distortion at the hands of museum professionals were apparent among Holocaust survivors in the creation of the United States Holocaust Memorial Museum (Linenthal 1995:127, cited in Sodaro 2018:42).

18. The similarity to French artist Christian Boltanski's exhibitions of worn clothing in Europe—which were likely a source of inspiration for the proposed room—was not lost on some. A member of the curatorial team jokingly referred to La Ofrenda as the "Boltanski room" when presenting the script to a group of artists.

19. As the researchers recognized at the time, this suggestion was consistent with the narrative structure ("before, during, and after the violence") that was often provided by NGOs in venues like regional art competitions in Ayacucho (e.g., Milton 2014b).

20. Not all victim-survivors in the Ayacucho meeting expressed this preference and willingness, and at least one participant expressed her unease at the idea (del Pino and Agüero 2014:125). Prior to the participatory process, though, the general assumption within the LUM was that victim-survivors would be reluctant to donate items to the national museum. Police and military-affiliated victims in Lima also indicated their willingness to provide uniforms, photos, and testimonies for the exhibition.

21. As the controversy involving Lima's Ojo que Llora memorial had illustrated (referenced in chapter 1; see also Drinot 2009; Hite 2007), naming the victims of the conflict could present certain complexities.

22. Shannon (2014:86) observes that "community wishes" became viewed as "expert contributions" in certain contexts and "configured as specifically non-expert"

in others, in the National Museum of the American Indian deliberations. The author demonstrates how "museological expertise could be trumped by community expertise, often glossed as community wishes" in the context of making a collaborative, co-curated exhibit that privileged Native voices and experiences (2014:100).

23. When I reviewed my field notes and the meeting logs for the Ayacucho portion of the process, an intervention by a young man during the meeting with victims' organizations (November 9, 2013) stood out as particularly influential in the formation of the anti-Ofrenda narrative. The man, who headed a regional consortium of victims' organizations, interjected when the researchers started into the room-by-room summary they typically presented before having participants share their impressions of the script. After citing his experience in a local memorialization project as well as his visit to Yuyanapaq at the Museo de la Nación, the man opined that the articles of clothing should not come first in the exhibition. Instead, "the first thing we should present is how Peru was, how it got to that moment, and after that we can present those garments" (del Pino and Agüero 2014:122). Reviewing the meeting log (2014:117–133) reveals that several participants echoed the influential leader's point in the course of the meeting, though there was never any identifiable consensus about what might replace La Ofrenda as the exhibition's opening room (suggestions alternated between "causes" of the violence and "happiness" before the war).

 In this and other meetings, La Ofrenda was not unanimously panned. Some used words like "interesting" and "excellent" (*excelentísima*) to describe it. Others held to the young leader's original position that there was nothing wrong with the clothing display, but that it should not come first in the exhibition (del Pino and Agüero 2014:125). Participants in the meeting with Ayacucho artists praised La Ofrenda and spoke of the need to shock the visitor emotionally, even if they took issue with the room's proposed title (the visitor did not "offer" anything). Further, the fact that participants in the meeting with Ayacucho victims' organizations suggested the possibility of using authentic articles of clothing for the display and debated how to make the La Ofrenda representative (e.g., incorporating the customary dress of different regions) could be read as indicating some level of support.

24. Anthropologist Miriam Kahn's (2000) thoughtful reflection on the making of a collaborative exhibit (Pacific Voices) at the Burke Museum of Natural History and Culture in Seattle emphasizes misunderstandings between curators and advisors. The author notes that "curators' academic ideas about polyphonic narratives and their focus on an exhibit process organized around a consensus-building model, often failed to mesh with local realities," with many community advisors preferring a more traditional mode of anthropological display (2000:65). McMullen (2008) provides another self-critical account of collaboration that centers on the issue of money and payments. For a Latin American case study, see sections of Viteri et al. (2019) on the creation of a collaborative ethnographic exhibit (Espiritualidades en Quito) exploring religious diversity in Quito, Ecuador.

25. Fabiana Li (2017:146–147) offers a similar account of a mining company's efforts to register, and subsequently circulate photos and videos of, "participatory monitoring" activities at Yanacocha (Cajamarca) in order to present an image of local cooperation and consent.

26. The TRC exhibit's fate did come up in the Lima meeting with human rights activists, though representatives from that community who were knowledgeable of the situation informed their colleagues that arrangements had been made to extend Yuyanapaq's lease at the Museo de la Nación (see chapter 3).

27. There was just one representative from the Peruvian National Police at the "military and police" meeting. LUM researchers and staff referred to the encounter primarily as a meeting with "militares," and several representatives from the Standing Commission of Peruvian Military History (CPHEP) were in attendance. A subtle expression of the police-military divisions I sketched in the introduction was apparent in the Lima meeting with victims from the armed forces and police. Juan Polanco, a police officer directly affected by the violence and head of an organization for police officers with disabilities, expressed the view that photos of the police should be separate from those of members of the armed forces, "so that they're not all together, mixed" (del Pino and Agüero 2014:214). I thank Marie Manrique for directing my attention to this quote.

 Another major actor in the armed conflict that lacked a significant presence in the LUM's participatory process were the rondas campesinas (though the Ayacucho meetings did include some participants who were former ronderos). On the marginalization of the rondas campesinas in transitional justice–oriented representations of Peru's armed conflict, see García-Godos (2008).

28. In most but not all of the meetings, participants were divided into small groups to discuss specific sections of the script. Participants voted on which topics to discuss prior to working in the subgroups.

29. In the context of ethnographic, archaeological, and art museums in the United States, there is a historical legacy of superficial and late-stage consultation efforts involving Native American communities, one that many contemporary initiatives seek to counteract (McMullen 2008; Shannon 2014; Swan and Jordan 2015).

30. Anthropologist Julia Paley (2001:140–181) examines how activists in La Bandera (Santiago, Chile) sought to reclaim the notion of participation in state and local efforts to respond to environmental health risks in their community. Residents articulated a concept of participation that stressed involvement in decision-making as well as accountability for government actions.

31. Li (2017:274–275) reports critiques similar to those of Sandra among participants in a mining-related consultation effort in Cajamarca. An influential environmental activist, for example, commented on company representatives' desire to "listen to and make a note of" residents' concerns without implementing significant changes.

32. The timing of my research did not allow me to extensively document how insights from the participatory process and subsequent consultation efforts did, in fact, inform the creation of the new script (often in subtle ways). Ponciano del Pino's inclusion in the final curatorial team provided an important link between the consultation process and the permanent exhibition's design. Chapter 6 incorporates material from interviews with members of the LUM curatorial team conducted after the museum's inauguration.

33. This insight is consistent with the perspective of museum studies scholars such as Wrightson (2017:44), who, commenting on collaborations involving indigenous peoples in Canada, argues that "by 'giving voice' or arbitrating narratives, museums maintain their own structural authority, despite the appeal to multivocality or transitive museology" (see also Fouseki 2010). Swan and Jordan (2015:71), drawing on their experience with collaborative initiatives and museum-community partnerships, advocate for "the application of shared systems of authority to address the inherent inequities in museum-community power relationships."

CHAPTER 6 MEMORY'S FUTURES

1. Shannon's (2014:90) ethnography of the National Museum of the American Indian (NMAI), for instance, registers how the curatorial department's emphasis

on collaboration with Native communities and "doing things the 'right' way" was met with mixed reactions from commentators in other NMAI departments and at the Smithsonian Institution, more generally. The dynamic between the participatory process researchers and the previous LUM curators (Miguel Rubio and Karen Bernedo) discussed in chapter 5 was arguably an "inter-departmental conflict" of this nature, but by 2014 there was little to no separation between consultation efforts and the work of drafting and implementing the exhibition script.

2. According to Ledgard, Hibbett, and de la Jara (2018:55) there was a final, somewhat spur-of-the-moment bid from the Ministry of Culture to include Yuyanapaq in the LUM midway through 2015, which apparently responded to the agency's desire to inaugurate the museum in a timely fashion.

3. As I note in chapter 5, some members of the High-Level Commission, including Pedro Pablo Alayza and Hilaria Supa (Ledgard, Hibbett, and de la Jara 2018:49), favored the inclusion of these themes.

4. These comments were made at a roundtable on "El Lugar de la Memoria, la Tolerancia y la Inclusión Social y la cultura peruana de posconflicto" at the Latin American Studies Association International Congress in New York in May 2016.

5. A three-minute video clip produced by artist Isabel Guzmán appears in this section as well. Entitled "Zero Investment," the video critically assesses contemporary (2015) levels of investment in Peru's education system.

6. As Milton (2018:96–97) observes, this statement essentially defends the institution against a charge (genocide) that the TRC never made.

7. Kahn (2000:62, 68) describes the writing of exhibit labels as a key example of how authorship becomes blurred in collaborative exhibits.

8. Delgado's project originated as a blog and Facebook page that the artist updated throughout 2011 (undiaenlamemoria.blogspot.com/). Some of its images were displayed in 2013 as part of Detonating: Peruvian Art after the TRC (Detonante: El arte peruano después de la CVR), an exhibit co-curated by Karen Bernedo and Víctor Vich at the Metropolitan Museum of Lima. See Saona (2014:125–129) for analysis of A Day in Memory.

9. One of my interlocutors emphasized the role of commissioner Pedro Pablo Alayza in defending the decision to profile Putis in the permanent exhibition.

10. In the context of making the Canadian Museum of Human Rights, discussions comparable to those surrounding "internal armed conflict" at the LUM took place about "genocide" and "cultural genocide" as terms for describing the historical experience of First Nations peoples (Busby, Muller, and Woolford 2015; Lehrer 2015).

11. A video recording of this event is available on the Catholic University of Peru's website: educast.pucp.edu.pe/video/7878/presentacion_muestra_permanente_lum.

12. Although LUM workers and curators generally considered the narrative-driven "One Person, All People" to be one of the most effective sections of the exhibition, curatorial team member Natalia Iguiñiz drew attention to the absence of testimonies from former members of insurgent groups, noting that the team's efforts to seek out such individuals (while working on a tight deadline) bore no results. Américo Meza's testimony includes discussion of his initial sympathy for Shining Path's cause and participation in Senderista-aligned communities at the National University of Central Peru (Huancayo) but emphasizes his ultimate rejection of the group's violent tactics.

13. Ledgard was dismissed from the project after making public comments that were critical of the level of support the LUM had received from the Peruvian state and the Ministry of Foreign Relations in particular (Ledgard, Hibbett, and de la Jara 2018:55).

14. Ledgard, Hibbett, and de la Jara (2018:58) acknowledge that this strategy limited the degree of participation at that stage of the project and reduced the LUM's visibility in the national news media in the months preceding its inauguration.

15. Olga González has begun to conduct ethnographic research on visitors' experiences and interpretations of aspects of the LUM exhibition, such as the testimonies in the "One Person, All People" room. Visitors and critics "not getting it" (from the perspective of exhibition developers) is a recurring theme in museum debates around the world. Some cases examined by anthropologists include non-Native reactions to the NMAI's Our Lives exhibit (Shannon 2014:163–180), the "Into the Heart of Africa" controversy at the Royal Ontario Museum (Butler 2007), and an unsuccessful hologram-based exhibit at the Jewish Museum of Vienna (Bunzl 2003). Handler and Gable's (1997:13–14) landmark study of Colonial Williamsburg provides an example of how ethnographic attention to the social life of museums can complicate simple "producer-product-consumer" models of cultural production. Macdonald (2002:94), focusing on a "visible site of intersection between science, state, materials, the public and other interest groups" at the Science Museum in London, presents an actor-network theory–inspired approach to authorship and meaning. For a long-term study examining visitor experiences at a Latin American memory site, see Kaiser (2020).

16. Especially in settings where reduced public spending on cultural institutions has resulted in museums relying more on visitation and private sponsorship, museum planners and administrators often struggle to adhere to core institutional values while seeking to attract a broader audience. A recent, illuminating examination of this problem is Matti Bunzl's (2014) ethnography of Chicago's Museum of Contemporary Art (MCA), which vividly portrays relations between the museum's curatorial and marketing departments in the lead-up to a major exhibit. Bunzl ultimately views the MCA curators as "waging a heroic battle for the traditional values of the contemporary art museum" (2014:78) at a time when there is considerable pressure to avoid exhibiting material viewed as challenging or unconventional. Handler and Gable (1997), in their study of Colonial Williamsburg, observed that despite the introduction of "new social history" perspectives at this institution during the 1970s and 1980s, critical reflection remained largely absent in the "living history" museum's depictions of eighteenth-century American life. Among the factors the authors identified in analyzing this outcome was an institutional culture that sought to promote "good vibes" among visitors and minimize politics and confrontation (1997:196–198). For insightful analysis of the tension between memory politics and commodification in Latin America, see the essays in Bilbija and Payne (2011).

17. Mauricio Zavaleta (2019), who coordinated the LUM for a time in 2018 before the appointment of noted historian Manuel Burga as director in August of that year, described the institution as "resembling a cultural center more than a space for welcoming civilian, police, and military victims." Zavaleta attributed this condition to a lack of clearly defined institutions and public policies for promoting reflection on Peru's armed conflict. The former LUM administrator also questioned the appropriateness of the Ministry of Culture as the entity charged with managing the memorial museum, observing that the LUM was "isolated" within the cultural sector.

18. Ledgard and others commented on the exhibit's depiction of historical phenomena that fell outside the scope of the exhibit's focus on 1992 as a pivotal year in the armed conflict (e.g., the Fujimori government's complicity in forced sterilization programs taking place in the late 1990s). For additional analysis of the controversy, see Hibbett (2017); Milton (2018:184–185).

19. For example, Donayre and others seized upon a LUM worker's remarks about the possibility of imprisoned Shining Path leader Abimael Guzmán receiving a medical pardon similar to the one granted by President Kuczynski to Alberto Fujimori, presenting the comment as if it were an endorsement of such a measure. The LUM employee who appears in the video—an education specialist at the museum who did not normally work as a guide but volunteered to serve in this role for the visiting "Colombian victim"—has given her own account of the congressperson's visit. Among other things, she noted that members of the group with whom Donayre visited the museum requested that the tour place particular emphasis on crimes committed by the armed forces against civil society (presumably as part of a bad faith effort to elicit material that would "demonstrate" such a bias). For an overview of the controversy that includes the video clip circulated by Donayre, see El Comercio (2018).

20. On a more personal level, I recall thinking that few things seemed less relevant at that precise moment than an investigation critically examining the process of creating the LUM; the institution and its workers simply needed to be defended.

21. The expressed aversion to producing "official memory" cannot simply be read as the importation of a Peruvian model, as this language is found in the 2011 law that calls for the Colombian museum's creation (CNMH 2017). Ana Guglielmucci's (2015) analysis of the National Museum of Memory initiative raises issues that resonate with aspects of the LUM's experience, such as tensions related to the museum's construction in the capital city of Bogotá (less affected by war than other regions) as well as a potential discrepancy between victim-survivors' symbolic importance in institutional discourse and their degree of involvement in the museum project. Milton (2018:256) speaks of the potential export of the LUM's approach to military collaboration in the Colombian context.

22. "Looking for Hope" was one of the eleven topics required by the High-Level Commission.

23. The interventions required some negotiation with the building's architects, who generally preferred not to enclose spaces within the exhibit in order to maintain the LUM's original architectural vision.

References

Agencia Andina. 2009. Comisión de alto nivel tomará en cuenta críticas sobre el "museo de la memoria." April 17. www.andina.com.pe/Espanol/Noticia.aspx?id=INYN5yEH KU4 =#.VCtaxPldXrM.

Agencia Andina. 2010. Carvallo: Se han disipado todos los prejuicios al Lugar de la Memoria. May 30. www.andina.com.pe/espanol/Noticia.aspx?id=jH2IHPGB6yM =#.VCtWk_ldXrM.

Agencia Andina. 2012. Perú espera concluir este año construcción de Lugar de la Memoria. June 13. www.andina.com.pe/Espanol/noticia-peru-espera-concluir-este-ano -construccion-lugar-de-memoria-416126.aspx#.VCtg6vldXrM.

Agencia EFE. 2015. Perú recuerda época de violencia con Sendero Luminoso en muestra fotográfica. March 21. www.efe.com/efe/america/politica/peru-recuerda -epoca-de-violencia-con-sendero-luminoso-en-muestra-fotografica/20000035 -2567664.

Agüero, José Carlos. 2015. *Los rendidos: Sobre el don de perdonar.* Lima: Instituto de Estudios Peruanos.

Aguirre, Carlos. 2011. Terruco de m . . . Insulto y estigma en la guerra sucia peruana. *Histórica* 37(1): 103–139.

Alcalde, M. Cristina. 2018. *Peruvian Lives across Borders: Power, Exclusion, and Home.* Champaign: University of Illinois Press.

Alonso, Ana María. 2004. Conforming Disconformity: "Mestizaje," Hybridity, and the Aesthetics of Mexican Nationalism. *Cultural Anthropology* 19(4): 459–490.

Alvarez, Sonia E., Evelina Dagnino, and Arturo Escobar. 1998. Introduction: The Cultural and the Political in Latin American Social Movements. In *Cultures of Politics/ Politics of Cultures: Re-Visioning Latin American Social Movements*, edited by Sonia E. Alvarez, Evelina Dagnino, and Arturo Escobar, 1–30. Boulder, Colo.: Westview Press.

Álvarez Rodrich, Augusto. 2018. Terruquear hasta que se enronchen. *La República*, June 10. larepublica.pe/politica/1258633-terruquear-enronchen/.

Andermann, Jens. 2007. *The Optic of the State: Visuality and Power in Argentina and Brazil.* Pittsburgh: University of Pittsburgh Press.

Andermann, Jens.2012a. Returning to the Site of Horror: On the Reclaiming of Clandestine Concentration Camps in Argentina. *Theory, Culture and Society* 29(1): 76–98.

Andermann, Jens. 2012b. Showcasing Dictatorship: Memory and the Museum in Argentina and Chile. *Journal of Education Media, Memory, and Society* 4(2): 69–93.

Andermann, Jens, and Silke Arnold-de Simine. 2012. Introduction: Memory, Community and the New Museum. Theme issue, "Memory, Community and the New Museum." *Theory, Culture and Society* 29(3): 3–13.

Anderson, Benedict. 2006 [1991]. *Imagined Communities: Reflections on the Origins and Spread of Nationalism*. Rev. ed. London: Verso.

Antze, Paul, and Michael Lambek. 1996. Introduction: Forecasting Memory. In *Tense Past: Cultural Essays in Trauma and Memory*, edited by Paul Antze and Michael Lambek, xi–xxxviii. London: Routledge.

Argumentos. 2009. Museo de la Memoria: Ideas urgentes. *Revista Argumentos* 3(4): 30–51.

Arnold-de Simine, Silke. 2013. *Mediating Memory in the Museum: Trauma, Empathy, Nostalgia*. London: Palgrave Macmillan.

Asencios, Dynnik. 2017. *La ciudad acorralada: Jóvenes y Sendero Luminoso en Lima de los 80 y 90*. Lima: Institutos de Estudios Peruanos.

Augé, Marc. 2004. *Oblivion*. Minneapolis: University of Minnesota Press.

Austin, J. L. 1962. *How to Do Things with Words*. London: Oxford University Press.

Babb, Florence E. 2011. *The Tourism Encounter: Fashioning Latin American Nations and Histories*. Stanford, Calif.: Stanford University Press.

Badaró, Máximo. 2011. Repensando la relación entre memoria y democracia: Entrevista a la socióloga argentina Elizabeth Jelin. *Stockholm Review of Latin American Studies* 7: 99–108.

Bakiner, Onur. 2015. One Truth among Others? Truth Commissions' Struggle for Truth and Memory. *Memory Studies* 8(3): 345–360.

Ballestero, Andrea S. 2012. Transparency in Triads. *PoLAR: Political and Legal Anthropology Review* 35(2): 160–166.

Basaure, Mauro. 2014. Museo de la Memoria en Conflicto. *Anuari de Conflicte Social* 4: 659–685.

Bennett, Tony. 1995. *The Birth of the Museum: History, Theory, Politics*. London: Routledge.

Bilbija, Ksenija, and Leigh A. Payne, eds. 2011. *Accounting for Violence: Marketing Memory in Latin America*. Durham, N.C.: Duke University Press.

Brodsky, Marcelo. 2005. *Memoria en construcción: El debate sobre la ESMA*. Buenos Aires: La Marca.

Bueno, Christina. 2010. Forjando Patrimonio: The Making of Archaeological Patrimony in Porfirian Mexico. *Hispanic American Historical Review* 90(2): 215–245.

Bueno-Hansen, Pascha. 2015. *Feminist and Human Rights Struggles in Peru: Decolonizing Transitional Justice*. Urbana: University of Illinois Press.

Buntinx, Gustavo, and Ivan Karp. 2006. Tactical Museologies. In *Museum Frictions: Public Cultures/Global Transformations*, edited by Ivan Karp, Corrine A. Kratz, Lynn Szwaja, and Tomás Ybarra-Frausto, with Gustavo Buntinx, Barbara Kirshenblatt-Gimblett, and Ciraj Rassool, 207–218. Durham, N.C.: Duke University Press.

Bunzl, Matti. 2003. Of Holograms and Storage Areas: Modernity and Postmodernity at Vienna's Jewish Museum. *Cultural Anthropology* 18(4): 435–468.

Bunzl, Matti. 2014. *In Search of a Lost Avant-Garde: An Anthropologist Investigates the Contemporary Art Museum*. Chicago: University of Chicago Press.

Burt, Jo-Marie. 2006. "Quien Habla Es Terrorista": The Political Use of Fear in Fujimori's Peru. *Latin American Research Review* 41(3): 32–62.

Burt, Jo-Marie. 2007. *Political Violence and the Authoritarian State in Peru: Silencing Civil Society*. London: Palgrave Macmillan.

Burt, Jo-Marie. 2014. The Paradoxes of Accountability: Transitional Justice in Peru. In *The Human Rights Paradox: Universality and Its Discontents*, edited by Steve J. Stern and Scott Straus, 148–174. Madison: University of Wisconsin Press.

Burt, Jo-Marie, and Casey Cagley. 2013. Access to Information, Access to Justice: The Challenges to Accountability in Peru. *SUR International Journal on Human Rights* 10(18): 75–94.

Busby, Karen, Adam Muller, and Andrew Woolford, eds. 2015. *The Idea of a Human Rights Museum.* Winnipeg: University of Manitoba Press.

Butler, Judith. 1990. *Gender Trouble: Feminism and the Subversion of Identity.* London: Routledge.

Butler, Shelley Ruth. 2007. *Contested Representations: Revisiting Into the Heart of Africa.* Toronto: University of Toronto Press.

Cabrera Espinoza, Teresa. 2014. El LUM va más allá de un museo. *La Mula,* June 10. redaccion.lamula.pe/2014/06/10/el-lum-va-mas-alla-de-un-museo/tecabrera/.

Cánepa Koch, Gisela, and Felix Lossio Chávez, eds. 2019. *La nación celebrada: Marca país y ciudadanías en disputa.* Lima: Fondo Editorial de la Universidad del Pacífico/ Fondo Editorial de la Pontificia Universidad Católica del Perú.

Carvallo, Fernando. 2010. Diez ideas falsas sobre el Lugar de la Memoria. *Le Monde Diplomatique* 3(34), March 13. www.eldiplo.com.pe/diez-ideas-falsas-sobre-el-lugar -de-la-memoria.

Castillo, María Elena. 2008. Yuyanapaq: Obligada visita. *La República,* March 20. www.larepublica.pe/20-03-2008/yuyanapaq-obligada-visita.

Celermajer, Danielle. 2013. Mere Ritual? Displacing the Myth of Sincerity in Transitional Rituals. *International Journal of Transitional Justice* 7: 296–305.

Chakrabarty, Dipesh. 2000. *Provincializing Europe: Postcolonial Thought and Historical Difference.* Princeton, N.J.: Princeton University Press.

Chávez, Claudia. 2011. Roca Rey presenta su guion del Lugar de la Memoria. *La Mula,* December 28. redaccion.lamula.pe/2011/12/28/roca-rey-presenta-su-guion-del -lugar-de-la-memoria/claudiapollo/.

Clark, Janine Natalya. 2013. Reconciliation through Remembrance? War Memorials and the Victims of Vukovar. *International Journal of Transitional Justice* 7(1): 116–135.

Clifford, James. 1997. *Routes: Travel and Translation in the Late Twentieth Century.* Cambridge, Mass.: Harvard University Press.

CNMH (Centro Nacional de Memoria Histórica). 2017. *Museo Nacional de la Memoria: Un lugar para el encuentro, Lineamientos conceptuales y guion museográfico.* Bogotá: Centro Nacional de Memoria Histórica.

Cole, Catherine M. 2010. *Performing South Africa's Truth Commission: Stages of Transition.* Bloomington: Indiana University Press.

Collins, Cath. 2010. *Post-Transitional Justice: Human Rights Trials in Chile and El Salvador.* University Park: Pennsylvania State University Press.

Collins, Cath. 2011. The Moral Economy of Memory: Public and Private Commemorative Space in Post-Pinochet Chile. In *Accounting for Violence: Marketing Memory in Latin America,* edited by Ksenija Bilbija and Leigh A. Payne, 235–263. Durham, N.C.: Duke University Press.

Collins, John F. 2015. *Revolt of the Saints: Memory and Redemption in the Twilight of Brazilian Racial Democracy.* Durham, N.C.: Duke University Press.

CONAVIP (Coordinadora Nacional de Organizaciones de Afectados por la Violencia Política del Perú). 2010a. Coordinadora Nacional de Organizaciones de Afectados por la Violencia Política del Perú, Abancay, Apurímac, abril de 2010. palabra-syviolencias.zoomblog.com/archivo/2010/05/.

CONAVIP (Coordinadora Nacional de Organizaciones de Afectados por la Violencia Política del Perú). 2010b. Pronunciamiento de CONAVIP sobre el Museo de la Memoria. kausajusta.blogspot.com/2010/11/pronunciamiento-de-conavip-sobre-el.html.

CPHEP (Comisión Permanente de Historia del Ejercito del Perú). 2012. *En honor a la verdad: Versión del Ejercito sobre su participación en la defensa del sistema democrático contra las organizaciones terroristas.* 2nd ed. Lima: CPHEP.

Crisóstomo Meza, Mercedes. 2018. Cuestionando estereotipos: Las presidentas de ANFASEP y sus espacios plurales de acción antes del conflicto armado interno. In *Género y conflicto armado interno en el Perú*, edited by Mercedes Crióstomo Meza, 109–152. Lima: Fondo Editorial de la Pontificia Universidad Católica del Perú.

CVR (Comisión de la Verdad y Reconciliación). 2003. *Informe Final.* Lima: Perú.

CVR (Comisión de la Verdad y Reconciliación). 2004. *Hatun Willakuy: Versión abreviada del Informe Final de la Comisión de la Verdad y Reconciliación.* Lima: Perú.

David, Lea. 2017. Against Standardization of Memory. *Human Rights Quarterly* 39: 296–318.

Dávila, Arlene. 2016. *El Mall: The Spatial and Class Politics of Shopping Malls in Latin America.* Berkeley: University of California Press.

Degregori, Carlos Iván. 1990. *El surgimiento de Sendero Luminoso: Ayacucho 1969–1979.* Lima: Instituto de Estudios Peruanos.

Degregori, Carlos Iván. 2009. Espacios de memoria, batallas por la memoria. *Argumentos: Revista de análisis social del IEP* 3(4): 3–10.

Degregori, Carlos Iván. 2011. *Qué difícil es ser Dios: El Partido Comunista del Perú–Sendero Luminoso y el conflicto armado interno en el Perú: 1980–1999.* Lima: Instituto de Estudios Peruanos.

De la Cadena, Marisol. 2000. *Indigenous Mestizos: The Politics of Race and Culture in Cuzco, Peru, 1919–1991.* Durham, N.C.: Duke University Press.

De la Cadena, Marisol. 2010. Indigenous Cosmopolitics in the Andes: Conceptual Reflections beyond "Politics." *Cultural Anthropology* 25(2): 334–370.

Del Pino, Ponciano. 2013. Introducción: Etnografías e historias de la violencia. In *Las formas del recuerdo: Etnografías de la violencia política en el Perú*, edited by Ponciano del Pino and Caroline Yezer, 9–24. Lima: Instituto de Estudios Peruanos/Instituto Francés de Estudios Andinos.

Del Pino, Ponciano. 2017. *En nombre del gobierno: El Perú y Uchuraccay; Un siglo de política campesina.* Lima: La Siniestra.

Del Pino, Ponciano, and José Carlos Agüero. 2014. *Cada uno, un lugar de memoria: Fundamentos conceptuales del Lugar de la Memoria, la Tolerancia y la Inclusión Social.* Lima: Lugar de la Memoria, la Tolerancia y la Inclusión Social.

Del Pino, Ponciano, and Eliana Otta. 2018. Extreme Violence in Museums of Memory: The Place of Memory in Peru. In *The Andean World*, edited by Linda J. Seligmann and Kathleen S. Fine-Dare, 355–370. Abingdon, UK: Routledge.

Del Pino, Ponciano, and Eliana Otta. n.d. Violencias extremas en museos conmemorativos: El Lugar de la Memoria en el Perú. Unpublished manuscript.

Del Pino, Ponciano, and Caroline Yezer, eds. 2013. *Las formas del recuerdo: Etnografías de la violencia política en el Perú.* Lima: Instituto de Estudios Peruanos/Instituto Francés de Estudios Andinos.

DeLugan, Robin Maria. 2012. *Reimagining National Belonging: Post–Civil War El Salvador in a Global Context.* Tucson: University of Arizona Press.

De Waardt, Mijke. 2016. Naming and Shaming Victims: The Semantics of Victimhood. *International Journal of Transitional Justice* 10(3): 432–450.

Diario Expreso. 2009. Museo de la Dincote. Editorial. *Diario Expreso*, September 9. editorialexpreso.blogspot.com/2009/09/museo-de-la-dincote.html.

Dietrich, Martha-Cecilia. 2018. Entre Memorias (Between Memories). *Journal of Anthropological Films* 2(2): e1559.

Dirks, Nicholas B. 1990. History as a Sign of the Modern. *Public Culture* 2(2): 25–32.

Draper, Susana. 2012. Making the Past Perceptible: Reflections on the Temporal and Visual Enframings of Violence in the Museum of Memory in Uruguay. *Journal of Educational Media, Memory and Society* 4(2): 94–111.

Drinot, Paulo. 2009. For Whom the Eye Cries: Memory, Monumentality, and the Ontologies of Violence in Peru. *Journal of Latin American Cultural Studies* 18(1): 15–32.

Drinot, Paulo. 2011. *The Allure of Labor: Workers, Race, and the Making of the Peruvian State*. Durham, N.C.: Duke University Press.

Drinot, Paulo. 2019. Contested Memories of the Peruvian Armed Conflict. In *Politics after Violence: Legacies of the Shining Path Conflict in Peru*, edited by Hillel David Soifer and Alberto Vergara, 285–311. Austin: University of Texas.

Duncan, Carol. 1991. Art Museums and the Ritual of Citizenship. In *Exhibiting Cultures: The Poetics and Politics of Museum Display*, edited by Ivan Karp and Steven D. Lavine, 88–103. Washington, D.C.: Smithsonian Institution Press.

Dwyer, Leslie. 2010. Building a Monument: Intimate Politics of "Reconciliation" in Post-1965 Bali. In *Transitional Justice: Global Mechanisms and Local Realities after Genocide and Mass Violence*, edited by Alexander Laban Hinton, 227–248. New Brunswick, N.J.: Rutgers University Press.

Earle, Rebecca. 2007. *The Return of the Native: Indians and Myth-Making in Spanish America, 1810–1930*. Durham, N.C.: Duke University Press.

El Comercio. 2009a. García: Museo de la Memoria no refleja la visión nacional. *El Comercio*, March 1. elcomercio.pe/politica/gobierno/garcia-museo-memoria-no-refleja -vision-nacional-noticia-252921.

El Comercio. 2009b. Mario Vargas Llosa le responde a críticos del Museo de la Memoria. *El Comercio*, December 16. elcomercio.pe/politica/gobierno/vargas-llosa -sobre-museo-memoria-no-convencere-que-tienen-manos-manchadas-sangre -noticia-382493.

El Comercio. 2018. Edwin Donayre y los efectos de su visita al LUM en claves. *El Comercio*, May 17. elcomercio.pe/politica/edwin-donayre-efectos-visita-lum-claves -noticia-520706.

Erll, Astrid. 2011. Travelling Memory. *Parallax* 17(4): 4–18.

Espacio360. 2013. Lugar de la Memoria, la Tolerancia y la Inclusión Social y su guion museográfico. *Espacio360*, December 12. espacio360.pe/noticia/cultura/lugar-de -la-memoria-la-tolerancia-y-la-inclusion-social-y-su-guion-museografico-31ad.

Espinosa, Augustín, Darío Páez, Tesania Velászquez, Rosa María Cueto, Evelyn Seminario, Salvador Sandoval, Félix Reátegui, and Iris Jave. 2017. Between Remembering and Forgetting the Years of Political Violence: Psychosocial Impact of the Truth and Reconciliation Commission in Peru. *Political Psychology* 38(5): 849–866.

Fassin, Didier, and Richard Rechtman. 2009. *The Empire of Trauma: An Inquiry into the Condition of Victimhood*. Princeton, N.J.: Princeton University Press.

Favre, Henri. 1984. Perú: Sendero Luminoso y horizontes oscuros. *Quehacer* 31: 25–34.

Feinstein, Tamara. 2014. Competing Visions of the 1986 Lima Prison Massacres: Memory and the Politics of War in Peru. *A Contracorriente* 11(3): 1–40.

Feldman, Ilana. 2008. *Governing Gaza: Bureaucracy, Authority, and the Work of Rule, 1917–1967*. Durham, N.C.: Duke University Press.

Feldman, Joseph P. 2012. Exhibiting Conflict: History and Politics at the Museo de la Memoria de ANFASEP. *Anthropological Quarterly* 85(2): 487–518.

Feldman, Joseph P. 2018. *Yuyanapaq no entra*: Ritual Dimensions of Post-Transitional Justice in Peru. *Journal of the Royal Anthropological Institute* 24(3): 589–606.

Felices, Paulo Billy. 2013. Obras de Lugar de la Memoria concluirán este año. *Espacio360*, August 28. espacio360.pe/noticia/actualidad/obras-de-lugar-de-la-memoria-concluiran-este-ano-8a26.

Ferguson, James, and Akhil Gupta. 2002. Spatializing States: Toward an Ethnography of Neoliberal Governmentality. *American Ethnologist* 29(4): 981–1002.

Fouseki, Kalliopi. 2010. "Community Voices, Curatorial Choices": Community Consultation for the 1807 Exhibitions. *Museum and Society* 8(3): 180–192.

Fraser, Nancy. 1990. Rethinking the Public Sphere: A Contribution to the Critique of Actually Existing Democracy. *Social Text* 25/26: 56–80.

Frazier, Lessie Jo. 2007. *Salt in the Sand: Memory, Violence, and the Nation-State in Chile, 1890 to the Present*. Durham, N.C.: Duke University Press.

Gandolfo, Daniella. 2009. *The City at Its Limits: Taboo, Transgression, and Urban Renewal in Lima*. Chicago: University of Chicago Press.

García, María Elena. 2005. *Making Indigenous Citizens: Identities, Education, and Multicultural Development in Peru*. Stanford, Calif.: Stanford University Press.

García, María Elena. 2013. The Taste of Conquest: Colonialism, Cosmopolitics, and the Dark Side of Peru's Gastronomic Boom. *Journal of Latin American and Caribbean Anthropology* 18(3): 505–524.

García Belaúnde, José Antonio. 2016. Una visita al Lugar de la Memoria. *El Comercio*, January 15. elcomercio.pe/opinion/colaboradores/visita-lugar-memoria-j-garcia-belaunde-262518-noticia/.

García-Godos, Jemima. 2008. Victim Reparations in the Peruvian Truth Commission and the Challenge of Historical Interpretation. *International Journal of Transitional Justice* 2(1): 63–82.

García-Sayán, Diego. 2018. LUM, producto de la sociedad peruana. *La República*, May 23. larepublica.pe/politica/1248295-lum-producto-sociedad-peruana/.

Garza, Cynthia M. 2014. Colliding with Memory: Grupo Cultural Yuyachkani's *Sin Título, Técnica Mixta*. In *Art from a Fractured Past: Memory and Truth-Telling in Post–Shining Path Peru*, edited by Cynthia E. Milton, 197–216. Durham, N.C.: Duke University Press.

Gavilán Sánchez, Lurgio. 2012. *Memorias de un soldado desconocido: Autobiografía y antropología de la violencia*. Lima: Instituto de Estudios Peruanos.

Gavilán Sánchez, Lurgio. 2015. *When Rains Became Floods: A Child Soldier's Story*. Translated by Margaret Randall. Durham, N.C.: Duke University Press.

González, Olga M. 2011. *Unveiling Secrets of War in the Peruvian Andes*. Chicago: University of Chicago Press.

González Cueva, Eduardo. 2006. The Peruvian Truth and Reconciliation Commission and the Challenge of Impunity. In *Transitional Justice in the Twenty-First Century: Beyond Truth versus Justice*, edited by Naomi Roht-Arriaza and Javier Mariezcurrena, 70–93. Cambridge: Cambridge University Press.

Goswami, Manu. 2002. Rethinking the Modular Nation Form: Toward a Sociohistorical Conception of Nationalism. *Comparative Studies in Society and History* 44(4): 770–799.

Graeber, David. 2015. *The Utopia of Rules: On Technology, Stupidity, and the Secret Joys of Bureaucracy*. Brooklyn, N.Y.: Melville House.

Granados Moya, Carla. n.d. Memorias disidentes: La incorporación de la memoria de los militares en el Lugar de la Memoria, la Tolerancia y la Inclusión Social. Unpublished manuscript.

Greene, Shane. 2006. Getting over the Andes: The Geo-Eco-Politics of Indigenous Movements in Peru's Twentieth-First Century Inca Empire. *Journal of Latin American Studies* 38(2): 327–354.

Greene, Shane. 2016. *Punk and Revolution: Seven More Interpretations of Peruvian Reality.* Durham, N.C.: Duke University Press.

Grimes, Ronald L. 1990. *Ritual Criticism: Case Studies in Its Practice, Essays on Its Theory.* Columbia: University of South Carolina Press.

Guglielmucci, Ana. 2015. El Museo de la Memoria y el Museo Nacional de Colombia: El arte de exponer narrativas sobre el conflicto armado interno. *Mediaciones* 15: 10–29.

Gupta, Akhil. 2004. Imagining Nations. In *A Companion to the Anthropology of Politics*, edited by David Nugent and Joan Vincent, 267–282. Malden, Mass.: Blackwell.

Halbwachs, Maurice. 1980 [1950]. *The Collective Memory.* Translated by Francis J. Ditter Jr. and Vida Yazdi Ditter. New York: Harper and Row.

Hale, Charles R. 2004. Rethinking Indigenous Politics in the Era of the "Indio Permitido." *NACLA Report on the Americas* 38(2): 16–21.

Hale, Charles R. 2005. Neoliberal Multiculturalism: The Remaking of Cultural Rights and Racial Dominance in Central America. *PoLAR: Political and Legal Anthropology Review* 28(1): 10–19.

Handler, Richard. 1988. *Nationalism and the Politics of Culture in Quebec.* Madison: University of Wisconsin Press.

Handler, Richard, and Eric Gable. 1997. *The New History in an Old Museum: Creating the Past at Colonial Williamsburg.* Durham, N.C.: Duke University Press.

Hansen, Thomas Blom, and Finn Stepputat, eds. 2001. *States of Imagination: Ethnographic Explorations of the Postcolonial State.* Durham, N.C.: Duke University Press.

Harrison, Simon. 2012. *Dark Trophies: Hunting and the Enemy Body in Modern War.* Oxford: Berghahn Books.

Hayner, Priscilla B. 2011. *Unspeakable Truths: Transitional Justice and the Challenge of Truth Commissions.* 2nd ed. Abingdon, UK: Routledge.

Heilman, Jaymie Patricia. 2010. *Before the Shining Path: Politics in Rural Ayacucho, 1895–1980.* Stanford, Calif.: Stanford University Press.

Hibbett, Alexandra. 2013. Remembering Political Violence: A Critique of Memory in Three Contemporary Peruvian Novels. PhD diss., Birkbeck College, University of London.

Hibbett, Alexandra. 2017. La reciente polémica alrededor del Lugar de la Memoria. *Disonancia: Portal de Debate y Crítica Social*, September 5. disonancia.pe/2017/09/05/la-reciente-polemica-alrededor-del-lugar-de-la-memoria/?#.

Hinton, Alexander Laban, ed. 2010. *Transitional Justice: Global Mechanisms and Local Realities after Genocide and Mass Violence.* New Brunswick, N.J.: Rutgers University Press.

Hite, Katherine. 2007. "The Eye that Cries": The Politics of Representing Victims in Contemporary Peru. *A Contracorriente* 5(1): 108–134.

Hite, Katherine. 2013. Voice and Visibility in Latin American Memory Politics. In *Sustaining Human Rights in the Twenty-First Century: Strategies from Latin America*, edited by Katherine Hite and Mark Ungar, 341–367. Washington, D.C.: Woodrow Wilson Center Press.

Hite, Katherine, and Cath Collins. 2009. Memorial Fragments, Monumental Silences and Reawakenings in 21st-Century Chile. *Millennium: Journal of International Studies* 38(2): 379–400.

Holmes, Douglas, and George E. Marcus. 2006. Fast Capitalism: Para-Ethnography and the Rise of the Symbolic Analyst. In *Frontiers of Capital*, edited by Melissa S. Fisher and Greg Downey, 33–56. Durham, N.C.: Duke University Press.

Hull, Matthew. 2003. The File: Agency, Authority, and Autography in an Islamabad Bureaucracy. *Language & Communication* 23(3–4): 287–314.

Hull, Matthew. 2012. Documents and Bureaucracy. *Annual Review of Anthropology* 41: 251–267.

Hunt, Tristram. 2004. Whose Truth? Objective Truth and a Challenge for History. *Criminal Law Forum* 15: 193–198.

Hurtado Meza, Lourdes. 2006. Ejército cholificado: Reflexiones sobre la apertura del ejército peruano hacia los sectores populares. *Íconos* 26: 59–72.

Huyssen, Andreas. 2003. *Present Pasts: Urban Palimpsests and the Politics of Memory.* Stanford, Calif.: Stanford University Press.

Ideele (Revista del Instituto de Defensa Legal). 2013. Denise Ledgard: "Tenemos que despojarnos un poco de la armadura de la CVR y mirar hacia el futuro." *Ideele Revista* 233. revistaideele.com/ideele/content/denise-ledgard-%E2%80%9Ctenemos -que-despojarnos-un-poco-de-la-armadura-de-la-cvr-y-mirar-hacia-el.

Isaac, Gwyneira. 2007. *Mediating Knowledges: Origins of a Zuni Tribal Museum.* Tucson: University of Arizona Press.

James, Erica Caple. 2004. The Political Economy of "Trauma" in Haiti in the Democratic Era of Insecurity. *Culture, Medicine and Psychiatry* 28: 127–149.

Jara, Daniela. 2018. Ética, estética y política del duelo: El Museo de la Memoria y los Derechos Humanos en Chile. *A Contracorriente* 15(2): 245–263.

Jáuregui, Eloy. 2016. Cicatrices y olvidos. *El Peruano (Variedades)*, October 7, 4–5.

Jeffery, Laura, and Matei Candea. 2006. The Politics of Victimhood. *History and Anthropology* 17(4): 287–296.

Jelin, Elizabeth. 2002. *Los trabajos de la memoria.* Buenos Aires: Siglo XXI.

Jelin, Elizabeth. 2010. The Past in the Present: Memories of State Violence in Contemporary Latin America. In *Memory in a Global Age: Discourses, Practices and Trajectories*, edited by Aleida Assman and Sebastian Conrad, 61–78. New York: Palgrave Macmillan.

Jelin, Elizabeth, and Victoria Langland, eds. 2003. *Monumentos, memoriales y marcas territoriales.* Madrid: Siglo XXI/SSRC.

Jiménez, Beatriz. 2009. Museo de la Memoria tiene alta aceptación. *La República*, March 11. www.larepublica.pe/11-03-2009/museo-de-la-memoria-tiene-alta-acep tacion-0.

Kahn, Miriam. 2000. Not Really Pacific Voices: Politics of Representation in Collaborative Museum Exhibits. *Museum Anthropology* 24(1): 57–74.

Kaiser, Susana. 2020. Writing and Reading Memories at a Buenos Aires Memorial Site: The Ex-ESMA. *History & Memory* 32(1): 69–99.

Karp, Ivan, Christine Mullen Kreamer, and Steven D. Lavine, eds. 1992. *Museums and Communities: The Politics of Public Culture.* Washington, D.C.: Smithsonian Institution Press.

Kent, Lia. 2019. Transitional Justice and the Spaces of Memory Activism in Timor-Leste and Aceh. *Global Change, Peace & Security* 31(2): 181–199.

Kernaghan, Richard. 2009. *Coca's Gone: Of Might and Right in the Huallaga Post-Boom.* Stanford, Calif.: Stanford University Press.

Kirshenblatt-Gimblett, Barbara. 1998. *Destination Culture: Tourism, Museums, and Heritage.* Berkeley: University of California Press.

Koselleck, Reinhart. 2002. *The Practice of Conceptual History: Timing History, Spacing Concepts.* Translated by Todd Samuel Presner. Stanford, Calif.: Stanford University Press.

Kratz, Corinne A. 2011. Rhetorics of Value: Constituting Worth and Meaning through Cultural Display. *Visual Anthropology Review* 27(1): 21–48.

Lambright, Anne. 2016. *Andean Truths: Transitional Justice, Ethnicity, and Cultural Production in Post–Shining Path Peru.* Liverpool: Liverpool University Press.

La Mula. 2018. Los curadores del LUM rechazan las acusaciones de apología al terrorismo en muestra permanente. LaMula.pe, May 19. redaccion.lamula.pe/2018/05/19/los-curadores-de-lum-rechazan-las-acusaciones-de-apologia-al-terrorismo-en-muestra-permanente/redaccionmulera/.

La República. 2010a. Guibovich: Estoy totalmente de acuerdo con el Lugar de la Memoria. *La República,* February 5. larepublica.pe/05-02-2010/guibovich-estoy-totalmente-de-acuerdo-con-lugar-de-la-memoria.

La República. 2010b. MVLL renuncia a presidencia de comisión del Museo de la Memoria. *La República,* September 13. larepublica.pe/13-09-2010/mvll-renuncia-presidencia-de-comision-del-museo-de-la-memoria.

La República. 2010c. Vargas Llosa: Museo de la Memoria se llamará Lugar de la Memoria. *La República,* January 27. larepublica.pe/27-01-2010/vargas-llosa-museo-de-la-memoria-se-llamara-lugar-dela-memoria.

La República. 2012. Lugar de la Memoria buscará frenar a grupos prosenderistas. *La República,* August 20. larepublica.pe/20-08-2012/lugar-de-la-memoria-buscara-frenar-grupos-prosenderistas.

La República. 2013. Avances en el Lugar de la Memoria. *La República,* January 22. larepublica.pe/politica/editorial-22-01-2013.

La Serna, Miguel. 2012. *The Corner of the Living: Ayacucho on the Eve of the Shining Path Insurgency.* Chapel Hill: University of North Carolina Press.

La Serna, Miguel. 2020. *With Masses and Arms: Peru's Tupac Amaru Revolutionary Movement.* Chapel Hill: University of North Carolina Press.

Lazzara, Michael J. 2017. The Memory Turn. In *New Approaches to Latin American Studies: Culture and Power,* edited by Juan Poblete, 14–31. Abingdon, UK: Routledge.

Leach, Edmund. 1965. The Nature of War. *Disarmament and Arms Control* 3: 165–183.

Ledgard, Denise, Alexandra Hibbett, and Blas de la Jara. 2018. *Retos y estrategias para una política pública de memoria: El proyecto Lugar de la Memoria, la Tolerancia y la Inclusión Social.* Cuaderno de Investigación no. 7. Lima: Escuela de Gobierno y Políticas Públicas de la Pontificia Universidad Católica del Perú.

Lehrer, Erica. 2015. Thinking through the Canadian Museum of Human Rights. *American Quarterly* 67(4): 1195–1216.

Lehrer, Erica, and Cynthia E. Milton. 2011. Introduction: Witnesses to Witnessing. In *Curating Difficult Knowledge: Violent Pasts in Public Places,* edited by Erica Lehrer, Cynthia E. Milton, and Monica Eileen Patterson, 1–22. Houndmills, UK: Palgrave Macmillan.

Lerner Febres, Salomón. 2004. *La rebelión de la memoria: Selección de discursos 2001–2003.* Lima: Instituto de Democracia y Derechos Humanos, Coordinadora Nacional de Derechos Humanos, Centro de Estudios y Publicaciones.

Lerner Febres, Salomón. 2018. Campaña contra la memoria. *La República,* May 24. larepublica.pe/politica/1248907-campana-memoria/.

Li, Fabiana. 2017. *Desenterrando el conflicto: Empresas mineras, activistas y expertos en el Perú.* Lima: Instituto de Estudios Peruanos.

Linenthal, Edward T. 2001 [1995]. *Preserving Memory: The Struggle to Create America's Holocaust Museum.* New York: Columbia University Press.

Llamo, Piero. 2013. A 10 años de informe CVR: "Ni verdad, ni reconciliación." *Correo,* August 25. diariocorreo.pe/ultimas/noticias/5955173/a-dias-de-decimo-aniversario-de-la-cvr-ni.

Macdonald, Sharon. 2002. *Behind the Scenes at the Science Museum.* London: Berg.

Macdonald, Sharon. 2013. *Memorylands: Heritage and Identity in Europe Today.* Abingdon, UK: Routledge.

Macher, Sofía. 2014. *¿Hemos avanzado? A 10 años de las recomendaciones de la Comisión de la Verdad y Reconciliación.* Lima: Instituto de Estudios Peruanos.

Manrique, Marie. 2014. Generando la inocencia: Creación, uso e implicaciones de la identidad de "inocente" en los periodos de conflicto y postconflicto en el Perú. *Bulletin de L'Institut Français d'Études Andines* 43(1): 53–73.

Mayer, Enrique. 1991. Peru in Deep Trouble: Mario Vargas Llosa's "Inquest in the Andes" Reexamined. *Cultural Anthropology* 6(4): 466–504.

Mayer, Enrique. 2009. *Ugly Stories of the Peruvian Agrarian Reform.* Durham, N.C.: Duke University Press.

McMullen, Ann. 2008. The Currency of Consultation and Collaboration. *Museum Anthropology Review* 2(2): 54–87

Message, Kylie. 2006. *New Museums and the Making of Culture.* Oxford: Berg.

Miller, Nicola. 2006. The Historiography of Nationalism and National Identity in Latin America. *Nations and Nationalism* 12(2): 201–221.

Milton, Cynthia E. 2011. Defacing Memory: (Un)tying Peru's Memory Knots. *Memory Studies* 4(2): 190–205.

Milton, Cynthia E., ed. 2014a. *Art from a Fractured Past: Memory and Truth-Telling in Post–Shining Path Peru.* Durham, N.C.: Duke University Press.

Milton, Cynthia E. 2014b. Images of Truth: Rescuing Memories of Peru's Internal War through Testimonial Art. In *Art from a Fractured Past: Memory and Truth-Telling in Post–Shining Path Peru,* edited by Cynthia E. Milton, 37–74. Durham, N.C.: Duke University Press.

Milton, Cynthia E. 2014c. Introduction. In *Art from a Fractured Past: Memory and Truth-Telling in Post–Shining Path Peru,* edited by Cynthia E. Milton, 1–34. Durham, N.C.: Duke University Press.

Milton, Cynthia E. 2015. Curating Memories of Armed State Actors in Peru's Era of Transitional Justice. *Memory Studies* 8(3): 361–378.

Milton, Cynthia E. 2018. *Conflicted Memory: Military Cultural Interventions and the Human Rights Era in Peru.* Madison: University of Wisconsin Press.

Milton, Cynthia E., and María Eugenia Ulfe. 2011. Promoting Peru: Tourism and Post-Conflict Memory. In *Accounting for Violence: Marketing Memory in Latin America,* edited by Ksenija Bilbija and Leigh A. Payne, 207–233. Durham, N.C.: Duke University Press.

Mitchell, Timothy. 1991. The Limits of the State: Beyond Statist Approaches and Their Critics. *American Political Science Review* 85(1): 77–96.

Montero-Diaz, Fiorella. 2016. Singing the War: Reconfiguring White Upper-Class Identity through Fusion Music in Post-War Lima. *Ethnomusicology Forum* 2: 191–209.

Mookherjee, Nayanika. 2011a. The Aesthetics of Nations: Anthropological and Historical Approaches. *Journal of the Royal Anthropological Institute* 17(1): 1–20.

Mookherjee, Nayanika. 2011b. "Never Again:" Aesthetics of "Genocidal" Cosmopolitanism and the Bangladesh Liberation War Museum. *Journal of the Royal Anthropological Institute* 17(1): 71–91.

Moore, Sally Falk, and Barbara G. Myerhoff, eds. 1977. *Secular Ritual.* Assen, The Netherlands: Van Gorcum.

Moser, Stephanie. 2010. The Devil is in the Detail: Museum Displays and the Creation of Knowledge. *Museum Anthropology* 33(1): 22–32.

Murphy, Kaitlin M. 2015. What the Past Will Be: Curating Memory in Peru's *Yuyanapaq: Para Recordar. Human Rights Review* 16: 23–38.

Nelson, Diane M. 2009. *Reckoning: The Ends of War in Guatemala.* Durham, N.C.: Duke University Press.

Núñez, Ana. 2014. Persiste esa sensación de que hay dos Perú: Que una cosa es lo que pasa en Lima y otra fuera de ella. *La República*, June 1. larepublica.pe/archivo/796 153-persiste-esa-sensacion-de-que-hay-dos-peru-que-una-cosa-es-lo-que-pasa-en -lima-y-otra-fuera-de-ella/.

Ong, Aihwa. 1999. *Flexible Citizenship: The Cultural Logics of Transnationality.* Durham, N.C.: Duke University Press.

Osiel, Mark. 1997. *Mass Atrocity, Collective Memory, and the Law.* New Brunswick, N.J.: Transaction Publishers.

Paley, Julia. 2001. *Marketing Democracy: Power and Social Movements in Post-Dictatorship Chile.* Berkeley: University of California Press.

Park, Rebekah. 2014. *The Reappeared: Argentine Former Political Prisoners.* New Brunswick, N.J.: Rutgers University Press.

Parker, D. S. 1998. *The Idea of the Middle Class: White-Collar Workers and Peruvian Society, 1900–1950.* University Park: Pennsylvania State University Press.

Patiño Rabines, Paola. 2014. Clase alta limeña y consumo de lo popular. In *Perspectivas sobre el nacionalismo en el Perú*, edited by Gonzalo Portocarrero, 57–97. Lima: Red para el Desarrollo de las Ciencias Sociales en el Perú.

Patterson, Monica Eileen. 2011. Teaching Tolerance through Objects of Hatred: The Jim Crow Museum of Racist Memorabilia as "Counter-Museum." In *Curating Difficult Knowledge: Violent Pasts in Public Places*, edited by Erica Lehrer, Cynthia E. Milton, and Monica Eileen Patterson, 55–71. Houndmills, UK: Palgrave Macmillan.

Payne, Leigh A. 2008. *Unsettling Accounts: Neither Truth nor Reconciliation in Confessions of State Violence.* Durham, N.C.: Duke University Press.

Perreault, Tom. 2015. Performing Participation: Mining, Power, and the Limits of Public Consultation in Bolivia. *Journal of Latin American and Caribbean Anthropology* 20(3): 433–451.

PNUD Peru. 2015. En Perú, recordando el pasado como un paso hacia la expiación. PNUD Perú, December 18. www.undp.org/content/undp/es/home/ourwork/our stories/in-peru--remembering-the-past-as-a-step-towards-atonement0.html.

Poole, Deborah, and Gerardo Rénique. 1992. *Peru: Time of Fear.* London: Latin America Bureau.

Poole, Deborah, and Isaías Rojas-Pérez. 2010. Memories of Reconciliation: Photography and Memory in Postwar Peru. *e-misférica* 7(2). hemi.nyu.edu/hemi/en/e-misferica -72/poolerojas.

Portocarrero, Gonzalo. 2012. *Profetas del odio: Raíces culturales y líderes de Sendero Luminoso.* Lima: Fondo Editorial de la Pontificia Universidad Católica del Perú.

Portugal Teillier, Tamia. 2015. Batallas por el reconocimiento: Lugares de memoria en el Perú. In *No hay mañana sin ayer: Batallas por la memoria y consolidación democrática en el Perú*, edited by Carlos Iván Degregori, Tamia Portugal Teillier, Gabriel Salazar Borja, and Renzo Aroni Sulca, 71–236. Lima: Instituto de Estudios Peruanos.

Postero, Nancy. 2017. *The Indigenous State: Race, Politics, and Performance in Plurinational Bolivia.* Oakland: University of California Press.

Povinelli, Elizabeth A. 2002. *The Cunning of Recognition: Indigenous Alterities and the Making of Australian Multiculturalism.* Durham, N.C.: Duke University Press.

Povinelli, Elizabeth A. 2011. *Economies of Abandonment: Social Belonging and Endurance in Late Liberalism.* Durham, N.C.: Duke University Press.

Prado, César. 2016. Mariátegui en su Laberinto. *Caretas,* January 7. www2.caretas.pe /Main.asp? T=3082&id=12&idE=1241&idA=74174.

Price, Sally. 2007. *Paris Primitive: Jacques Chirac's Museum on the Quai Branly.* Chicago: University of Chicago Press.

Puente-Valdivia, Javier. 2013. La problemática del museo como espacio de representación: De Benedict Anderson al Lugar de la Memoria del Perú. In *La memoria histórica y sus configuraciones temáticas,* edited by Juan Andrés Bresciano, 565–582. Buenos Aires: Ediciones Cruz del Sur.

Quintanilla Flores, Santiago. 2017. Evitar convertirse en piedra: Reflexiones sobre el arte de Sendero Luminoso en la exposición Esquirlas del Odio. *Arte & Diseño* 5: 72–81.

Reátegui, Félix, Rafael Barrantes, and Jesús Peña. 2010. *Los sitios de la memoria: Procesos sociales de la conmemoración en el Perú.* Lima: Instituto de Democracia y Derechos Humanos de la Pontificia Universidad Católica del Perú.

Rodrigo Gonzales, Paloma. 2010. Lugar de la Memoria: The Peruvian Debate on Memory, Violence and Representation. MA thesis, Center for Iberian and Latin American Studies, University of California at San Diego.

Rojas-Perez, Isaias. 2017. *Mourning Remains: State Atrocity, Exhumations, and Governing the Disappeared in Peru's Postwar Andes.* Stanford, Calif.: Stanford University Press.

Root, Rebecca K. 2009. Through the Window of Opportunity: The Transitional Justice Network in Peru. *Human Rights Quarterly* 31(2): 452–473.

Root, Rebecca K. 2012. *Transitional Justice in Peru.* London: Palgrave Macmillan.

Rothschild, Amy. 2017. Victims versus Veterans: Agency, Resistance and Legacies of Timor-Leste's Truth Commission. *International Journal of Transitional Justice* 11(3): 443–462.

Rubin, Jonah. 2018. How Francisco Franco Governs from beyond the Grave: An Infrastructural Approach to Memory Politics in Contemporary Spain. *American Ethnologist* 45(2): 214–227.

Rubio Zapata, Miguel. 2015. "El arte como campo de destrucción de la memoria": Una aclaración indispensable. Scribd. www.scribd.com/document/291715845/Una -aclaracion-indispensable-Por-Miguel-Rubio.

Salazar Borja, Gabriel. 2015. Sin debates no hay campo de estudios sobre memoria y violencia política en el Perú. In *No hay mañana sin ayer: Batallas por la memoria y consolidación democrática en el Perú,* edited by Carlos Iván Degregori, Tamia Portugal Teillier, Gabriel Salazar Borja, and Renzo Aroni Sulca, 239–301. Lima: Instituto de Estudios Peruanos.

Salvi, Valentina. 2015. "We're All Victims": Changes in the Narrative of "National Reconciliation" in Argentina. *Latin American Perspectives* 42(3): 39–51.

Saona, Margarita. 2014. *Memory Matters in Transitional Peru.* London: Palgrave Macmillan.

Sastre Díaz, Camila Fernanda. 2015. Tensiones, polémicas y debates: el museo "Lugar de la Memoria, la Tolerancia y la Inclusión Social" en el Perú post-violencia política. MA thesis, Latin American Studies, Universidad de Chile.

Schwenkel, Christina. 2009. *The American War in Contemporary Vietnam: Transnational Remembrance and Representation.* Bloomington: Indiana University Press.

Shannon, Jennifer A. 2014. *Our Lives: Collaboration, Native Voice, and the Making of the National Museum of the American Indian.* Santa Fe, N.M.: School for Advanced Research Press.

Sharma, Aradhana, and Akhil Gupta, eds. 2006. *The Anthropology of the State: A Reader.* Malden, Mass.: Blackwell.

Sharp, Ethan. 2014. Visualizing *Narcocultura*: Violent Media, the Mexican Military's Museum of Drugs, and Transformative Culture. *Visual Anthropology Review* 30(2): 151–163.

Shaw, Rosalind. 2007. Memory Frictions: Localizing the Truth and Reconciliation Commission in Sierra Leone. *International Journal of Transitional Justice* 1(2): 183–207.

Shaw, Rosalind, and Lars Waldorf, eds., with Pierre Hazan. 2010. *Localizing Transitional Justice: Interventions and Priorities after Mass Violence.* Stanford, Calif.: Stanford University Press.

Silva Santisteban, Rocío. 2009. *El factor asco: Basurización simbólica y discursos autoritarios en el Perú contemporáneo.* Lima: Red para el Desarrollo de las Ciencias Sociales en el Perú.

Smith, Laurajane, and Kalliopi Fouseki. 2011. The Role of Museums as "Places of Social Justice": Community Consultation and the 1807 Bicentenary. In *Representing Enslavement and Abolition in Museums: Ambiguous Engagements*, edited by Laurajane Smith, Geoff Cubitt, Kalliopi Fouseki, and Ross Wilson, 97–115. Abingdon, UK: Routledge.

Sodaro, Amy. 2018. *Exhibiting Atrocity: Memorial Museums and the Politics of Past Violence.* New Brunswick, N.J.: Rutgers University Press.

Starn, Orin. 1995. Maoism in the Andes: The Communist Party of Peru–Shining Path and the Refusal of History. *Journal of Latin American Studies* 27: 399–421.

Starn, Orin, and Miguel La Serna. 2019. *The Shining Path: Love, Madness, and Revolution in the Andes.* New York: W. W. Norton.

Stern, Steve J. 1998a. Beyond Enigma: An Agenda for Interpreting Shining Path and Peru, 1980–1995. In *Shining and Other Paths: War and Society in Peru, 1980–1995*, edited by Steve J. Stern, 1–12. Durham, N.C.: Duke University Press.

Stern, Steve J., ed. 1998b. *Shining and Other Paths: War and Society in Peru, 1980–1995.* Durham, N.C.: Duke University Press.

Stern, Steve J. 2010. *Reckoning with Pinochet's Chile: The Memory Question in Democratic Chile, 1989–2006.* Durham, N.C.: Duke University Press.

Stern, Steve J. 2015. Las verdades peligrosas: Comisiones de la verdad y transiciones políticas latinoamericanas en perspectiva comparada. In *Políticas en justicia transicional: Miradas comparativas sobre el legado de la CVR*, edited by Ludwig Huber and Ponciano del Pino, 111–133. Lima: Instituto de Estudios Peruanos.

Stern, Steve J. 2016. Memory: The Curious History of a Cultural Code Word. *Radical History Review* 124: 117–128

Strathern, Marilyn, ed. 2000. *Audit Cultures: Anthropological Studies in Accountability, Ethics, and the Academy.* London: Routledge.

Swan, Daniel C., and Michael Paul Jordan. 2015. Contingent Collaborations: Patterns of Reciprocity in Museum-Community Partnerships. *Journal of Folklore Research* 52(1): 39–84.

Tate, Winifred. 2007. *Counting the Dead: The Culture and Politics of Human Rights Activism in Colombia.* Berkeley: University of California Press.

Taussig, Michael. 1991. *The Nervous System.* London: Routledge.

Tenorio-Trillo, Mauricio. 1996. *Mexico at the World's Fairs: Crafting a Modern Nation.* Berkeley: University of California Press.

Thays, Iván. 2008. *Un lugar llamado Oreja de Perro.* Barcelona: Anagrama.

Theidon, Kimberly. 2004. *Entre prójimos: El conflicto armado interno y la política de la reconciliación en el Perú.* Lima: Instituto de Estudios Peruanos.

Theidon, Kimberly. 2013. *Intimate Enemies: Violence and Reconciliation in Peru*. Philadelphia: University of Pennsylvania Press.

Thurner, Mark. 2011. *History's Peru: The Poetics of Colonial and Postcolonial Historiography*. Gainesville: University Press of Florida.

Ulfe, María Eugenia. 2013a. Dos veces muerto: La historia de la imagen y vida de Celestino Ccente o Edmundo Camana. *Memoria y sociedad* 17(34): 81–90.

Ulfe, María Eugenia. 2013b. *¿Y después de la violencia que queda? Víctimas, ciudadanos y reparaciones en el contexto post-CVR en el Perú*. Buenos Aires: Consejo Latinoamericano de Ciencias Sociales.

Ulfe, María Eugenia, and Cynthia E. Milton. 2010. ¿Y, después de la verdad? El espacio público y las luchas por la memoria en la post CVR, Perú. *e-misférica* 7(2). hemispheric institute.org/hemi/en/e-misferica-72/miltonulfe.

Ulfe, María Eugenia, and Vera Lucía Ríos. 2016. Toxic Memories: The DINCOTE Museum in Lima, Peru. *Latin American Perspectives* 43(6): 27–40.

Vaisman, Noa. 2017. Variations on Justice: Argentina's Pre- and Post-Transitional Justice and the Justice to Come. *Ethnos* 82(2): 366–388.

Vargas Llosa, Mario. 2009. El Perú no necesita museos. *El Comercio*, March 8.

Vergara, Alberto, and Daniel Encinas. 2016. Continuity by Surprise: Explaining Institutional Stability in Contemporary Peru. *Latin American Research Review* 51(1): 159–180.

Vermeulen, Pieter, Stef Craps, Richard Crownshaw, Ortwin de Graef, Andreas Huyssen, Vivian Liska, and David Miller. 2012. Dispersal and Redemption: The Future Dynamics of Memory Studies—A Roundtable. *Memory Studies* 5(2): 223–239.

Vich, Víctor. 2001. *El discurso de la calle: Los cómicos ambulantes y las tensiones de la modernidad en el Perú*. Lima: Red para el Desarrollo de las Ciencias Sociales en el Perú.

Vich, Víctor. 2002. *El caníbal es el otro: Violencia y cultura en el Perú contemporáneo*. Lima: Instituto de Estudios Peruanos.

Viteri, María Amelia, Michael Hill, Julie L. Williams, and Flavio Carrera, eds. 2019. *Diversidades espirituales y religiosas en Quito, Ecuador: Una mirada desde la etnografía colaborativa*. Quito: USFQ Press.

von Bieberstein, Alice. 2016. Not a German Past to Be Reckoned With: Negotiating Migrant Subjectivities between Vergangenheitsbewältigung and the Nationalization of History. *Journal of the Royal Anthropological Institute* 22(4): 902–919.

Weissert, Markus. 2016. Memories of Violence, Dreams of Development: Memorialisation Initiatives in the Peruvian Andes. PhD thesis, Free University of Berlin.

Weld, Kirsten. 2014. *Paper Cadavers: The Archives of Dictatorship in Guatemala*. Durham, N.C.: Duke University Press.

Whipple, Pablo. 2013. *La gente decente de Lima y su resistencia al orden republicano*. Lima: Instituto de Estudios Peruanos.

White, Geoffrey M. 1995. Remembering Guadalcanal: National Identity and Transnational Memory-Making. *Public Culture* 7: 529–555.

White, Geoffrey M. 1997. Museum/Memorial/Shrine: National Narrative in National Spaces. *Museum Anthropology* 21(3): 8–27.

White, Geoffrey M. 2016. *Memorializing Pearl Harbor: Unfinished Histories and the Work of Remembrance*. Durham, N.C.: Duke University Press.

Williams, Paul. 2007. *Memorial Museums: The Global Rush to Commemorate Atrocities*. Oxford: Berg.

Wilson, Richard A. 2001. *The Politics of Truth and Reconciliation in South Africa: Legitimizing the Post-Apartheid State*. Cambridge: Cambridge University Press.

Winter, Franka. 2019. "I Would like Citizenship to Mean Understanding the Other": Relational Notions of Citizenship in a Divided City. In *Citizenship in the Latin American*

Upper and Middle Classes: Ethnographic Perspectives on Culture and Politics, edited by Fiorella Montero-Diaz and Franka Winter, 83–98. Abingdon, UK: Routledge.

Wrightson, Kelsey R. 2017. The Limits of Recognition: *The Spirit Sings*, Canadian Politics, and the Colonial Politics of Recognition. *Museum Anthropology* 40(1): 36–51.

Yezer, Caroline. 2007. Anxious Citizenship: Insecurity, Apocalypse and War Memories in Peru's Andes. PhD diss., Department of Cultural Anthropology, Duke University.

Yoneyama, Lisa. 1999. *Hiroshima Traces: Time, Space, and the Dialectics of Memory*. Berkeley: University of California Press.

Youngers, Coletta A. 2003. *Violencia política y sociedad civil en el Perú: Historia de la Coordinadora Nacional de Derechos Humanos*. Lima: Instituto de Estudios Peruanos.

Zapata Velasco, Antonio. 2010. La Comisión de la Verdad y Reconciliación y los medios de comunicación. Documento de trabajo 158. Lima: Instituto de Estudios Peruanos.

Zavaleta, Mauricio. 2019. Donayre, La Resistencia y los espacios de memoria. *El Comercio*, November 12. elcomercio.pe/opinion/colaboradores/donayre-la-resistencia-y-los-espacios-de-memoria-por-mauricio-zavaleta-noticia/?ref=ecr.

Index

Note: Page numbers in *italics* indicate figures.

Drinot, Paulo, 15, 31, 163n4
drug trade, 55, 160n11

Each Person, A Place of Memory (Del
Pino and Agüero), 110, 114, 143
El Comercio (newspaper), 32, 138, 161n22
El Frontón massacre (1986), 136
El Salvador, 50, 158n28
ESMA Site Museum (Argentina), 43,
158n28, 168n9
ethnographic research strategy, ix–x
EU-LAC/ALCUE Summit (2008), 33
Executive Directorate against Terror-
ism of the National Police of Peru
(DIREJCOTE), vii, 155n1 (intro.).
See also DINCOTE
exhibition development, 158n29,
159n30. *See also* LUM; memorializa-
tion initiatives; museum objects
exhumations, 126, 128, 144, 156n13

Fassin, Didier, 82
Favre, Henri, 26
Final Report (TRC). *See under* Truth and
Reconciliation Commission
Franco, Francisco, 50
Fujimori, Alberto, viii; capture and
display of Guzmán by, 1, 29, 32;
convictions of, 10, 165n8; extradition
of, 101; LUM exhibit on, 136; pardon
of, 141, 174n19
Fujimori, Keiko, 42, 137

Gambia, 147
Gamboa, Georgina, 128
García, Adelina, 83–86, 112
García, Alan, 14, 19, 32–34, 39, 136
García Belaúnde, José, 138
García-Sayán, Diego: LUM role of,
42–43; on LUM's goals and process,
92–93, 96–97, 99, 105, 107, 120, 141;
pre-LUM work of, 91–92; on title of
LUM project, 44; on Yuyanapaq, 77
Gavilán Sánchez, Lurgio, 94, 96, 98,
166n16

GEIN (Special Intelligence Group), 2
genocide *vs.* cultural genocide, as term,
172n10
German institutional and financial
support, 160n15; acceptance of, 36;
for ANFASEP, 8; for LUM, 14, 39;
rejection of, 32–35
Giampietri, Luis, 98
global *vs.* local discourses, 49–50,
162nn4–6. *See also* memorialization
initiatives; transnational culture of
memorialization
Gonzalo, President. *See* Guzmán, Abimael
gray zones, 86, 96, 100, 165n7
Grupo Colina, 95
Guatemala, 50
guerrilla movement in Peru, 25–27. *See
also* Shining Path
Guibovich, Otto, 36
Guzmán, Abimael: background and
description of, 26; capture of, viii, 1,
29, 156n9; DINCOTE museum
display of, 1–2; pardon of, 174n19.
See also Shining Path

Hatun Willakuy (TRC), 12. *See also
under* Truth and Reconciliation
Commission
Hermoza Ríos, Nicolás, 131
Hibbett, Alexandra, 15, 122, 128
history *vs.* memory, 6–7, 14–16, 146,
157n21. *See also* LUM; memorializa-
tion initiatives
hostage crisis. *See* Operation Chavín de
Huántar
#HoyNosEscuchamos, viii
Hull, Matthew, 114
Humala, Ollanta: accusations against,
97, 164n8; LUM and, vii, 14, 42–43,
75, 97; on memory and reparations, 19
Human Rights and Democracy Institute
(IDEHPUCP), 63
human rights memory *vs.* salvation
memory, 32
human rights museum. *See* LUM

About the Author

Joseph P. Feldman is currently a part-time assistant professor in the Department of Sociology and Anthropology at Southwestern University and a research fellow at the Teresa Lozano Long Institute of Latin American Studies at the University of Texas at Austin. Between 2016 and 2020 he was an assistant professor in the School of Anthropology at the Pontificia Universidad Católica de Chile and an affiliated researcher at the Center for Intercultural and Indigenous Research.